EXPRESSIONS: New Art from Germany

Expressions

New Art from Germany

Georg Baselitz, Jörg Immendorff
Anselm Kiefer, Markus Lüpertz
A. R. Penck

Jack Cowart
Organizing Curator and Editor
The Saint Louis Art Museum

Consultant Siegfried Gohr

Prestel-Verlag Munich
in association with
The Saint Louis Art Museum

Contributors

Jack Cowart, Ph. D.
Curator of 19th & 20th Century Art
The Saint Louis Art Museum
Initiating curator and director of the exhibition
Essayist

Siegfried Gohr, Dr. phil.
Director, Josef-Haubrich-Kunsthalle, Cologne,
West Germany
Consultant to the exhibition
Essayist

Donald B. Kuspit, Ph. D.
University Distinguished Professor, Rutgers
University, art historian and contemporary art
critic
Essayist

Renate Winkler
Librarian, Staatliche Akademie der
Bildenden Künste, Karlsruhe, West Germany
Bibliography

This book is published in connection with the exhibition
EXPRESSIONS: *New Art from Germany* organized by Jack Cowart for
The Saint Louis Art Museum, St. Louis, Missouri and presented at:

The Saint Louis Art Museum
June-August 1983

The Institute for Art and Urban Resources (P.S.1),
Long Island City, New York
October-November 1983

Institute of Contemporary Art, University of Pennsylvania,
Philadelphia, Pennsylvania
December 1983-January 1984

The Contemporary Arts Center, Cincinnati, Ohio
December 1983-January 1984

Museum of Contemporary Art, Chicago, Illinois
February-April 1984

Newport Harbor Art Museum, Newport Beach, California
April-June 1984

Corcoran Gallery of Art, Washington, District of Columbia
July-September 1984

This book and the exhibition it accompanies have been supported by
generous grants from:
 The National Endowment for the Arts
 The Federal Republic of Germany
Additional funding for programs in St. Louis has been provided by:
 Goethe Institute Chicago, German Cultural Center

© 1983 by The Saint Louis Art Museum and
Prestel Verlag
© Illustrations by the artists

Typesetting by Filmsatz Schröter GmbH, Munich
Printed by Wenschow GmbH, Munich
Bound by Oldenbourg GmbH, Munich
Printed in Germany
ISBN 3-7913-0639-1

Contents

·

Acknowledgments

The organization of this project beginning in St. Louis has resulted in long lines of communication and a large working team supplying support and counsel. The Saint Louis Art Museum, its Boards of Commissioners and Trustees and the Director, James D. Burke, are due my particular thanks for their enthusiasm. St. Louis is a city with a tangible German heritage stretching from the mid-19th century to the present. The influence of the German Expressionist artist Max Beckmann, living here between 1947 and 1948, remains strong within the art community memory. The resulting collections and international attitudes here are bases for our excitement concerning newer developments in West Germany. I want to thank all of our staff and support groups who have helped make this project a reality.

Dr. Siegfried Gohr served as primary consultant for many aspects of the project's relationships to West Germany. His expertise and unselfish willingness to help this venture from its very beginning contributed fundamental momentum to its eventual success. Gohr's professional experiences with the selected artists and his knowledge of their works have been of particular value. He has provided a constant link between St. Louis and the European collectors, artists, dealers, publisher and other art professionals. My thanks to Siegfried Gohr are profound because he served my complex plan so well.

Each of the artists, Georg Baselitz, A. R. Penck, Anselm Kiefer, Jörg Immendorff and Markus Lüpertz, has given his sincere support to this project. They have endured inquiries and proposals, but without their active participation our goals would not have been realizable.

This is an international project receiving financial aid from both the Federal Republic of Germany and the United States. We sincerely thank Dr. Peter Hermes, Ambassador to the Federal Republic of Germany and Dr. Haide Russell, Cultural Counselor, Washington, for their roles in obtaining the support of their government to help defray some of the costs of this publication and related exhibition. Dr. Oskar von Siegfried, Consul General to the Federal Republic of Germany, and Dr. Horst A. Kuhnke, Deputy Consul General, Chicago, graciously arranged for additional research funding. Dr. Wolfgang Ule, Director, Goethe Institute Chicago, has provided support for film and lecture programs related to the exhibition in St. Louis. We especially thank the National Endowment for the Arts, a Federal Agency of the United States government, for its major grant which reduced the direct expenses of the exhibition.

The participation of the arts institutions on the exhibition tour guaranteed the viability of EXPRESSIONS. We gratefully acknowledge and thank: Alanna Heiss, Executive Director, The Institute for Art and Urban Resources; Janet Kardon, Director, Institute of Contemporary Art, University of Pennsylvania; Sarah Rogers-Lafferty, Curator in charge for exhibitions, The Contemporary Arts Center; John Hallmark Neff, Director, Museum of Contemporary Art; The Board of Trustees, Newport Harbor Art Museum; and Jane Living-

ston, Associate Director, Corcoran Gallery of Art. We appreciate their support and the support of their boards and staffs.

Special thanks are due the many lenders to this project. Without their sacrifices the quality of touring exhibitions such as EXPRESSIONS would be greatly compromised. Their willingness to part with their superb holdings has given this exhibition the chance to display much of the best work by these artists to new audiences throughout the United States.

As a long but sincere listing, we offer evidence of our appreciation for the generous assistance, encouragements and many other contributions given by: Michael Werner, Cologne; Nancy Gillespie de la Selle, Paris; Sabine Knust, Munich; Hans Neuendorf, Hamburg; Rudolf Springer, West Berlin; Marian Goodman, New York; Helen van der Meij, Amsterdam and London; Anthony d'Offay, London; Xavier Fourcade, New York; Ileana Sonnabend, New York; Fred Jahn, Munich; David Nolan, New York; Mary Boone, New York; Rhona Hoffman, Chicago; Hester van Royen, London; Paul Maenz, Cologne; and Rudolf Zwirner, Cologne. Also: Ernst Busche, West Berlin; Dr. Carla Schulz-Hoffmann, Munich; Dr. Evelyn Weiss, Cologne; Nicolas Serota, London; Dr. Klaus Gallwitz, Frankfurt; Dr. Rudi Fuchs, Eindhoven; Frits Keers, Amsterdam; Johannes Gachnang, Bern; Dr. Heiner Horsten, Consul, General Consulate of the Federal Republic of Germany, New York; Doris and Charles Saatchi, London; Martijn and Jeannette Sanders, Amsterdam.

In closing, thanks to all the other friends of this project and to those close to us who have so generously offered assistance and comfort during the research, labor and extended travels required by this compelling undertaking.

Jack Cowart

Jack Cowart　Expressions

We are today witness to a number of related but still largely unrecon-
ciled developments concerning figurative painting, sculpture and the
graphic arts in West Germany. These dramatic current events have
done much to tip the stylistic balance of power away from the
international tendencies of conceptual or non-figurative modes
under the dominant influence of American contemporary art, artists
and critics. From the early 1960s in Germany there have been artists
who have set their course contrary to such pervasive stylistic abstrac-
tion. During the early 1970s common attitudes coalesced to broaden
the action of painting and the use of figurative relationships and
subject matter to include narrative, history and myth. Most of these
elements had been hitherto declared unqualified for serious discus-
sion as vanguard art. But by the second half of the 1970s, the artists
Georg Baselitz, Jörg Immendorff, Anselm Kiefer, Markus Lüpertz
and A. R. Penck had reached an apogee of intellectual maturity and
technical expertise. Their examples made the issues unavoidable.
Beyond an understandable amount of posturing and breast-beating,
their works and decisive actions now stand as provocative models of
intention, imagination and quality. These artists must be reckoned
with, since their activities prove central to subsequent evaluation of
both so-called figurative art and its co-existent mingling with hybrid
abstract and conceptual arts.

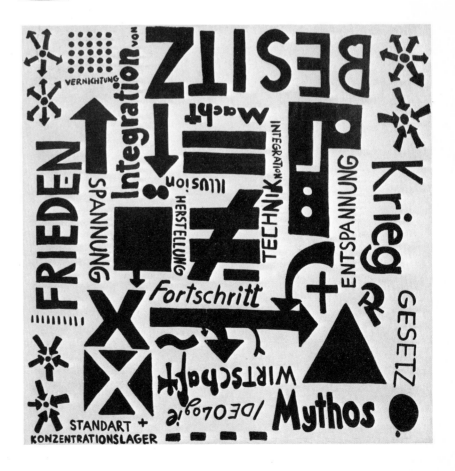

Fig. 1. A. R. Penck: *Standart*, 1973, acrylic on can-
vas, 285 x 285 cm

This publication and exhibition have been established to document and gain access to the best and most influential of these artists' works from the late 1960s to the present. Despite a bewildering barrage of art criticism and gallery response to the current European expressions, this is the first focused, American museum-originated inspection of the German contributions. Our perception of the aesthetic and historical problems is still changing by the nature of these prior activities, but the goal is to make a current overview with comparison to related contemporary developments, critical thought and response. Specific areas where these artists have left indelible marks upon the surface of new art will be identified.

It is not proposed here that Baselitz, Immendorff, Kiefer, Lüpertz and Penck are the only notable artists, figurative or otherwise, working in Germany today. Far from it, indeed, recent developments indicate new vitality in respected but previously remote figures (Sigmar Polke, for example) and the emergence of a whole new

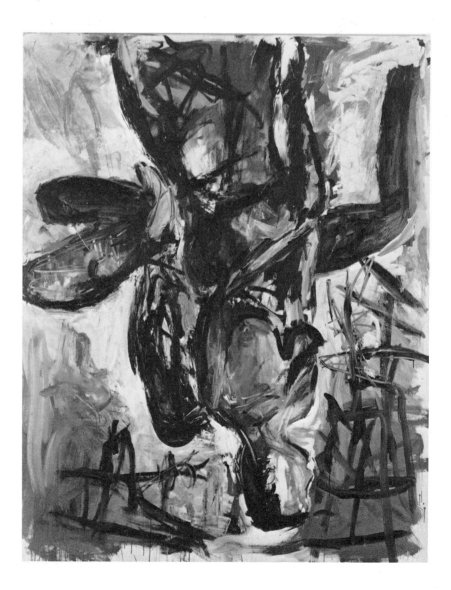

Fig. 2. Georg Baselitz: *Elke v*, 1976, oil on canvas, 200 x 162 cm

Fig. 3. Jörg Immendorff: *Café Deutschland 1*, 1977/78, synthetic resin on canvas, 282×320 cm, Neue Galerie – Museum Ludwig, Aachen

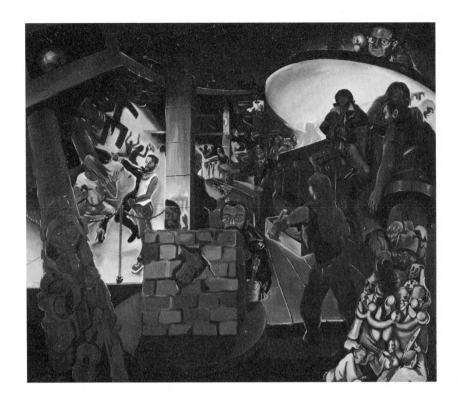

generation of active younger artists (in Berlin, Cologne, Düsseldorf, Hamburg and elsewhere). However, while not constituting an organized group, the five fiercely independent artists in this exhibition were chosen for the common threads of their relationships to questions of style, imagery and art function. Of equal importance was the timing of their evolution from a highly pressurized, self-contained, almost naive artistic situation unique to West Germany. Having done much of their fundamental theorizing in a vacuum during the 1960s, they remained only slightly recognized during the early 1970s. Even now as they have broken that hermetic seal to disperse broadly into an international atmosphere, these artists still offer perhaps the purest test case of aggressive aesthetic development relative to new expressionist attitudes.

Having evolved from the artistic experiences of Berlin, Düsseldorf and the Eastern Bloc, rather from more reflexive internationalized groups, these five have significant views and nomenclatures which set them apart as particularly telling examples. By the development of their changed artistic languages these artists have created influences which deny the middle ground. Great tensions persist between the traditions of international abstract art and also between the infrastructures of contemporary figurations, historical German Expressionism and their political, ideological and aesthetic camps. Younger generations of artists must now embrace or reject them. Baselitz, Immendorff, Kiefer, Lüpertz and Penck have become either revered points of achievement or targets of contemporary derision. These intense debates have high moral overtones and large issues seem to

Fig. 4. Anselm Kiefer: *Wege der Weltweisheit – die Hermannsschlacht*, 1978 (Ways of World Wisdom – Hermann's Battle), woodcut and paint on paper, ca. 300 x 330 cm

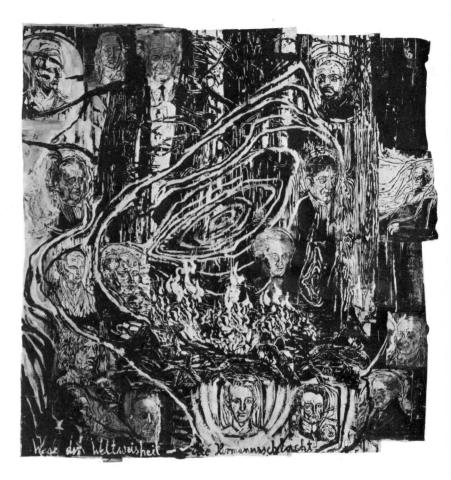

1
The late 1960s was a time of anti-authoritarian movements in Germany. It was a vital period and, due to certain German preoccupations with the relationships between art and ideology, numerous exhibition/manifestations evolved. *Fluxus* and other neo-Dada events were legion and among the most notable »political« exhibitions was the Badischer Kunstverein *Kunst und Politik* (Art and Politics), 1970, beginning in Karlsruhe, then to Wuppertal, Frankfurt and Basel. The Kunstverein Hannover organized *Kunst im politischen Kampf* (Art in the Political Struggle) in 1973, as an invitation to scrutinize the possibilities of artistic work as political practice. Immendorff was one of the colloquium participants, no doubt due to his *Lidl* activities and his other optimistic, pacifistic political postures. A related response was the ICA, London *Art into Society; Society into Art*, 1974, established on the Hannover model. The London catalogue has a helpful bibliography for the period.

be at stake. Such matters, however, will be evaluated best from the long view, not from the trenches where humor is today so scarce.

Baselitz, Immendorff, Kiefer, Lüpertz and Penck are not apolitical, despite the difference of their styles from the work of Josef Beuys, Hans Haacke, Wolf Vostell and others better known to us for their distinctly European art / political struggles. These five also have direct engagement and precise views concerning the current West German cultural, social and political situation. They are deeply aware of the kinds of attitudes expressed in the 1970 *Kunst und Politik* exhibition, for example[1]. From the late 1960's student revolts to the extreme terrorist gangs and the deterioration of the West German economic miracle, these artists' urgencies are calculated (artistic/political) aggressions in their own right. Immendorff was at the Düsseldorf Academy with Beuys during its most turbulent days. Kiefer would follow, though the effects of events were still being felt. Baselitz, Lüpertz and Penck have each experienced the bizarre global power struggle centered on West Berlin. Three of the five have birthplaces now in the Eastern Bloc, a fourth grew up in a border-town. Each establishes so many symbolic consequences in his work, overloading it with multiple contexts, that the art sometimes sags. But, at other times the art and its politics of art and life mix perfectly and the work rushes powerfully ahead.

Fig. 5. Markus Lüpertz: *Drei Bilder über den Frühling – Stil Technik/III: Der Regen,* 1978 (Three Paintings About Spring – Style Technique/III: The Rain), mixed media on canvas, 200×250 cm, Museum Moderner Kunst, Vienna – Sammlung Ludwig

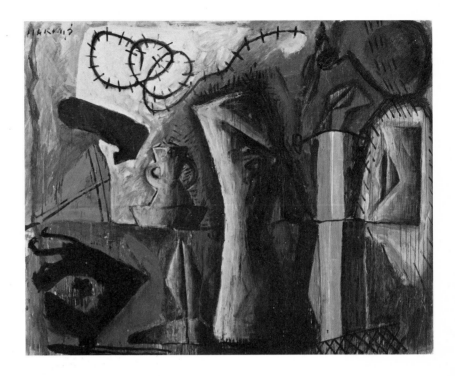

2
The astonishing complexity of art/life sources can only be alluded to, even by such an encyclopedic catalogue as *Szenen der Volkskunst* (Württembergischer Kunstverein, Stuttgart, 1981). This is a vast compendium of traditional, contemporary, sub-, mass-, and alternative cultural attributes. Siegmar Holsten illustrates a number of image sources of Lüpertz in the artist's exhibition catalogue, Hamburger Kunsthalle, 1977. Baselitz's personal collection of first Mannerist prints, then curious antiques and now, African art, is well known. Penck develops hieroglyphs, obscure, mathematical scientific sources and multiple personalities within his modern feudal system. Kiefer's extensive relationship to cultural and intellectual histories, land, property, and indicative universal myths all compound upon one another. Immendorff mixes symbologies of bars, discotheques, street cultures, »universal questions«, war machines and political slogans together with his invented iceblocks, snowstars and people-types.

The choice of Baselitz, Immendorff, Kiefer, Lüpertz and Penck represents an American view taken to emphasize the phenomenon and achievements of the West Germans and their qualities deemed most provocative to current developments of figurative art in the United States. While these artists have been seen together in large European exhibitions they have not previously been set in such an exclusive grouping with calculated themes. The five artists have chosen extreme positions, capturing an expressive essence of contemporary youth with its all-encompassing power and optimism and an almost simultaneous hopelessness. Each artist is consciously multivalent, profligate, destabilizing our order as he criticizes our models and paradigms. Theirs is a trap of passion and constricted environment, with unlimited direct involvement by the artists in their art. Verging on a conspicuous romanticism, they seek to pose uncommon challenges through exploitation of technique, style, materials and notions of subject matter.

Better than others, Baselitz, Immendorff, Kiefer, Lüpertz and Penck have symbolic compositions which conflict with objective reality. Each of them brings curious individual combinations of source materials, effusive autobiography and a crypto-mythological deathliness mixed with other cultures in quantities natural to them but quite unnatural to us[2]. They have set out on a rich war of style *(Stilkrieg),* raising contradictory questions and answers and working against complacency. Their crusades come at a time of hot professional debate between abstract and figure, the history of expression and new expressive motifs.

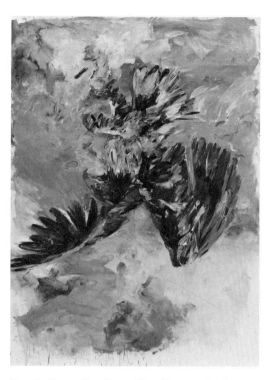

Fig. 6. Georg Baselitz: *Adler (Fingermalerei)*, 1972 (Eagle – Fingerpainting) oil on canvas, 250 x 200 cm, Private Collection, Munich

Baselitz is the senior artist of the grouping, having been visibly active in exhibiting and making statements concerning the formulation and roles of art for over twenty years. He represents one of the strongest continuous positions for systematic efforts to merge abstraction with pictorial imagery and to revitalize the picture plane's textural oil paint skin. His 1967 paintings, *B. für Larry* and *Zwei Meissner Waldarbeiter*, are early examples of successful destructuring. His comprehensive experiments continued with works made by fingertips applying the paint, especially the richly modulated *Fingermalerei* canvases of 1971-73. Subject images are disjunct from any armature and, as in *Apfelbaum*, they suggest a world turned on its head. The human figure as the nominal subject is the strength of Baselitz's work of the late 1970s to the present. In both his massive sculpture and his paintings he makes bodies into types of tribal, Gothic, Mannerist and fantastical portraits.

Referring not only to pre-Renaissance polyptychs and serial imagery in modern abstract art but also to cinematic conventions, Baselitz develops repeating groups, series, two-three-or multi-part paintings. The elements are given various placements within the picture frame. Their sideways, up, down, and around orientations are gravity-free, like cameras on a co-axial bearing. Baselitz and Penck are the inventive, often stunning, colorists of the exhibition, though they achieve their ends by diametrically opposed means. Penck stains his canvases while Baselitz slathers on the oil paint, keeping it gritty, thick, seemingly cold-painted, layer worked upon layer. Edges flicker secondarily between the slabs of colors. He builds a kind of optical relief by leaving ridges and dragged passages, traces of blatant art action not unlike the hacking cuts, sawing and splintering of his roughly-hewn wooden sculptures. His drawings and prints have the

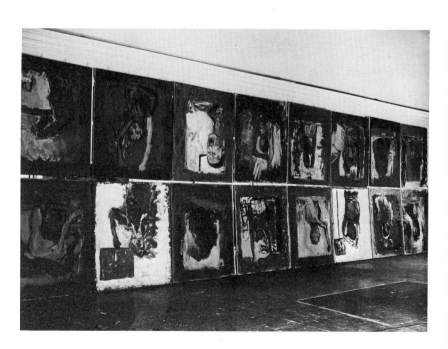

Fig. 7. Georg Baselitz: studio with *Strassenbild*, 1979/ 80 (Street Painting)

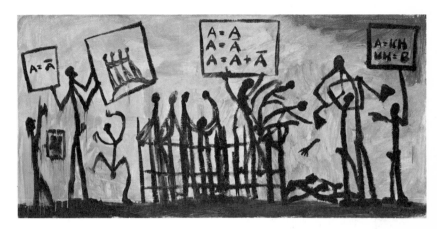

Fig. 8. A. R. Penck: *Ein mögliches System*, 1965 (A Possible System), oil on canvas, 95 x 200 cm, Museum Ludwig, Cologne

Figs. 9. and 10. A. R. Penck and Peter Kowald in concert, Kunsthalle Cologne, 1981, at the opening of the Penck retrospective exhibition

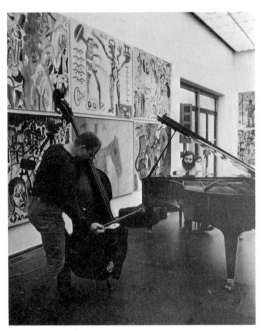

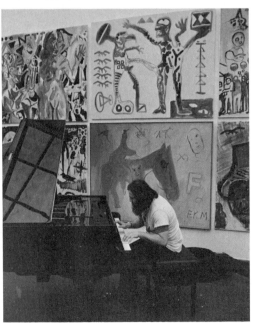

same feel, the artist working upon and into the materials, abruptly overlaying and exposing the processes.

Baselitz is the artist most visibly concerned with the artist/master-work dilemma, where the object is the vessel intended to receive positive artistic genius. He is also aware of ego, the persona of the artist. These are tense ventures since Baselitz fully subscribes to the contrary manifesto to disorder art principles, especially figuration, and to deny personal conventions.

A. R. Penck is a most complex and elusive artist, despite the superficial clarity of his images. Self-taught as an artist, writer, musician, filmmaker, he is eclectic, broadly interested in matters ranging from scientific lore and cybernetics to social and political systems. This artist has led an unusual life of alternate artistic/anti-artistic identities: Alpha; Ypsilon; Mike Hammer; T. M. (Tancred Mitchell or Theodor Marx); A. R. Penck; and his current alias, α. υ. Born Ralf Winkler, he lived first in what is now East Germany. Having achieved permission to leave the East in 1980 he moved to Cologne. His work has almost always dealt with crossing over, the bridging of voids. He is an embodiment of the ruptures and dichotomies caused by the present West-East, positive-negative, happy-sad cultural conditions. He is artistic, he is martyred, proposing a kind of tortured negative proof: I am not–therefore I am, or vice-versa.

Stick figures, warriors, tribal festivities, symbols and strange worlds are found in Penck's highly autobiographical paintings and works on paper from as early as 1965. He has made elegant grafitti as diagrams of sinister consciousness. Works like *Standart*, 1969, or *Untitled*, ca. 1970/74, have broad central images, masses of brushing with counterpoints of quickly sketched lines, circles, rectangles and paint drips within limited color range. Later his colors are put into compositions in unimaginable combinations but with astonishing effect. *Fest*, 1974, is a beautifully seductive painting with an unusual coral/pink background, and red, white, blue, green, and brown aboriginal x-ray figures dispersed about the surface. Its ritual attributes all seem a romance away from the real. He is the artist-hallucinator.

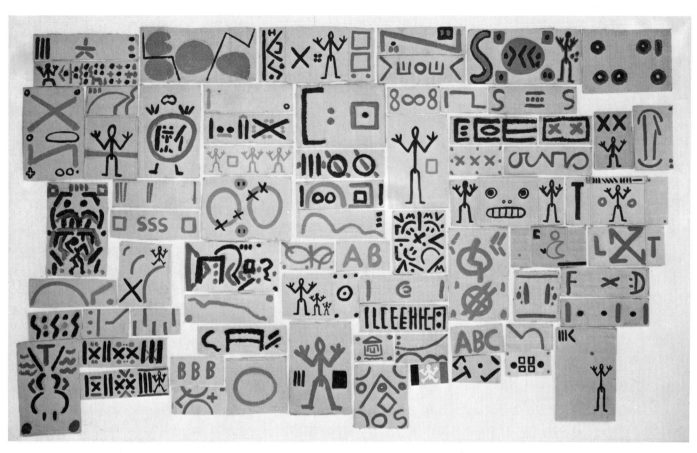

Fig. 11. A. R. Penck: installation of *Standart*, 1972, paintings on cardboard at Wide White Space Gallery, Antwerp

Penck's chopped totem sculptures are given meanings for their remaining wood areas, of course, but even the removed, cut-away zones have designated content identities. Likewise in his paintings, levels of positive-negative reality shift quickly, on, off, then on again, as in the alternating dense black and white patterns of *Verwendung-Verschwendung*, 1975, and the masked images of *Requiem für Waltraud (N-Komplex)*, 1976. The more recent *Standart 5*, 1980, is a joyous large-scale, uninhibited color wheel of saturated, thin latex pigment stains. Just after, come the skeletonal, macabre *T3(R)* and *Krieger*, 1982, as haunting, destructive nuclear-age horrors. His hieroglyph paintings, symbolic languages, curious writings, watercolors, drawings, prints, sculptures and musical improvisations ceaselessly issue forth. They seem to be parenthetical by-products, as parenthetical as the artist sometimes views himself. Even the materials of thin fabric, common paper, diluted stains and simple wood negate preciosity. Penck minimizes his presence as an artistic figure to become a polar coordinate to many of his peers. He is like the North Pole: that place which attracts the navigational magnetic compass from afar but repels and disorients it when approached. Both these modes represent the artist and he offers no mediation. In all, Penck has done the most to infuse art with new visual and linguistic force, giving strong sensations of radical potential.

Anselm Kiefer uses his art to erode our social compact. The artist raises problems by mixing cultural, military, philosophical and ancient histories, almost as irritants to the visual elements. Of the five artists, Kiefer comes closest to the line separating so-called acceptable subject matter from suspicious behavior. Regardless, the dark heroism of his works and their grand scale exceed much being done today and his organic, visceral traits relate to important European conceptual and performance arts.

Kiefer scrapes away at dangerous truths and potent myths with his dramatic mixes of real materials. His work has an apocalyptic vision, a sense of disease. The paintings, books and drawings are literally built of dirt, sand, wood, straw, painted papers, over-processed photographs, woodblock prints, and modeled lead foil. Their dark brown or carbon black surfaces are made to look scorched, like relics from some firestorm. Such literalness opens him to criticism for breaking the barriers meant to restrain German notions of idealism, absolutism and militarism, despite the fact that such qualities have been central to human condition throughout all time and are hardly exclusive to his nation.

His works offer substantial, almost operatic, provocation with curious unexpected flights of fancy and surprising invention. Kiefer's

Fig. 12. Anselm Kiefer: studio with a *Wege der Weltweisheit* (Ways of World Wisdom), in progress, ca. 1978

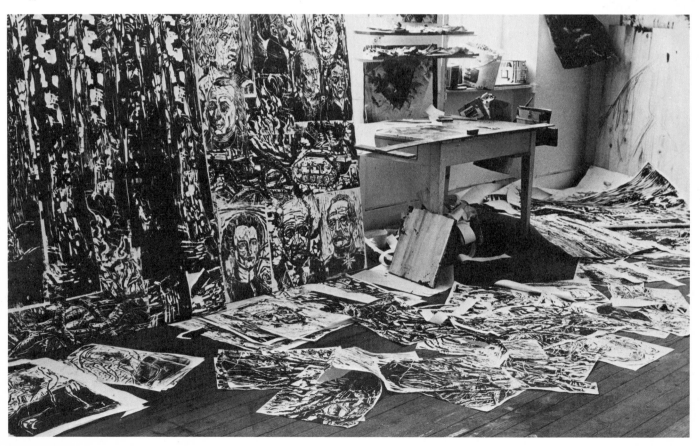

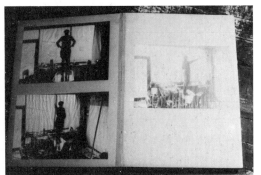

a

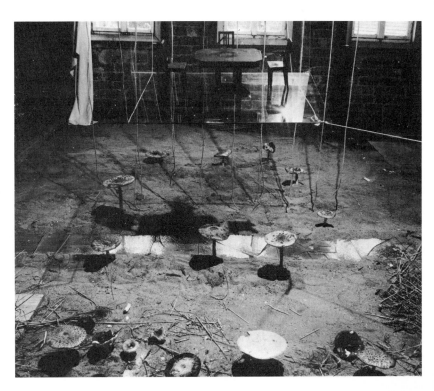

deep forests, tinges of blood red, images of stags, faces, monuments, flames on pools of water, winged palettes, piles of painted straw, metal objects and stapled-on identification tags denote romantic excess. His archaizing activities seem unbounded. The profusion of parts has all the compatibility of oil and water. Only Kiefer's constant visual agitation of the discordant elements makes them appear kept in solution, within intended range.

The artist's thick painted books and highly manipulated, mixed-media photograph/drawings offer more private and less bombastic experiences. The linkage with their intellectual source material is more direct. Their soft-edged focus draws in the viewer as if to a clandestine peephole of another time. The images make no glorification, rather, a flat, bare wintry light pervades. We are at the northern front looking at chilling artistic metaphors with no Mediterranean spark.

Jörg Immendorff's art is his vehicle for agitation, propagandizing and codifying his brand of symbolic politics. Each work is made to be a proscenium where types play out their roles of good or evil, mixed with deviate folk art attributes of inscribed narrative texts and repeated images in sequential story lines. Immendorff's grandest reality has become his vast *Café Deutschland* painting cycle, 1977 to the present and its current off-shoots, like *Naht*, 1981, and *Ölige Freunde*, 1982, his sculptures and related drawings. Going beyond the scope of any single artist, the works swirl about, broadcasting scrambled messages, like bulletins from the cultural battle front. The series

b

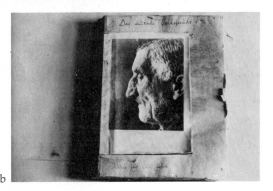

c

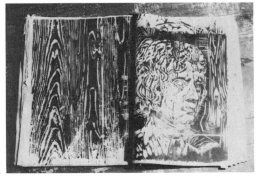

d

Fig. 15. Renato Guttuso: *Caffè Greco,* 1976, oil on
canvas, 282 x 333 cm, Museum Ludwig, Cologne

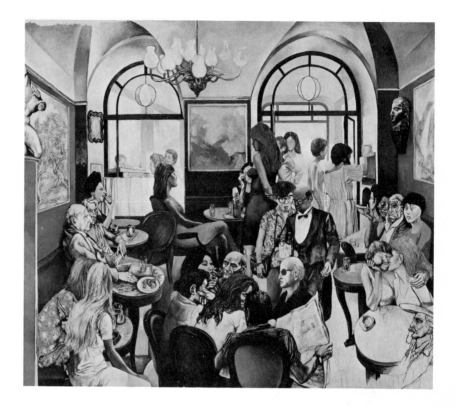

began as a culmination of his having seen Renato Guttuso's painting
Caffè Greco in illustration, then his first meeting with Penck in East
Berlin and finally seeing the Guttuso on exhibit at the Kunsthalle,
Cologne. Immendorff decided to make a living café, not a memorial
like Guttuso's. His works concern a divided culture and country,
symbolized by hot and cold, open and closed. The divisions of his
works are as if all the occupants carry physical traces of bisecting
walls with them.

 Each of his works becomes a resistance »action«, disarming formal
art esthetes on the outside. In the United States such protest art
placarding has yet to transcend a minor position. It is considered
juvenile and illegible and is ignored in our diffuse heterogenous
society. Immendorff risks the embarrassment, however, and from his
kind of artist's concentration camp he telescopes personal artistic
struggles into symbols for the largest issues, proclaiming universal
questions and world problems *(Weltfrage)*. Clichéd, trivialized media
images of the Brandenburg Gate, East and West German govern-
ments, Communist soldiers, world political figures, tanks, barbed
wire, eagles and artists' nightclubs *(Kneipen)* are remodeled in his
canvases and sculptures. Immendorff has aggressively worked these
curiously dissipated old forms into contemporary statements about
totalitarianism, pressure and the arrogance of power.

 His large dark paintings on the theme of a revolutionary disco-
theque are jammed with dozens of subjects and invented images in
strong oil colors. These, plus his heavily carved sculptures and

Fig. 13. Anselm Kiefer: artist's books – (a.) *Die
Überschwemmung Heidelbergs,* 1970 (The Heidelberg
Flood), photographs and collaged elements,
double page, 30 x 22 cm each, (b.) *Das deutsche Volks-
gesicht (Kohle für 2000 Jahre),* 1974, (The Face of the
German People – Coal for 2,000 Years) mixed
media, cover, 57 x 45 cm, (c.) *Ausbrennen des Land-
kreises Buchen,* 1974 (Burning Out the Buchen Dis-
trict) painted canvas, double page, 60 x 45 cm each,
(d.) *Teutoburger Wald,* 1977 (Teutoburg Forest)
woodcuts, double page, 64 x 48 cm each

Fig. 14. Anselm Kiefer: studio installation for *Die
Donauquelle,* 1978 (The Danube's Source)

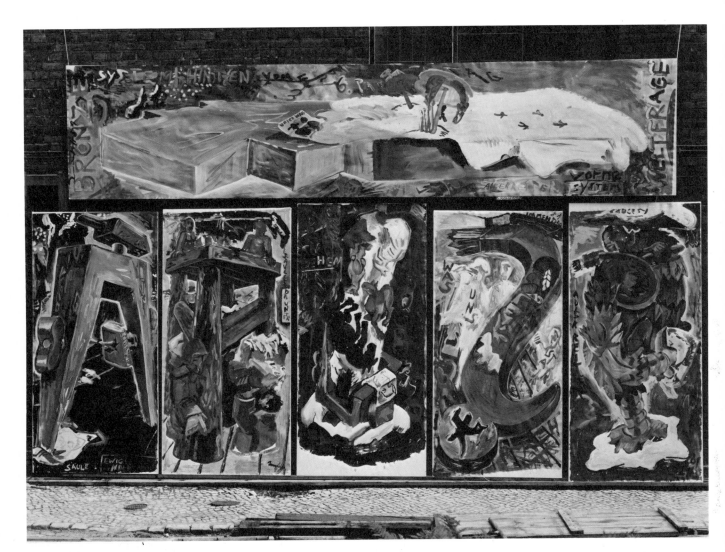

Fig. 16. Jörg Immendorff: *Naht-Quadriga*, 1981 (Seam – Quadriga), mixed media on paper and canvas, six panels, composite ca. 338 x 550 cm, Galerie Springer, West Berlin

3
Lüpertz's appropriation of the »dithyramb« is an example of his artistic license. In his desire for a unifying, constructive essence right for our time Lüpertz took this term, denoting an ancient lyric poem used in the Dionysian cult, and applied it to his work. Lüpertz's *dithyrambe* signifies an attitude not unlike the use of the word *dada* earlier in 20th century art. Lüpertz was aware of neo-Dada activity in Berlin during the 1960s, however he has a more positive outlook than any of these previous artists.

staccato drawings, accumulate to take their toll. Their new brutal bulk begins to violate our own security systems. They crack our nonchalence and cause us doubt. Immendorff's work can be fragile as art, but it is effective as imagistic discourse on actual oppression. His is a convincing reaction of victims living at the global superpowers' equivalent of Ground Zero.

Markus Lüpertz took painting and the painted subject as his constant theme beginning with his 1963/64 formulation of a utopian ecstatic »Dithyramb of the Twentieth Century«[3], and he has continued to work in multiple series aimed at the simultaneous acceptance and rejection of art sources and materials. Large eerie floating forms, field-format paintings with strong repeated shapes were among his earlier works. Next were the »motif« paintings of the early '70s in which Lüpertz took critical advantage of certain taboo German items (helmets, uniforms, military insignia) and set them against artistic attributes, like palettes. With his appropriation of the historical triptych format and the repetition of central images, Lüpertz

became an expert at artificial composition which is concept-laden, abstracted and representational. He unified all the opposites.

With a keen sense of manipulating content, he began his impulsive commentary on social, historical and cultural stereotypes. His »Stil« paintings are sardonic actions making quick appropriation of elements from Picasso, Cubism and literary Surrealism. Elsewhere he has fully modeled work after Maillol or Balthus. Wanting to epitomize what it means to be modern, Lüpertz changes subjects and styles rapidly. Such changes are further evidence of his revolt against a severely disrupted artistic tradition. He is making pompous art to undermine pomposity, with dark colors meant to resonate bright colorfulness. His recent 48-painting suite and its related eight mixed-media sculptures on themes from *Alice in Wonderland* are highpoints of mysterious analysis and technical virtuosity. These works consolidate Lüpertz' position as one most capable of sustained commentary on the making of art in the face of a nightmarish contemporary situation.

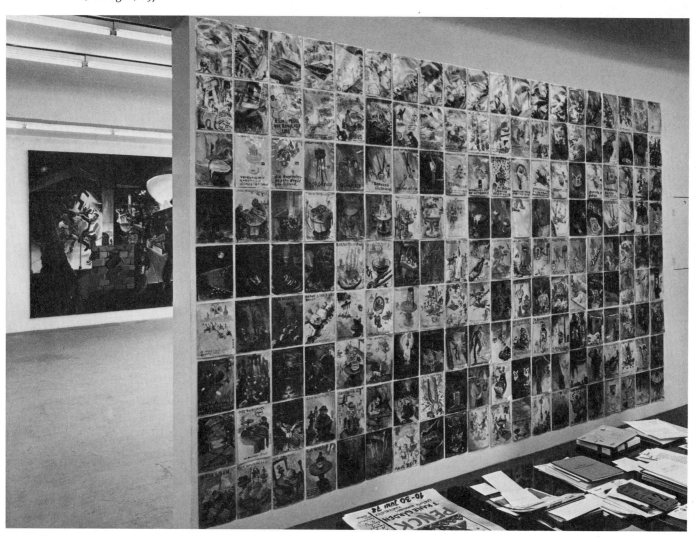

Fig. 17. Jörg Immendorff: installation of *Café Deutschland* drawings and painting, Galerie Michael Werner, Cologne, 1978

Fig. 18. Georg Baselitz: studio with sculptures, in progress, 1982

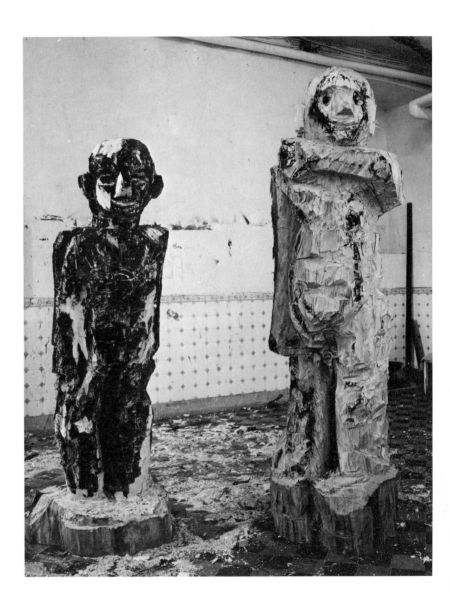

Sculpture by Baselitz, Immendorff, Lüpertz and Penck are included here. Their most recent works are explicitly hacked, cut away with axes, chain saws and tools. It is personal strength against the hard mass of the wooden log or plaster block. The artist eventually gains through his perseverence but the core material is not fully subservient. If they were sculptors instead of painter-sculptors more complete transformations would result. As it is, these artists accept the persistence of their conventional totem-like or architectural forms and the rough edges, splinters, wood grains. They seem to relish the tensions caused by no new sculptural process or invention in relation to Gothic, tribal works or German Expressionist sculpture. They have knowingly flirted with the temptations of folk craft but, on the contrary, they have denied the integrity of their materials. For example, Penck has used one of his tree trunk totems as the model for an unusual casting in iron. Immendorff and Lüpertz have used their

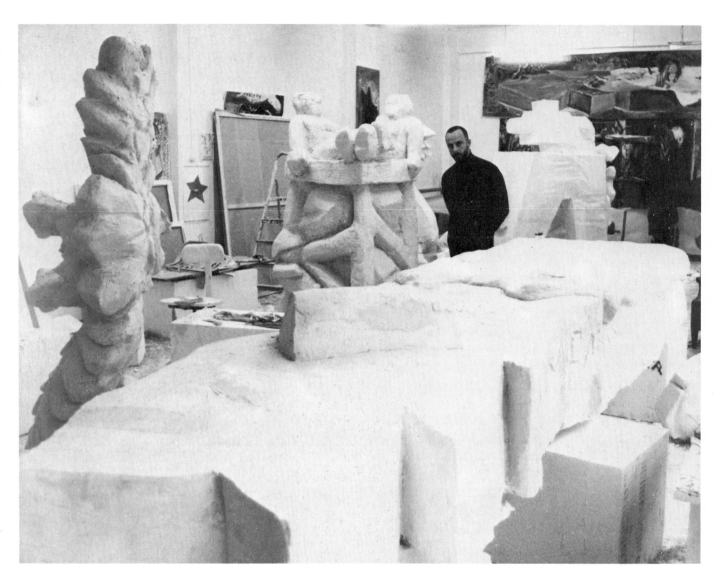

Fig. 19. Jörg Immendorff: studio with *Brandenburger Tor* (Brandenburg Gate), plaster model for bronze, 1981/82

plasters to generate bronzes which are then painted. This masks the metal surface and its evolution and is not a sculptor's habit.

The recent works are monumental in size and in the scale of their surface-cut planes. They are consciously related to, but still challenge, earlier German Expressionist work, just as Baselitz and Immendorff's large woodcuts and linocuts compete with Expressionist prints. All such early twentieth-century work was declared degenerate during the Nazi régime. Lüpertz notes that his age group is the first post-World War II German generation to feel free of guilt, so why not enjoy it, using their freedom and illusions of freedom.

As a museum director and curator, Siegfried Gohr is an active participant in the current artistic explosion. As a German art historian he is in a position to offer a number of points about why and how the arts in his country have gotten here from there, through the Nazi hiatus. »There« was the beginning point, the German cultural bed-

Fig. 20. Markus Lüpertz: studio with *Standbein-Spielbein* (Contrapposto), plaster model for bronze, 1982

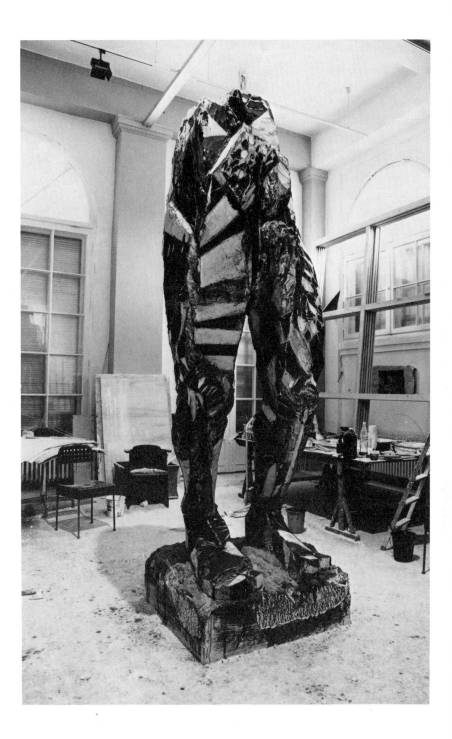

rock of their highly individualized flowering of Northern European Medieval, Gothic, Renaissance and Mannerist art. Transitions followed in the seventeenth and eighteenth centuries but the nineteenth century resulted in profound intellectual and Romantic structures. This was a prelude to the art developments of the Twentieth century, including: Cubism; Non-Objective art; Dada; Surrealism; die Brücke and der Blaue Reiter (these two lumped under the term German Expressionism); and the curious Neue Sachlichkeit

(New Objectivity). All of these were cultural markers as visible to artists as the cathedrals, old buildings and narrow streets were to German pedestrians. Much of both was swept away, 1930-1950. Gohr clarifies the issues of this disruption of artistic identity, the fracturing of his country and the compensating prevalence of imported ways of thinking and art styles by the 1950s and '60s. Artists like those in this publication and exhibition, therefore, faced a number of challenges by the 1960s and '70s. In »The Difficulties of German Painting with Its Own Tradition« Gohr gives his deeply informed younger generation view from Germany, with specific emphasis on Baselitz, Immendorff, Kiefer, Lüpertz and Penck.

Donald Kuspit's essay, »Flak from the ›Radicals‹: the American Case Against Current German Painting«, establishes points of reference concerning American (or at least New York-based) critical response to such new German developments. Kuspit writes on the basis of his experience, as an American, in German art and philosophy and through his early interest in these artists. His enthusiastic reviews of the first New York exhibitions by the Germans, when printed in *Artforum* and *Art in America*, brought charges of »treasonable« behavior from some colleagues in the more American nationalist art clique. And as New York is still shifting under the weight of increasing numbers of European artists, a residue of chauvinist, protectionist reaction may remain.

But more central to Kuspit's present argument are definitions of what valid leftist-progressive criticism would be, whether it now exists, and how or why German activities triggered initial negative response. Much concerns the defining and application of our conceptions of what is expression, what is natural, and what is meant by: abstract; modern; postmodern; figurative. Each new manifestation today raises complex issues of values, terminologies, references, contradiction and authoritarianism. It is unavoidable that highly technical debate ensues because abstract and post-abstract arts are no less complex than contemporary society. Linguistic preparation must be made since specialized critical and aesthetic lines are drawn, and spheres of influence are established. Kuspit's essay helps set an objective foundation for the relevance of these artists for us in the United States.

By identifying the more telling universal qualities and the applicability of their art, the sum of EXPRESSIONS: New Art from Germany should be the demonstration of these artists' pertinence to a wide range of art and culture beyond sectarian post-war issues of West Germany.

Siegfried Gohr # The Difficulties of German Painting
with its Own Tradition

I

It soon became apparent after World War II that as they consolidated, the two opposing political systems in East and West had actually split the avant-garde period by 1955. This put Germany, after a decade of indecision, firmly in the grasp of two mutually exclusive artistic doctrines. There were artists, of course, who attempted to build on those traditions and achievements which Hitler's arts policy had cut short in 1933; their efforts were explained away and finally smothered by a stylistic consensus that in the western section of Germany brought forth a tamed version of non-objective abstraction, and to the east a social realism based on Soviet models. The ideal stereotypes, which politics made available to art on both sides, left German artists no room for an attempt to meet international standards, not by imitating outside models but by consciously developing new ones out of the idea which two world wars had so violently destroyed, and hence, from a position of historical identity, to risk comparison on the international stage.

At the beginning of the new era marked by the year 1945, German art once again found itself in a situation which had hampered it many times in the past, which indeed had shaken it to its very foundations. Again, artists' freedom of choice was so constricted by political and social realities that they had no opportunity to take advantage of what was so often declared to be their right–the liberty to realize themselves fully through the medium of their art. What arose from these conditions was an art characterized, in many of its manifestations, by a kind of weightlessness–an art cut off from the gravity of reality and equipped with a merely spurious seal of modernity. I say spurious because it was widely held at the time that an abstract approach was the sole proof of progressiveness, just as later the seal of modernity was awarded only to such works as included prefabricated parts lifted from contemporary popular culture. What these postwar German styles lacked was resistance, in an existential sense. Their practitioners took the attacks of a recalcitrant or openly doctrinaire section of the public which, after marshalling humanist arguments against abstraction, accused Pop Art of lacking profundity, as an infallible sign of their own aesthetic progressiveness.

The positions were staked out such that international comparison need not be feared, and that those artists who attempted to take up the thread where the Third Reich had severed it were assured of obscurity. Their efforts, doubtless, would have been more convincing if they had looked German history squarely in the face. As it was, objective analysis yielded to a taboo–Germany was taboo, its recent history had been blotted out by economic prosperity and its citizens' lives had been traumatized.

Abstract Expressionism in the United States and *Informel* in France were justified by their opposition to an »unprohibited« realism, the

best forms of which had never been compromised by association with fascism; in contrast postwar German art, by expunging Nazi art from memory, forsook its historic legitimization. The style merely illustrated the conception of freedom; artists deployed it like some iconographic set. Jackson Pollock, by contrast, truly practiced this liberty in his painting, and practiced it radically. In other words, postwar German abstraction was not authentically abstract; it confessed to abstraction because that was what the times demanded of it as an official style. Major achievements in German art have again and again grown out of opposition to this kind of forced consensus.

What I wish to emphasize here is this: beyond the conflicts of the avant-garde that impel artists everywhere onto the margins of modern society, Germany has always had to cope with a specific difficulty. In Germany, not only has new art had to struggle for public acceptance but art itself, true art, has had to struggle against the dominance of a rigid artistic mediocrity. And this is as true today as it was in the past.

It had already become evident in the time of Grünewald and Dürer that this situation compelled them to split their artistic existence into public and private halves in order to carry out the work their genius demanded of them. Mathias Grünewald apparently took an active part in the revolutions of the Peasants' War and Reformation, while Dürer apparently observed both events with sympathy but without public participation. Yet it is precisely Dürer's work that reveals that many far-reaching innovations, those manifested in his self-portraits and watercolor landscapes for example, had to be worked out in private. By donating his *Four Apostles* to his home city of Nürnberg, Dürer tried to open up a field for artistic activity beyond those of Church and Court. Yet the very act of donating this work means that here again the initiative was his, the artist's, and not that of the burghers or the community. The event was a remarkable one, a tribute, at an early date, to the self-confidence of German artists; a self-confidence, sadly, that after the mid-sixteenth century succumbed to the iconoclastic excesses of the Reformation.

Towards the end of the sixteenth century, spurred by contacts with the Netherlands and Italy which such cities as Hamburg, Frankfurt, Augsburg, Prague and Munich established, German art began to orient itself increasingly to European standards. Nevertheless, as was often to be the case, the best German artists, Adam Elsheimer and Johann Liss, went to Italy, where they contributed centrally to the formation of the early Baroque style in painting. In the late seventeenth and early eighteenth centuries, the Church and feudal princes made their reappearance as patrons of the arts, a patronage which especially in the southern German territories led to a renascence in architecture, sculpture and painting. In many instances, however, the finest work was done by Italian architects and artisans who were often granted commissions in preference to native-born artists of equal skill. Painting, too, depended on inspiration from

Italian masters who lived in Germany; Tiepolo at Würzburg is a prime example.

The neo-Classicism that with Goethe's patronage superseded the last offshoots of Rococo was not really strong enough to serve as a substructure for German painting. Unlike its French relative, it had no roots reaching back into the seventeenth century. German neo-Classicism was an inordinately literary construction that brought both Philipp Otto Runge and Caspar David Friedrich more in the way of education and self-correction than in inspiration. Romantic art found itself reduced, in the end, to landscape painting, again not a sufficient basis on which to build a national tradition. And even landscape, thanks to Goethe's involvement, was compelled to signify more than it showed, to contain, in other words, those allegorical qualities without which the literary critics of painting would not be satisfied. Even Adolf von Menzel, when he began to turn the achievements of Romantic realism in landscape to his own ends, using them to clothe his conception of a light-pervaded nature, was thrown back on the private sphere. His most daring works arose out of his homelife with brothers, sisters and relatives, portraits and interiors that were not made public until much later. These reveal a Menzel so much abreast of his times that it is no exaggeration to speak of him as a true contemporary of the French Impressionists.

The significant fact remains, however, that it was not these revolutionary paintings from Menzel's private studio which were received and judged by his contemporaries, but rather those elaborate historical and monumental compositions into which his superb detail studies had been incorporated. Such studies, when seen by themselves, show Menzel to be a modern realist who overcame the compulsions placed on him and the stylizations demanded of him by a philistine environment. This split between public and private personalities runs through his entire lifework.

To create a public realm for visual art has been the problem continually faced by German art, which can certainly boast as many talents and even geniuses as any other school. Yet it has not been able to provide the circumstances necessary for them to come to fruition.

With Berlin's rise as a capital of a united Germany in the wake of 1871, the flow of artistic news from France began to increase. Museums and private galleries exhibited the Impressionists for the first time in Germany, opening up vistas of a modern art against which the officially sponsored historicism began to look less impressive. New developments were encouraged also by accommodating French influences to the indigenous realism that traditionally characterized painting in Prussia. Not until the first decade of the twentieth century, however, with the aesthetic revolution that spread, interestingly, not from Berlin but from Dresden and Munich, did German art attain international stature. This reputation was destined to be short-lived. Many promising artists did not survive World War I and after

the war, realistic tendencies gained continually in importance. The Bauhaus and Post-Expressionism were not nearly so influential at the time as the exhaustive appreciations and exhibitions that have since been devoted to them would suggest. At any rate, the rise of fascism and its pseudo-classic style soon put modernism on the defensive all over Europe. In Nazi Germany the threat was real, and physical; modern art and artists were defamed and driven out of the country, destroying even that small freedom to produce art independent of the official line which had been so laboriously achieved since 1880. This is a problem that, though it has been discussed by influential commentators on the history of German art, has up to now been treated in only very general terms.

Max Sauerlandt, for example, described his impressions of the *German Century Exhibition* of 1906 in the following words: »A general characteristic of German artistic life in the nineteenth century was its lack of a healthy, vital tradition. Numerous significant powers were at work everywhere throughout the country, but their efforts went on beneath the surface; and the greatest among them, precisely, were thrown back upon themselves, while the more facile talents, carried along by the academic current, often achieved quicker and broader recognition.«

And Paul Ferdinand Schmidt, touching on nineteenth century German art in the introduction to his *History of Modern Painting* of 1952, writes: »France possessed the invaluable advantage of a concentration of all her powers in the capital, Paris, where the struggle of opposing powers took place in the public eye. In Germany, however, where art was fragmented and development was divided among several centers, no clear overview could be had. So it came about that a knowledge of long-forgotten artistic standards was not revived until the start of the twentieth century when, at the *German Century Exhibition* of 1906, the leading figures were finally recognized.« Schmidt goes on later to expand these remarks by saying that »An odd development had brought it about that in German art, the fundamental ideas were rarely, or only insufficiently, given lasting expression.«

These statements, taken together, indicate that the history of German art cannot be adequately outlined in terms of those categories and stylistic developments which in earlier centuries proved so useful when applied to Italian and, later, to French art. If we agree that historical situations affect art, then these situations must be used to judge it. What is required, in other words, is an art-historical method that would comprehend the twin fronts on which artists in Germany have been compelled to fight: first, their struggle against traditional modes without which painting would undergo no historical development; and second, the defenses they have raised against the demands of the mediocre, even vulgar tastes of society and its representatives which have always constricted the space in which they move.

II

From the short outline of German art history given above we may conclude that to judge the achievement of any artist, purely aesthetic criteria must be supplemented by an evaluation of his position in society, by sociological criteria, in other words. Now, this is bound to remain obscure to anyone who sees painting in terms of an abstract-realistic dichotomy and thus divides the field into an ostensibly progressive, abstract half and an ostensibly reactionary, realistic one. The works of the artists represented here do not fit smoothly into either of these categories.

It has often been maintained that German painting of the 1960s and '70s, after shaking off the domination of *Informel* and Abstract Expressionism, relapsed into mimesis, into a function for art which the prewar avant-garde had long superseded by raising aesthetic research to a non-representational level. This accusation of a relapse into realism can be countered simply by looking at the work of the artists represented here. Equally mistaken is the second conclusion based on this view, namely that recent German painting is neo-Expressionist. To employ this term is to misjudge both historic Expressionism and German art of the 1960s and '70s.

The Expressionists of the *Brücke* group, it is true, never actually cut themselves off from real appearances, and after World War I most of them returned to one or another more »harmonious« realistic style. But historically, Expressionism comprised both this realist stream and those more abstract tendencies out of which non-objective art grew. Now, to call recent German painting »expressionistic« and to interpret this for all practical purposes as meaning »realistic« is to rob historic Expressionism, after the fact, of half its ramifications. The great pre-World War I exhibitions, for instance the second exhibition of the New Munich Artists Society of 1910 (organized chiefly by Kandinsky) and the 1912 *Sonderbund* show in Cologne, treated both expressionist-realist works and expressionist-abstract ones as equally legitimate statements of the modern position.

By reducing the complexity of the new German painting in favor of an oversimplified scheme of right and wrong application of avant-garde standards, critics all too often perpetuate the division of the modern movement which I described at the outset.

III

Georg Baselitz deals with motifs that play a role in a personal context; rather than with nature or outside reality, however, his work is concerned with painting as art. It is worth noting that Baselitz himself always speaks of the »motifs« of his canvases but never of themes, subjects, or objects.

In this connection, the word »motif« denotes something that already existed in painted form before the artist took it up and developed it. The fragmentation and reversal of his motifs since circa 1967 are the clearest indication of the fact that Baselitz's goal lies elsewhere than in the treatment of any particular theme. Ever since his manifestos of 1962-63 and his heroic images it has been evident that he takes up subjects, and treats them as motifs, only on a constructive and speculative pictorial level. Baselitz moves on a meta-level in painting, that is, he neither illustrates a theme nor demonstrates a method but achieves both in one, by lending such prominence to his position as an artist in the aesthetic decision-making process that his work holds open to him an operational possibility of both a social and historic nature. The »I« of the artist controls his method, his approach to painting, while never falling into anecdote or illustrative self-portrayal. This »I« designates a general stance which reflects, through the work, the status of the artist and his value within the social system.

What the work reveals is that the relationship of artist to society and to history is a tragically divided one. We find support for this interpretation of Baselitz's work as that of an aesthetic intelligence applied at a pre-existing level of imagery, in a list of artists whom Baselitz considered significant during the various phases of his development: Artaud, Vrubel, Chaissac, Schönberg, Gallén-Kallela, the Mannerists, Rayski, Malevich, Balthus, Guston, African art, Munch, etc. Note that none of these was an Expressionist in the narrow sense. These names represent a view of art that looks back to the 1920s and to the turn of the century, not in search of stylistic models but—and this is the common denominator of all these so diverse artists—in search of art as existence, as a life-plan drawn up in opposition to the prevailing norms. By the same token, Baselitz's beginnings, particularly his manifestos, hark back to Dada and certain aspects of Surrealism.

His conception of painting has shown both that it is impossible for modern art to deal naively with nature, and that artists must defend themselves against pressures to conform—a necessity particularly marked in Germany, a society that in the immediate postwar period derived its standards from external sources and, oriented to the West and to America, once again relinquished its own tradition.

A longer look at the works of those artists who, with Baselitz, represent the new German painting, confirms that despite their

differences they have one important thing in common: their images are not illustrations but projections, counterplans to the status quo which, though they may often be legible in figurative terms, are not realistic in the narrow sense. Fictional regions and aesthetic forms are the points from which they approach the world in a new and provocative way. For these other artists, too, the »I« as authority, as source of artistic energy and conductor of research, holds a central place.

Markus Lüpertz, to set off a new and independent phase in his work, posited the »dithyramb«, a fictitious formal set which seems to reply more to Picabia than to the pre-World War I period in art. With the aid of this figuration, Lüpertz, like Baselitz with his heroes, built the foundations for a style that describes social realities without illustrating them. The artist himself remains omnipresent in the paintings as prime mover. Lüpertz's dithyramb stands, on the one hand, for a new beginning in his work, and, on the other, for the artist's initiation into the mysteries of the self. Dionysus, the god of the dithyramb, symbolizes the wholeness of the artist's projected personality. By fixing his point of departure in this way, Lüpertz placed himself consciously and directly in line of the uncertainties which German artists have always faced when attempting to break out of their constricting conditions.

The attributes of art played a particularly important role in his work from 1972 to 1974. *Death and Painter, The Painter's Coat, Palette Mushroom* are canvases that define the profession and the rank of the artist in society. As with Baselitz, this definition is not carried out in a self-portraying, illustrative manner; the method Lüpertz found to master the tightrope-walk between representation and formal freedom, between destruction of existing motifs and their reemployment, has over the years remained basically unchanged despite the changing aspect of his work. Under the dictate of his painting hand, Lüpertz compels these motifs and stylistic quotations to undergo a transubstantiation, thus putting at his disposal syntactic possibilities that range from the monumental to the intimate.

The closed and tightly interlocking system of social norms and opinions that these artists face puts them in the paradoxical position of having to apply their lever to normality from a point outside that system. *Dithyramb, Motif* and *Style Painting* are the constructs that Lüpertz has created to this end. I say constructs because none of the possibilities he advances is related naively or directly to reality. It does happen, however, that Lüpertz sometimes brings his images so close to reality that pseudo-objects result, e. g. his *Hovering Dithyramb*, of 1969, the conglomerations of fictitious objects in his motif paintings, or the refractions to which he has subjected the abstract styles of the 1950s in his recent paintings.

In different ways, both Baselitz and Lüpertz unsettle the figure-ground relation in order to arrive at a new definition of painting

capabilities. The problem of coordinating figure and ground–a simple, illustrational superimposition which is no longer convincing in modern painting–is the central problem of A. R. Penck's work and one that he has systematically analyzed. Penck's work is only one more indicator of the fact that artists' decisions do not depend alone on creative needs, or taste, or aesthetic norms. He has shown that by making decisions on the level of imagery an artist can react to existing conditions and act to change them. While Baselitz and Lüpertz, by destroying or expanding motifs, exemplify the confinement of self and how it can be overcome by breaking out of the constrictions of pictorial space, Penck sets up model images which represent and elucidate the way in which stylistic systems function.

To this end, Penck has developed a number of image types which arose out of his position within a collective society in process of change. Against the exclusive claims of the State, he has set a world of imagery that traces, with just as much internal consistency, the possible relationships of individual to collective. His *World Views* of 1963-65 and the *System Paintings* of 1965-66 demonstrate, on the one hand, that lack of communication between human beings that can lead to violence and mutual fear. On the other hand, Penck has crystallized in his imagery prototypical situations designed to increase our awareness for the irrational motives that often exist at the heart of seemingly rational models. From his original lapidary style with its dark stick-figures on a light ground, Penck gradually went over to a give-and-take between figure and ground, the figures raising their arms both defensively and supplicatingly, the canvases becoming, from 1969 to 1971, monumental paintings nearly ten feet square. What characterizes these works in terms of aesthetic structure is that the figures, as they come into being, actually bring the ground into being as well; in other words, by making a statement about themselves they simultaneously make a statement about the system to which they belong and upon which they depend. To communicate a dependency and to stand up for one's own needs in the face of it, and to do this in one and the same act of visualization is the dichotomy to which Penck's figures give expression and to which they are exposed. Figure and ground in his painting take on the meaning of elements of a »physics of society«, since Penck creates, between these elements and human perception, a true bond.

His art is far removed from any painterly illusion or realism. In his work of 1970 and thereafter, paint was rarely employed for the sake of its own qualities but to differentiate and clarify content. After abandoning the frontal, standing figure in the early 1970s, Penck changed the style of his serial images in the course of investigations that led to an increase in the number of pictorial elements and in the methods used to create them. Again employing the figure-ground relation as a criterion by which to judge this change, Penck's work up to about 1975 appears to demonstrate that complex structures can work both figuratively and symbolically by communicating, through signs, the

gestural qualities of the figures and the spatial forces of the ground. The ground in these paintings could be interpreted both positively and negatively; the figures either actively or passively. Penck expanded this method both in terms of variety of scenes and attributes, and in terms of brilliancy of color, until finally the intrinsic structure to which figure and ground equally owed their existence split apart, rent by internal forces, scattering islands of figures and signs across an imaginary space. Later, about 1977 or 1978, these elements settled down into smaller, horizontal images collectively entitled *Chameleon*.

When he arrived in West Germany in 1980, Penck went back to his original stick-figures as something familiar with which he could orient himself to the new situation. Rather than the square format, however, he began employing rectangular canvases which allowed him to arrange the events on the painting surface between two poles. His move to West Germany faced the artist with a twofold problem: first, to find a mode of communication suited to the new social system he had entered; and second, to simultaneously continue his exploration of the East-West theme. To solve this problem he worked out a diptych-like composition, applying methods to integrate figure and ground which were based on those of his *World* and *System* images.

By distilling his imagery to the highest possible degree of clarity Penck has, as it were, closed in on the unspoken motives behind human behavior, motives that since they are fed by fear and violence, perpetuate fear and violence. This focus on the irrationality of apparently rational systems touches the core of Germany's historical uncertainties which led, eventually and by various bypaths, to fascism. Penck is not so much concerned to illustrate this irrationality as to derive an indirect proof of its existence from an analysis of the ostensibly rational systems that give rise to it.

The generalizing manner in which Penck views German realities East and West holds certain parallels to the work of Jörg Immendorff, whose themes reveal an involvement with the German situation as it reflects the two dominating political blocs at their point of confrontation. Immendorff's work invites the mistaken label of realistic, since it presents recognizable scenes set in a defined space. The label seems to fit even better when one considers that in *Café Deutschland*, a key series of works begun after his *Lidl* period, Immendorff alludes very directly to a pictorial idea of Renato Guttuso's, namely his *Caffè Greco*.

Yet since Immendorff—very much in the same spirit as the aesthetic antiworld of *Lidl*—envisions a place which exists only by force of artistic imagination, he cannot be said to approach reality so much through the sense of sight as on the basis of a conception, an idea called *Café Deutschland*. Immendorff draws on his personality, his experience and on the historic data at his disposal to lend this conception an effect of both reflecting and clashing with reality.

Appeals made either in writing or through gestures and action, have been an important element in Immendorff's work since the

1960s, and have directly influenced the aesthetic structure of his paintings. The artist frequently does without the foreground traditionally stipulated for works on canvas, to shift the pictorial boundary closer to the spectator.

This he does by a different method in each type of image. For the smaller formats of such works as *Don't Paint Anymore, Running* and *Top Toing Art (teine tunst mache)* he has developed an impasto technique by which he models the objects directly on the painting surface without defining them spatially. The larger canvases of 1977 and thereafter, when he began work on the *Café Deutschland* theme, are more complex in structure, but all evince a constant which consists in the arrangement of objects on an inclined plane. Immendorff achieves a strange state of ambiguity in these large paintings between a fictitious, conceptual space and the »real« things placed within – or before – that space. If we concentrate on looking at these canvases abstractly, what emerges is a tipped-forward section of perspective space which neither begins at the lower edge of the painting nor clearly ends at the horizon of the scene represented but is swallowed up by a zone of darkness. This inclined plane is strewn with objects which compel us to perceive them frontally, from our spectators' point of view, and which refuse to conform to the lines of perspective.

Adding to this tension inherent in his pictorial structures, Immendorff creates further contradictions in terms of paint handling – in one passage, he may employ it as a soft, flowing material only to shift abruptly to a hard, impersonal and abstract treatment.

As regards lighting effects, by juxtaposing extremes from »glaring« to »obscured«, Immendorff brings about a perceptual balance between depth and plane, openness and density that seems all the more surprising when one considers that his acrylic material has been applied rapidly in a thin, even layer, objectively, as it were, without deference to the particular thing depicted. Immendorff's technique allows him to deal with content and pictorial articulation, with reality and conception, in terms of a unified structure. The fact that this is predicated on an involvement with the German situation, that Immendorff brings into his work his experiences as an artist living in Germany, opens the new German painting to an analysis of the here and now.

Like Immendorff and Penck, Anselm Kiefer is concerned with Germany, or more precisely with Germany's past and the way its history is transmitted and understood. As his theme, he has chosen elements of a particular consciousness that present German history as embodied in a few outstanding events or in figures raised almost to mythic proportions, as in his *Hermann's Battle*, »*Ladybird Fly*«, *The Nibelungs' Song, Poland is Not Lost Yet, German Spiritual Heroes* and *Ways of World Wisdom*. The conceptual aspect of Kiefer's work has been frequently emphasized, as has its connection to nineteenth century history painting and landscape painting; it has even been termed a »painting of ideas«. It is true that Kiefer reflects both on the

possibilities open to painting and on historical circumstances, and this has given rise to the basic constellation in his work – his method of alienating landscapes and, less often, interiors (in 1973 and 1981) by adding writing, inserting images, or applying other materials to the painted surface. It is these additions that have earned his painting the label »conceptual«, which in a sense is true, but not exclusively. The essence of his work is really to be found in the relation it upholds between a basic painted image (which reveals Kiefer's mastery of the medium) and what has been called its conceptual level – a relation that amounts to a knife-edge balance between sensuousness and allegory.

The roots of Kiefer's imagery, like those of Baselitz in his *Pandemonium*, reach back to the late Romanticism of the last decades of the nineteenth century. The ambivalence of beauty, as weapon and defense, as good and evil, is given precise thematic expression in his work. Thus the palette may serve both as a positive symbol, for example in the images with angels or winged palettes, and as an instigation to destruction, in *Nero Painting*, for instance, where flames leap from palette to landscape.

Kiefer takes the discord at the heart of beauty as a subject in its own right. He can do this thanks to a complex understanding of his medium which leaves paint as material open to interpretation in several directions. Especially in his large-format works, the encrusted paint is powerfully and effectively present, a presence that particularly in the blacks is so concentrated as to communicate almost physically an experience of ashes and burnt materials. In other canvases, the paint may be transfigured to an evocation of light or the preciousness of gold.

These paintings actually define themselves on the level of the painted surface, before the addition of verbal or pictorial associations. That being assumed, the conceptual aspect of Kiefer's work can be described not as being directed, as Conceptual Art is, against the delusive sensuous and material qualities of painting, but as being based firmly in color and paint and their ambiguity. The levels of his paintings, understood literally as levels, mutually amplify and interpret each other.

Since 1980, the development of Kiefer's work has brought about a *rapprochement* between the two levels of meaning to an extent that the verbal messages and extraneous materials – straw, for instance – fuse with the paint layer. These materials sometimes even replace a painted rendering, when straw is used to represent hair or sand is used to symbolize the sands of the Prussian plains. This change was accompanied by a new range of subject-matter. Kiefer has begun to turn away from visions of destruction and incineration to achieve poetic images of nature and feminine beauty (Margarete-Sulamith) which nevertheless still have an undertone of deep existential melancholy.

IV

Painting as both a means of self-assertion and a strategy by which a viable basis for the artist in society may be worked out – this thought, which has continually accompanied my foregoing remarks, seems to take on concrete shape in a number of works that cannot really be called self-portraits but might better be characterized as »self-images«. In each case, rather than a likeness of the kind we are accustomed to expect from a traditional self-portrait, the artist has made a complex statement that transcends the individual. Thus we look in vain in these works for characterizations of particular persons.

Such imitation of appearances was far from Baselitz's mind when he painted that key work of his early period, *The Great Friends.* The two figures stand in the midst of a ravaged landscape, overarched by a black sky. Whether to resign to the catastrophe or to try to build a new future – this is the question the two friends resolve, and the artist has stated it with existential seriousness. A similar pressing decision, actually more of an initiation, was described by A. R. Penck in his *Crossing* of 1963. It shows a figure constructed of thin black lines balancing on a burning plank over an abyss, its elongated arms extended to left and right, just managing to keep an approximate equilibrium in a precarious situation – and in the pictorial space.

In a few instances Markus Lüpertz has created works of a self-portrait character, either obvious or concealed – for example a series of drawings executed in 1966 in which he transmuted his likeness into dithyrambic forms. Later, in 1972 and 1973, in such works as *Painter's*

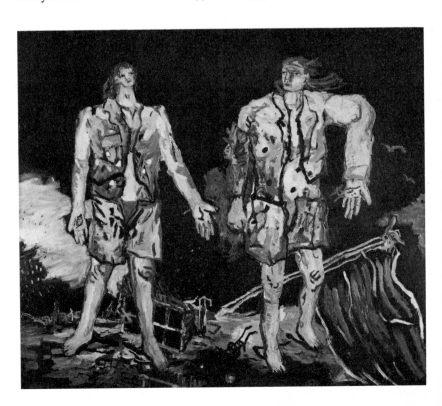

Georg Baselitz: *Die großen Freunde, 1965.* (The Great Friends), oil on canvas, 250 × 300 cm

TOP: A. R. Penck: *Der Übergang*, 1963. (Crossing), oil on canvas, 94 x 120 cm

BOTTOM: Markus Lüpertz: *Eskalation – dithyrambisch*, 1973. (Escalation – dithyrambic), distemper on canvas, 213 x 380 cm

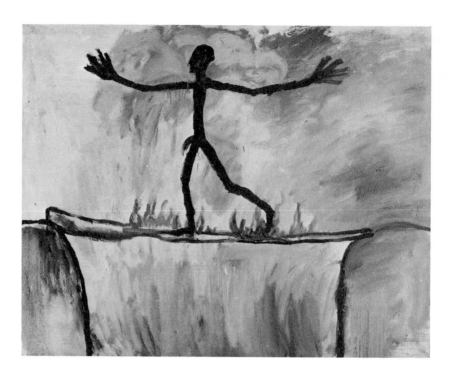

Coat – Dithyrambic, Death and Painter – Dithyrambic, and *Escalation – Dithyrambic* he expressed his concern to lend new significance to pre-existing models in painting, the theme of the artist and his relation to art history. In paintings such as these the motifs, transcending their historical determination, were again put at the disposal of contemporary artists and the new painting.

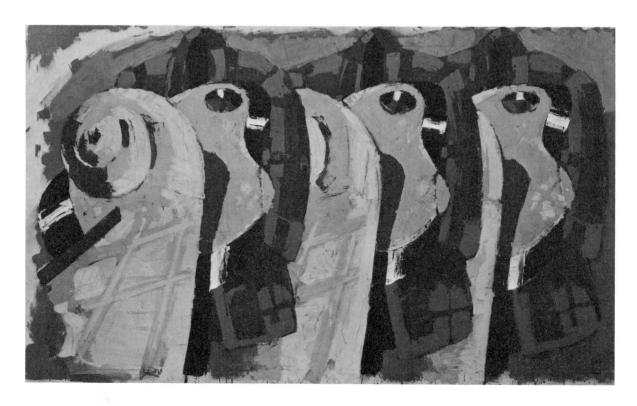

Jörg Immendorff: *Ich*, 1968. (I), watercolor,
21 × 29 cm

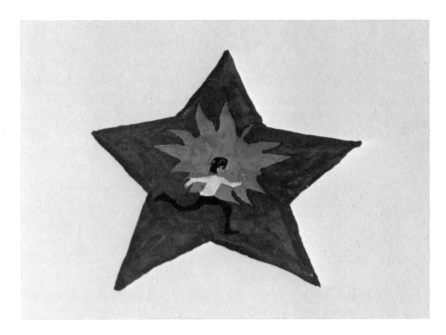

In 1968, Jörg Immendorff executed a watercolor in which he depicted himself at the center of a blue star, running. Its title – »*I*«. The exploding red flame in the hand of the hurrying figure in the five-pointed star symbolizes the message that self carries to the world. By conceiving this image in a shape resembling a flag or a political emblem or a revolutionary badge, Immendorff signals that his message is supra-individual and concerns us all.

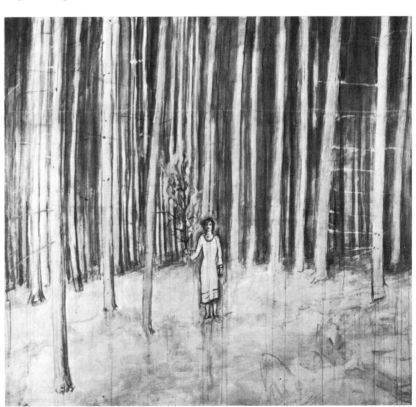

Anselm Kiefer: *Mann im Wald*, 1971. (Man in
Forest), oil on canvas, 174 × 189 cm

Anselm Kiefer's œuvre began with the self-images he painted in 1969 and thereafter – *Occupations* (1969), *Heroic Symbols* (1970), *Man in Forest* and *Untitled* (1971), this last with a portrait of the artist inserted into it. All of these works are manifestations of an artistic stance that in a very original and independent way exemplifies Kiefer's concern – to understand and depict himself as an artist on the meta-level of art, a level which comprehends both paint as material and the theme of German history. With the aid of historical imagination, Kiefer liberates the sensuous qualities inherent in the painting medium.

Ever since the Middle Ages, German art has brought forth countless self-depictions and self-interpretations. The circumstances of their country's history have again and again spurred German artists to this kind of exploration, down to the present day. And it is in these circumstances, in the German dilemma, that the legitimacy of the stance and the work of the artists represented here is rooted.

From the German by J. W. Gabriel

Donald B. Kuspit

Flak From The »Radicals«:
The American Case
Against Current German Painting

In the late 1970s a new German painting arrived on the American scene. Perhaps the climax of that first appearance occurred at the end of 1981, when five German painters–Georg Baselitz, Markus Lüpertz, A. R. Penck, Rainer Fetting and Salomé–were shown in seven New York art galleries. The new painting was fiercely opposed from the start. Violent anger met its own violence, as if to defy its authority. Its forceful paint and use of the figure were like red flags to the bull of Abstraction. The defenders of Abstraction, both conceptual and perceptual, accused the new painting of reactionary authoritarianism. It regressed, they argued, not merely to expressionism (a decadent style) but to painting (an obsolete convention). Above all, the new German painting was said to lack the critical character of modern art–as if Abstraction, with its tired strategies of negation, was still critical with respect to society and other art. In sum, the German neoexpressionists, as they were called, were regarded as the creaters of a neobourgeois art.

Not only were the German painters »postmodern«, as Benjamin H. D. Buchloh wrote, in perhaps the most powerful attack–a Marxist blitzkrieg–on them, they were not even novel. Their »newness« consisted in their »current historical availability, not in any actual innovation of artistic practice«. They were a reminder that »the collapse of the modernist paradigm is as much a cyclical phenomenon in the history of twentieth-century art as is the crisis of capitalist economics in twentieth-century political history.«[1] The collapse is tied to the renewal of political oppression. The new painting symbolizes this oppression for Buchloh, which is why he regards it as more a social symptom than artistic innovation. It never occurs to him that the modernist paradigm might have collapsed of its own weight– that it might have been a hollow ruin needing only a push to fall in on itself. Buchloh never considers the possibility that Modernism might have become an empty stereotype of itself, and that its strategies of »parody and appropriation« might have been overused and abused to the point of becoming mechanical reflexes. Nor is it recognized that new critical strategies, rather than old involuntary responses, might be required in a situation in which neither the artistic nor social alternatives are particularly clear. None of these considerations occurs in the criticism of new German painting. It is presented as a handicapped art, crippled by multiple sins of regression–sins of commission adding up to one major sin of omission, namely, the absence of the epistemological understanding of art called »Modernism«.[2]

Buchloh is the foremost critic attempting to dismiss the new German painters. Thomas Lawson, Douglas Crimp, Peter Schjeldahl, Kim Levin, and the conceptual artist Joseph Kosuth also consis-

1
Benjamin H. D. Buchloh, Figures of Authority, Ciphers of Regression: Notes on the Return of Representation in European Painting, *October*, no. 16 (Spring 1981): p. 55.

2
Douglas Crimp, The End of Painting, *October*, no. 16 (Spring 1981): p. 80.

tently deny their importance. In one way or another they are regarded as foolishly traditional. But perhaps these critics are not sufficiently self-critical to see their own approaches as conventional and traditional to the point of being obsolete, which is why they may be unable to see the critical point of the new German painting. These critics above all intend to deny its vanguard character, because to acknowledge its radicality would mean for them to deny their own. They have an unwittingly ahistorical and thus subtly irrelevant conception of avant-garde radicality. They refuse to see themselves as traditionalists loyal to an old cause of Modernism, for then they would have to see themselves, rather than the Germans, as decadent. Unwilling to re-examine the concept of avant-garde intention, they regard the new German painting as a simulated vanguardism, succeeding in its deception because it looks »different« at the moment.

For these critics, the new German painting is willfully decadent, not only incapable of rising to the heights of modernist criticality. To the extent they can demonstrate the outright decadence of the new German painting–blurring perception of it with their label »neo-expressionist« is an easy way of doing so–they protect their own reputations as progressive and radical. They want the panache of being left-leaning without any conception of what an authentic leftist art and society might be these days. The new German painting is a convenient whipping boy for ineffectual, directionless criticism–a criticality that no longer really knows its goals. Indeed, it is too impotent to imagine any future for art other than the same modernist missionary position of »classical« negation.

For its critics, the major sign of decadence in the new German painting is its return to »the perceptual conventions of mimetic representation«–surely the most misunderstood feature of the new painting. It is not merely a matter of reaffirming referentiality and the hierarchy of figure-ground relationships. Rather, it is a matter of creating a fictional reference, of which the figure is the instrument, to create an illusion of being-natural[3]. The creation of this illusion–to bring into question the artificiality of art and technological society–is a major critical aspect of the new German painting. A kind of artificial natural expression is used to lay bare the artificiality and abstractness of all expression, particularly our own modern abstractness, subtly devaluing and distancing us from the world of experience.

The point seems self-evident: whatever access abstraction affords is relinquished by its eventual possession of us. It is as though our power of abstraction–and our apparent power over the world–grows only at the expense of our naturalness. To survive, it must take a scandalous form, such as that shown in the new German painting, where it at once becomes an ideal of sensibility and an invasion from an unexpected, hidden reality. The »natural« shows itself as a case of the return of the repressed in the service of the ego of art. Since we no longer know what it is to be natural, nature is no longer a norm, and there is no norm of what it is to be natural, only the deceptive

3
See Donald B. Kuspit, New German Painting: The Recovery of Expression, Frederick S. Wight Art Gallery, University of California, Los Angeles for a fuller discussion of this idea.

possibility of being »natural« through the release of repressed attitudes and gestures.

Marxist critics assume that the »natural attitude« to things is the enemy, for it implies a refusal to suspend our relations with them for the sake of an analysis of our attitude toward them. Such a disengagement presumably leads to an abstract understanding of their meaning. But in a world overdetermined by analytic abstractions—artificial understandings of all kinds—which seem to have an »expressivity« of their own, the natural attitude toward things becomes a desirable if elusive goal, a critical factor for survival, and the only method for the recovery of concreteness and engagement. The natural attitude implies the creation of a new kind of concreteness, resistant to abstraction, even questioning the abstractness of its own expression. In the new German painting, concreteness through the skeptical gesture—the disintegrative and self-destructive mark—is the proposed mode of operation of the new natural attitude.

The new German painters question the tendency to take abstraction literally without denying its value as figurative language. This is a not unfamiliar enterprise; all thought and art eventually recur to it, as to a touchstone. But the new German painting's means of accomplishing this critique of abstraction are especially appropriate for our times. The Germans create an illusion of intense but bizarre naturalness, involving the invention of »disfigured« forms that are recognizable as still existing within the horizon of the natural. These forms, transformed by the experience of abstraction, so they become allegorical, are energetically—aggressively—asserted. They have at once the conceptual power of authoritative abstractions and the »natural« power of things to which we are concretely—passionately—committed. They are doubly focused, and thus become fixed points of reference as limits to our becoming and signs of its elemental forcefulness. The historical German symbols within the new painting show this double character, making them especially trenchant. They are at once abstract spectres and natural realities; on the one hand they are fatalistically accepted as irrevocable absolutes and on the other overcome by being artistically appropriated and experienced, digested by a powerful creative process. The forms are partly demonic, nightmarishly possessing us in a bad dream of history from which we cannot awaken; and partly »second nature« to which we must become critically reconciled, over which we must imaginatively triumph.

In the new German paintings we watch these signs which no longer clearly signify yet are still charged with significance. They are being absorbed by a new generation of Germans who have not experienced the reality of which the signs are the vestige, yet upon whom they impinge. Yielding their paralyzing, hypnotic abstractness in their passage from the collective unconscious through the artist's personal consciousness, these symbols can finally be laid to rest. In Anselm Kiefer, for example, we watch these signs—still hauntingly contemporary—of German historical and cultural power,

being laid to rest in the collective consciousness by being treated idealistically as unconditional sources of artistic power. They become freshly originative, and are thus revealed as archetypal. They suggest that art still has a redemptive power of transformation over history—that art can be an effective intervention in history, using its materials to reveal something more fundamental yet inseparable from it. Such artistically transformed historical signs—transformed to reveal the artistic process in history—are no longer restless, aimless ghosts but latent forces that give, and take, »natural« form. Kiefer's use of paint is like the use of fire to cremate the bodies of dead, however dubious, heroes, in the expectation of their Phoenix-like resurrection in another form. The new German painters perform an extraordinary service for the German people. They lay to rest the ghosts—profound as only the monstrous can be—of German style, culture, and history, so that the people can be authentically new. They are collectively given the mythical opportunity to create a fresh identity. They can now identify themselves without first being identified as the »strange Others«. They can be freed of a past identity by artistically reliving it.

The new German painting naturalizes a de-natured abstract notion of »being German«, without first forcing a new German nature upon us. Instead, the figures it offers remain highly ambiguous »disfigures«, who inhabit an allegorical realm. They are forever disfigured because there are no norms of natural appearance to determine them. There is no norm of—or guidelines for—»being German« today. Not being normative, they can signal a new German freedom. Not being actual, they can »naturally« symbolize new German possibility. Thus, to see these pictures is to be confronted with the special necessity and special freedom of the Germanic today. Indeed, it is the same necessity and freedom that constitutes us all, for we are all increasingly possessed by an abstract past that we must transcend. Above all, we are increasingly possessed by the demonic power of abstraction. It makes us forget our potential for naturalness, which, for all its uncertainty, is more of a clue to our future than the certainty our abstract knowledge gives us. The new German painters want to recover this apparently specious naturalness because they regard it as the only alternative to an abstractness that has made us hollow. The disclosure of the hollowness within the superficially solid Germanic insignias is the beginning of the recovery of an uncertain naturalness—a demonstration of an uncertainty which itself can become a source of »naturalness«.

II

The new German painters do not seek unmediated expression, as their critics have thought. Rather, using an already existing code of natural expression which depends on the spontaneous union of opposites in a single gesture, the German painters attempt to pro-

voke in us resistance to abstraction. But the point is that an abstract gesture that is only superficially spontaneous is used, as in the best of Baselitz, to disintegrate a dominating abstraction, a representation that has acquired the status of an abstraction because of its typicality. What it »represents« is undone, leaving us with the »abstract« naturalness and riskiness of it as an »expression«. There is no real appeal to instinct in this use of gesture. From the beginning it is socially determined, just as the figures are culturally conditioned. Neither gesture nor figure tries to escape its overdetermined situation, nor do they attempt to articulate a freedom that does not exist. Rather they together stage a freedom–the freedom to resist mythologized abstractions. This staged freedom, in turn, gives the myth of natural expression substance.

The new German expressionism, then, has nothing to do with the biological utopianism of the old German Expressionism. Rather, the new German painting involves a sense of social dis-appearance, a certain »symbolic truth«.[4] This accounts for its use of mythological German iconography–one of landscape as well as allegorical emblems. That is, it makes use of old abstractions of culture and history which have disappeared, but still exist as »dis-appearance«. To exist as a dis-appearance–as a barren sign–is to be read as an appearance signalling a contradictory and ambiguous state of affairs. In the new German painting there is a vivifying, unresolved contrast between the allegorical figural abstractions embodying old German expectations and the new German energy embedded in hyperactive paint. But the situation may be reversible; an old energy may be renewed by the paint, and a new expectation may be announced by the allegorical figural abstractions. The contrast between old abstractions and a new concreteness and naturalness of energy is crucial to the new German painting. The figural abstractions become more symbolic than allegorical in that they participate in and present the problem rather than represent an unequivocal meaning. And the painterly is probably there less in and for itself than defiantly, as if to create an artificial rawness. For all this sense of manipulation and equivocation, the paintings bespeak a wounded, disturbed state. The tension between the abstract and the energetic creates a sense of untamed expression. They come to us as deviant, incompletely socialized expressions, under the sway of blind »abstract« necessity.

Whether or not this theory is correct, Buchloh's assessment of the new German painters as artists who »internalize oppression« falsifies them in a particularly vicious way. For the two steps of this internalization are classic stages of the development towards fascism: »first in haunting visions of incapacitating and infantilizing melancholy and then, at a later stage, in the outright adulation of manifestations of reactionary power«.[5] From helplessness embodied in desperate paint action to fantasy figuration that fulfills the unconscious wish for a strong-man leader, Buchloh suggests that the art perhaps coyly, perhaps unawares, flirts with authoritarianism. It is an art, he and the

4
Alfred North Whitehead, *Adventures of Ideas* (New York, The New American Library, Inc., 1955; A Mentor Book), p. 247. To paraphrase Whitehead, symbolic truth involves the establishing of a community of subjective form between aesthetic appearance and the reality of such dimly perceived things as »National Life, or ... the Essence of God«. By putting such »dim objective reality in an emotional clothing« which changes it into a clear appearance, its subjective form or basis is disclosed – the subjective form of a community (p. 248).

5
Buchloh, *op cit.*, p. 41.

other critics suggest, without irony and with absolutist demands–an art that provokes with its own naiveté. They do not imagine that the new painterly figuration may involve, in Craig Owens' words, »a *critique* of representation, an attempt to use representation against itself to challenge its authority«.[6] In the case of the new German painting representation is used to create a fiction of the natural, a presentational effect that is the implicit ideal of every representation.

Where art once tried to imitate nature, »nature« is now an artistic effect, a fiction achieved through manipulation of representative style. The natural is no longer unconditionally given as a starting point that informs one's abstractions from it, but rather an end to which one must regress, with no certainty that one has ever reached it. Nature is no longer the self-evident touchstone of art, but a desirable and unexpectedly necessary ideal effect and perhaps the only hope for self-innovation in a world where the self is at once abstract and dispensable. The new German painting reminds us that nature has »dis-appeared« but can be recovered abstractly, which, paradoxically, makes it a more haunting »dis-appearance«. As in the past, it is nature which seems to propose »salvation«. But ironically it is now absent: nature itself has become as absorbed into abstraction as everything else, and exists only as an uncertain effect of artificial »nature«. The »naturalness« offered by the new German painters is a fiction of concreteness, created from representative abstractions. The semblance of nature that exists in these paintings has the power to haunt us rather than to define us. It is not clear whether this makes it more or less alive than when it was taken for granted; the ideal of naturalness remains, however, powerfully possessive of our souls. In the new German painting we see a new return to nature, involving the re-naturalization of denatured gesture and symbol.

The under-used style of painterly figuration becomes representative of the natural mode because, being declassé, its fictionality is already self-evident. In contrast, the over-used styles of Abstraction have an apparent substantiality that makes it hard to see them as fictions. Since Abstraction today is a fiction which no longer signifies, its effect of »presence« is no longer guaranteed; in fact, it increasingly calls itself an effect of absence. The apparent naturalness of Abstraction today has to do with belief in itself as the ontological basis of art. But this insistence on its own fundamentality means that it is no longer regarded critically and that it no longer has a critical effect on us. Abstraction today does not, as it once did, force us back on ourselves in a searching critical process. Instead, today it is painterly figuration that comes to us as critically significant, forcing us to be self-conscious and self-critical in relation to it. It is not only that the new German painting is in need of explanation, but what we must also explain is why it seems natural to us: we are forced to explain ourselves–to renovate our sense of self. The fact that it comes to us as natural with a question mark gives it enormous critical consequence

6
Craig Owens, Representation, Appropriation and Power, *Art in America*, 70 (May 1982): p. 9.

and enormous power over us. This in part is why the new German painting is an avant-garde art. Like the truly avant-garde, it seems groundless or obscure, yet makes us aware of our unexpectedly compelling relationship to it. Abstract art is no longer compelling or fascinating; it no longer brings us face to face with unexpected forces in ourselves. The new German painting is a compelling and driven art, making us aware of how driven we are. This is why it is not beyond criticism, as Abstraction thinks it is.

For Abstractionists, Expressionism, by reason of its inherent irrationality and unself-conscious extroversion, is the one modern movement that does not originate in self-criticality. At best, it is accepted by them as a feeble attempt to be socially critical and shocking. Yet in the current situation perhaps it is the reconstruction of reality posed by the expressionists that has more critical validity than the deconstructive post-painterly styles of Duchamp and constructivism, and later of Rauschenberg and Manzoni. For Buchloh these are »the two essential instances in modern art when ... painting was radically questioned for its claim to organic unity, aura, and presence, and replaced by heterogeneity, mechanical procedures, and seriality«.[7] New German painting does not wish to reinstate the old claims of organic unity, aura, and presence of painting, but to let us know that heterogeneity, mechanical procedures, and seriality no longer carry out the subversive function of the modern aesthetic. Nor does the new representationalism accomplish this subversive task since it, too, is heavily dependent on this heterogeneity, mechanical procedures, and seriality, all somewhat forced today, in contrast to their earlier usage.

The issue becomes clear in the current conflict between painting and photography. In the nineteenth century, painting was the dominant art, the carrier of criticality, while photography became, in Baudelaire's words, the means by which »art further diminishes its self-respect by bowing down before external reality«. Baudelaire thought of photography as »a cheap method of disseminating a loathing for history and for painting«, which meant for him a loathing for tradition and »the domain of the impalpable and the imaginary«. Photography, offering us the »fanaticism« of »Narcissus«, undermines the »happiness to wonder« and to dream, and so to create »the Beautiful«.[8] To Baudelaire photography was a narcissistic art that eliminated the tragic or elegant–different shapes of critical understanding. Photography, in fact, was altogether incapable of and antithetical to critical artistic understanding, for it celebrated immediate facts that were far from wonderful and, untransformed by true art, far from meaningful. The heterogeneity disclosed by the mechanical procedures and the seriality of photography was regarded, like other purely material developments of progress, to be detrimental to artistic genius.

The shape of the debate has changed now, for photography is sometimes regarded as potentially more critical than painting. It is

7
Buchloh, *op cit.*, p. 59.

8
Charles Baudelaire, The Salon of 1859, *The Mirror of Art*, ed. Jonathan Mayne (Garden City, N. Y., Doubleday & Co., 1956; Doubleday Anchor Books), pp. 230-233.

more at the center of modern life, so that critically used it can have more subversive impact. Photography usurps art because it shows that all art is destined for the imaginary museum André Malraux wrote of, which »consists of all those works of art that can be submitted to mechanical reproduction and, thus, to the discursive practice that mechanical reproduction has made possible: art history«.[9] Photography thus dominates and critically brackets art by changing the way it is situated, and photography used as art can change our understanding of the Beautiful and the dream. As Duchamp put it, photography gives us a freedom, the possibility of a philosophical outlook, that painting, overly bound to its physicality, can hardly imagine. This conception of painting as more physical than mental, and so less likely to aid the understanding of our condition, is at the root of the current rejection of painting, particularly the new German painting, which seems to give itself uncritically to the physical side of painting. The current rejection is an extension and confirmation of the Duchampian rejection, just as Thomas Lawson's attempt to appropriate painting as a subversive method and use its discursive nature to cause trouble[10] is dependent upon Duchamp's attempt to put »painting at the service of the mind« (1946). And just as Duchamp said he was more interested in recreating ideas in painting than in achieving mechanical cinema effects through painting, so Lawson acknowledges that some of the most challenging contemporary work uses photography and photographic imagery. Like Duchamp, Lawson wants to escape the photographically »illustrative«, but like Duchamp, he is dependent upon it.

Neither Lawson nor Crimp in their modernist attacks on new German painting pay serious attention to the Duchamp they cite. Writing to Alfred Stieglitz, Duchamp asserts: »You know exactly what I think of photography. I would like to see it make people despise painting until something else will make photography unbearable«.[11] It may be that photography has made itself unbearable by reason of its excessive popularity with both ordinary and avant-garde usage. It may be that it has made a fetish of popularity, in fact, made it the only criterion of significance and a self-justifying end. This is why the authentic avant-garde may despise photography and return to painting, not for its physicality, but for the idea of natural expression that painting might give us. Painting can be seen as the antidote to popular and transparently artificial expression, as it is becoming increasingly clear photography is.

Photographic expression symbolizes what is non-natural–not the same as what is unnatural, although subsuming it–that permeates existence in a technologically and capitalistically advanced society. Photography can function this way because it represents the domination of social authority through its »spying« on our existence. Photographic documentation, seemingly all-pervasive, has come to represent an authoritarian penetration of existence, a manipulation and control of existence to an extent that can be regarded as the rape of its

9
Crimp, *op cit.*, p. 81.

10
Thomas Lawson, Last Exit: Painting, *Artforum*, 20 (October 1981): p. 45.

11
Quoted by Crimp, *op cit.*, p. 75.

most profound expectations. Photographic penetration of existence summarizes the total availability of our lives for social use, an availability which is no longer even experienced as coercive. It represents the pre-plotting of life, the predetermination of life's own patterns of self-realization. Photography represents our complete exposure to society, our fraudulent openness to its ministrations, and our lack of critical relationship, i. e., resistance, to its »necessity«. The form of that necessity is photographic; it is a form which destroys our otherness and which makes us identifiable with society. Without our potential otherness, the very source of our naturalness, we are merely photographic specimens under a societal microscope. We have become totally and visibly available, and thus totally appropriated, as the radical critics we are discussing would say. They think they can appropriate what has already appropriated them completely, that they can struggle against appropriation by counter-appropriation. But their sad little game–Lawson's game, the game Buchloh thinks Sigmar Polke plays–loses track of the alternatives, which exist only fictionally, in painting, a medium long ago discarded as all too »appropriate«.

Photography, with its heterogeneity, mechanical procedures, and seriality, symbolizes the powerful control a technologically advanced society has on existence. When every new photograph of the same thing simply confirms its sameness or reveals another interior perception of its self-identity, existence becomes totally conscious and abstract. It is possessed as a concept as much as a precept. The new German painters work with the idea of an unconscious image and generate a fresh sense of concreteness. They know that very idea is a fiction, but it is presented as the only viable alternative to the supposedly non-fictional photographic image. What Baselitz, Lüpertz, Penck, Immendorff, and Kiefer achieve through their de-socialization of imagery is a defeat of the realism of photographic identity, which is the instrument as well as the consequence of our increasing appropriation by the forces of Abstraction, ambiguously disclosing themselves as forces of domination as well as liberation.

III

The fullest critical presentation of the new German painting to date in the American art press has occurred in *Artforum*. It is worthwhile to examine the strategy of this presentation, to note the way the art made itself felt as increasingly radical, and the way it eventually has come to be experienced as avant-garde. This changed awareness of the art shows the way recognition of it became a matter of more than usual importance, requiring more than the usual art historical techniques. The art showed its complexity through the realm of implications it seemed to evoke and by the way it seemed to require a variety of perspectives to make these implications clear. It is only by surviv-

12
See Donald B. Kuspit, Bernd Zimmer at Barbara Gladstone and K. H. Hödicke at Annina Nosei, *Art in America*, 69 (November 1981): pp. 170-71. I do not entirely repudiate the concept of »Pop Expressionism« I spoke of in these reviews, but it would have to be more developed–more fully articulated. I began to take a different view in my »Report from Berlin, ›Bildwechsel‹: Taking Liberties«, *Art in America*, 70 (February 1982): pp. 43-49. Finally in my reviews of »A. R. Penck at Sonnabend« and »Georg Baselitz at Fourcade«, *Art in America*, 70 (February 1982): pp. 138-39, I came to the art more fully. I treated it more comprehensively and analytically in »Acts of Aggression: German Art Today« (Part I), *Art in America*, 70 (September 1982): pp. 140-51 and »Acts of Aggression: German Painting Today« (Part II), *Art in America*, 71 (January 1983): pp. 90-101. See also my review of »Michael Büthe at Holly Solomon«, *Arts Magazine*, 57 (December 1982): p. 18 and »Jörg Immendorff at Sonnabend«, *Artforum*, 21 (January 1983): p. 75 and »Painting to Satiety: Franz Hitzler and Troels Wörsel«, *Arts Magazine*, 57 (February 1983): p. 86-87.

13
Stuart Morgan, Cold Turkey: »A New Spirit in Painting« at the Royal Academy of Arts, London, *Artforum*, 19 (April 1981): p. 47.

14
Bazon Brock, The End of the Avant-Garde? And So the End of Tradition. Notes on the Present »Kulturkampf« in West Germany, *Artforum*, 19 (June 1981): p. 62.

15
Ibid., p. 67.

ing this critical challenge that the new painting showed its sturdiness. Disclosed as major art, its significance became all the more pressing. What became most clear was that its assumed obviousness dissolved as its more problematic ambiguities were revealed. It was more convoluted than the first reviewers of it, including myself, were led to believe.[12]

The initial presentation of the new German painting was the review of the Royal Academy of Arts, London, exhibition, »A New Spirit in Painting«, by Stuart Morgan. It sounded an ambiguous, hesitant note from the start. There was a querulous, irritated tone that was seldom absent in these articles, a sign of an insistent cross-examination of the art. Quoting Nietzsche's characterization of Modernism as »the opposition between external mobility and a certain inner heaviness and fatigue«, Morgan characterizes Kiefer's paintings as »bogs of dark impasto« and describes Lüpertz's three *Black, Red, Gold Dithyramb* paintings as having »all the subtlety of a visual gangbang«.[13] He asserts that K. H. Hödicke and Rainer Fetting »can produce large, fluent neo-Expressionist works without relying on bombast«, and poses a decisive question: »Does some proportional relation exist between external mobility and inner fatigue, between the nervous brushstroke and the burden of the past?« The recognition of this tension, arising from an uncertain handling of a charged subject matter, keynotes most of the discussion of the new German painters. It is a recognition of the way a regressive visual mobility is used dialectically to subsume a regressive, fatiguing, emotionally »heavy« or depressing content. It is also an example of how regressive means are used to combat the dead weight of the past so that freedom, however illusory, from the past might be achieved.

In Summer 1981, *Artforum* published a defense of the new German painting by Bazon Brock, an aesthetician at the University of Wuppertal, West Germany. The piece was a response to an exhibition by Baselitz and Kiefer at the German Pavilion at the Venice Biennale where the works were »almost universally rejected by the German critics«.[14] Brock believes the reason for the critics' disdain was that they felt that »Kiefer and Baselitz were using obsolete methods to promote equally obsolete German mythology«. Brock found this objection »untenable«, and his brilliant response includes an investigation of the dialectic between tradition and the avant-garde. His argument verges on asserting the Jewishness of Baselitz and Kiefer, as well as Hans-Jürgen Syberberg, the director of the film, *Our Hitler*. He takes Jewishness to be »the permanent opposition . . . to any literal execution of a myth, a revelation, or a system of thought« in the face of the typical German »idealistic« attempt »to take scientific and artistic system constructs literally, and to enforce their exact execution«.[15] The German painters are seen to be deconstructing German cultural history and style, in an attempt to restore its strength, which like that of any cultural thought, exists in the »discrepancy between plan and execution, between idea and practice«. If the system con-

struct is applied literally, it is bound to have inhumane and destructive results. The Brock article is immediately followed by six pages devoted to Kiefer's *Gilgamesch* project, which involves the use of photography as much as paint. The subtlety of the two-fisted presentation – explication of theory and demonstration of artistic practice – is that it immediately states the international relevance of the new German artists, who are articulating a universal problem of identity. They are understood to question the extent to which an artist is or is not identified with his culture, i. e., is or is not independent or critical of it: is or is not a form of »discrepancy« within it, the seam by which it comes apart as much as by which it is held together. The power of *Artforum*'s presentation of the new German painters is that it shows them as operational in a larger-than-German context, freshly raising the issue of what culture is and how it functions.

In September 1981, Wolfgang Max Faust dealt with the painting of a number of younger Germans, particularly the work of the Mülheimer Freiheit group and the Berlin students of K. H. Hödicke. Again the painters were presented as confronting the broad issue of culture as well as the specifically German situation. The self-contradictory character of the Mülheimer Freiheit group is emphasized: »Their paintings are blasts of sheer joy of contradiction«.[16] They are finally understood as creating a »willful dissociation of the factors of subjectiveness and style«, using techniques of *art brut* at one extreme (Peter Bömmels) and at the other »highly eclectic and syncretist images« (Georg Jiri Dokoupil). Their erraticness is understood in social as well as aesthetic terms, and is taken to have general implications for the situation of the artist, who is confronted with popularized abstracted, appropriated styles and social uncertainty. It is responsive to a situation of appropriation as well as instability, and by a technique of »both obvious and tricky« quick-changes, the artists take us into their »confidence«. They reflect our psychopolitical reality in »a realm of proliferating appearances that play with every conceivable reference offered by history as well as by evanescent individual viewpoints and obsessions«.[17] Their art is shown to be perhaps the most doggedly socially responsive there is, where art itself is understood to be an incendiary political part of the unstable, anxiety-arousing social contract.

With Thomas Lawson's article, »Last Exit: Painting«, October 1981, there is a return to a negative note, with a conceptualist American critic defending the honor of avant-garde criticality against the »pseudo-expressionists . . . part of a last, decadent flowering of the modernist spirit«.[18] Lawson comes up with his own dialectical appropriation of painting, while dismissing the expressionists for ingratiating themselves by pretending to be »in awe of history«. A warning flag should go up with the word »ingratiate«, since we last read it in Michael Fried, who used it to eliminate whole squadrons of artists and to establish a rigid hierarchy of significance which shut out certain categories of art as well.[19] The dialectical intention of Lawson

16
Wolfgang Max Faust, »Du hast keine Chance. Nutze sie!« With It and Against It: Tendencies in Recent German Art, *Artforum*, 20 (September 1981): p. 39.

17
Ibid.

18
Lawson, *op cit.*, p. 41.

19
Michael Fried, *Absorption and Theatricality, Painting and Beholder in the Age of Diderot* (Berkeley, University of California Press, 1980), p. 5, distinguishes between »much seemingly difficult and advanced but actually ingratiating and mediocre work« of the 1960s and »the very best recent work – the paintings of Louis, Noland, Olitski, and Stella and the sculptures of Smith and Caro«. The ingratiating work is inherently – can never be anything but – mediocre because it seeks »to establish . . . a *theatrical* relation to the beholder«, i. e., to, indeed, ingratiate itself with the beholder. The work Fried endorses is inherently great because, in an exemplary way, it is »in essence *anti*-theatrical«, i. e., »treated the beholder as if he were not there«. It goes without saying that for Fried, Expressionist and current expressionist art even more would be theatrical, by reason of its demonstrativeness. In fact, Fried might argue that it makes a fetish of theatricality, broadcasting it not only as the (false) essence of art, but of being. For Fried, who is implicitly a monist, being must – monadically – rest in itself, and anti-theatrical art is a demonstration of this in-itselfness of being.

and Fried (the one coming from the left, the other from the right) is betrayed by this attempt to identify a group of artist-pariahs who attempt to be engaging, catering to our populist taste for exhibitionistic entertainment. Because such artists have broad implications, they cannot be critical, thus they cannot be allowed to join the radical elite. The major value of Lawson's article is the question it raises about the relevance of painting to avant-garde art today. His magic act, in which you see painting cut in half and then put whole again, is just that: an insubstantial act to obscure the fact that his own conceptualized brand of painting is heavily dependent upon photography and is thus subject to the objections to photography. But the importance of Lawson's article is that it forcefully raises the objection of regressive medium, following the objection of cultural regression like a second strong ware.

The new German painters had staying power, even surviving my own working over and through them in the November 1981 issue of *Artforum*.[20] Lawson's attempt to find a progressive and enlightened, if somewhat mechanical, use for painting was for me as little an issue then as was the German critics' attempt to defend the new painters against charges of cultural recidivism. Instead I saw the art as a response to the pressures of popular culture, synthesizing a traditional Modernist childlikeness with a traditional cultural Faustianism. I viewed the intense, forced childlikeness as ethical and political in point, quixotic yet militant, personally psychodramatic, and anti-authoritarian in its depiction of figures of authority. My article was followed by seven pages of a Penck project, »involving the interaction of criticism, poetry, and art«. Again, unity of theory and practice, criticism and art was achieved. The art had been disclosed by some of its exemplary practitioners, and the evaluation by some of its most committed critics. A complete, and completely serious, presentation of it had been made. Significant sides of the argument for and against it had been heard, and major examples of the art shown. Its urgency had been met by an urgent critique.

It was now time to deal with the new art in greater detail since by late 1981 neither theoretical nor art historical comprehensiveness was at stake. An innovative framework had been created and some of the most serious artists had been located in it. Now other highly individual artists were brought to the public's attention. In March 1982, Sigmar Polke was located art historically by Buchloh, in terms of the avant-garde strategy of parody, in a line from Picabia through Pop art.[21]

In the summer of 1982, Siegfried Gohr examined Baselitz's early hero paintings, largely in terms of the need for an image »reconciling the conflict between the realistic tradition of 19th-century art and Modern painting's own epistemological needs«.[22]

Critical pressure was kept up in the form of Joseph Kosuth's May 1982 attack on painting in general and the new expressionism in particular. Kosuth implicitly lumped all kinds of painters together in

20
Donald B. Kuspit, The New (?) Expressionism: Art as Damaged Goods, *Artforum*, 20 (November 1981): pp. 47-55.

21
Benjamin H. D. Buchloh, Parody and Appropriation in Francis Picabia, Pop, and Sigmar Polke, *Artforum*, 20 (March 1982): pp. 28-34.

22
Siegfried Gohr, In the Absence of Heroes: The Early Work of Georg Baselitz, *Artforum*, 20 (June 1982): pp. 67-68.

a lower class, much as Lawson did explicitly. They both despair of painting and the latest expressionist attempt to revive it. Kosuth introduces the notion of expressionism as an institutional style and the idea that the best of the neo-expressionists result from »not simply painting but making a reference to painting, a kind of visual quotation, as if the artists are using the found fragments of a broken discourse«.[23] Painting, like many other customs that can survive as »formal conventions long after they've lost their meaning«, lives on as a kind of »device« within a larger, less institutionalized, not yet fully acculturated, enterprise. As in Lawson, painting is allowed if it is used critically, i.e., for non-painting ends.

Finally in September 1982, there is an extensive theoretical review of documenta 7 by five writers, followed anticlimactically by a group of reviews concerning specific documenta installations.[24] In general, the writers dismember the ideology but do not deny the validity of the German artists or the reasons for their contemporary recognition. I understand them now in terms of Modern traditionalism and the search for an authentic identity in a world which seems to allow for none. I saw them as an exploration of traditional identities accepted as authentic, with the artist like a sand crab, trying to live in an alien shell in the hope that he or she might gain an understanding of what a home might be (while knowing that they can never actually have their own by the terms of the modern condition). With this understanding came the recognition that the new German expressionism is a true home for radical art today.

23
Joseph Kosuth, Necrophilia, Mon Amour, *Artforum*, 20 (May 1982): p. 60.

24
The articles were by Annelie Pohlen, Kate Linker, Donald B. Kuspit, Richard Flood and Edit deAk, *Artforum*, 21 (September 1982): pp. 57-75 and articles by Richard Flood, Donald B. Kuspit, Lisa Liebmann, Stuart Morgan, Annelie Pohlen, *Artforum*, 21 (October 1982): pp. 81-86.

Catalogue

Editor's Note

Works are identified here first by their German titles, then by English translations where necessary. The common painting media have been translated as follows: *Acryl* = acrylic; *Kunstharz* = synthetic resin; *Leimfarbe* = distemper; *Öl* = oil. The primary supports have been translated as follows: *Holz* = wood; *Leinwand* = canvas; *Nessel* = cloth; *Rupfen* = burlap. Dimensions are given in centimeters, height preceding width.

Unless otherwise noted the illustrated works in this catalogue are courtesy of, or property of, Galerie Michael Werner, Cologne.

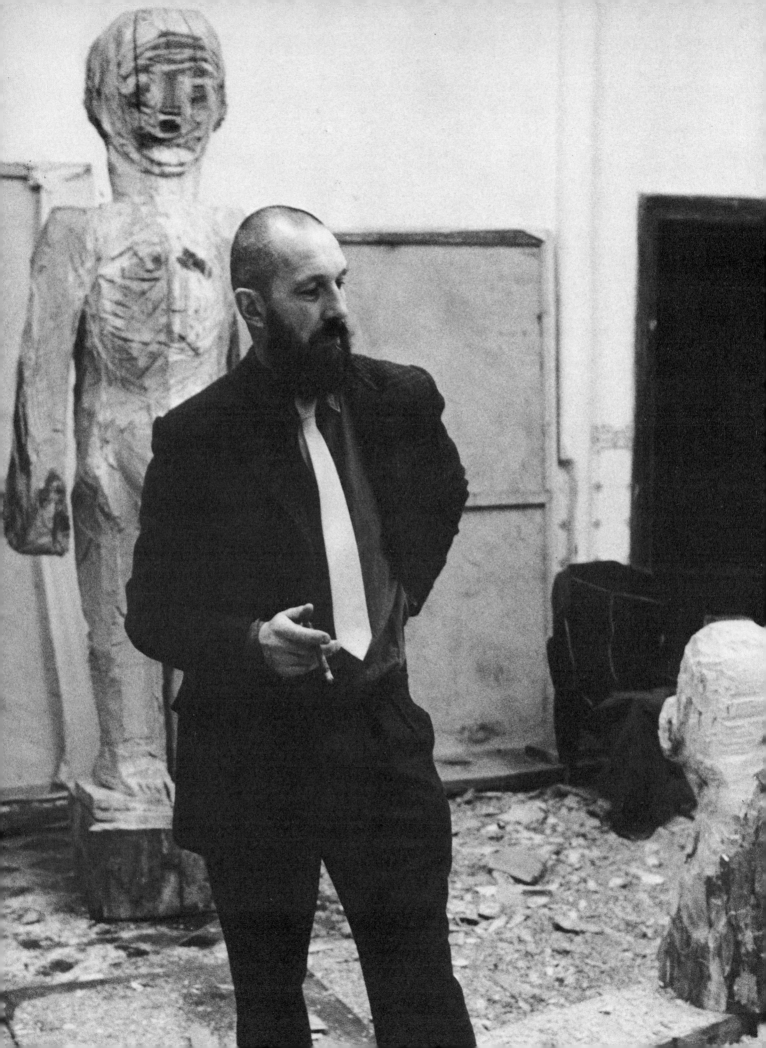

Georg Baselitz

Biography

1938	Born January 23, in Deutschbaselitz, Saxony (not far from Dresden, now in East Germany). Family name of Kern.
1950	Family moves to Kreisstadt Kamenz, Saxony
until 1950	attended school (Volksschule/Gymnasium)
1956	moves to West Berlin, assumes name of his birthplace
1956-57	Studies painting in East Berlin at the Hochschule für Bildende und Angewandte Kunst with Professor Womacka, and painting with Professor Behrens-Hangler. Expelled for »social and political immaturity«.
1957-64	Studies painting in West Berlin at the Hochschule für Bildende Künste with Professor Hann Trier
1961	First »Pandämonium« manifesto, and exhibition with Eugen Schönebeck. Friendship with Ralf Winkler (A. R. Penck).
1962	Second »Pandämonium« manifesto and exhibition with Eugen Schönebeck. Marriage to Elke Kretzschmar. Birth of first son, Daniel.
1965	Stipend to Villa Romana, Florence and Villa Romana Prize
1966	Moves from Berlin to Osthofen, near Worms. Birth of second son, Anton.
1968	Stipend of Kulturkreis im Bundesverband der Deutschen Industrie
1971	Moves to Forst in the Weinstrasse
1973	Studio in Mussbach in the Weinstrasse
1975	Moves to Schloß Derneburg near Hildesheim
1977	Works at the Staatliche Akademie der Bildenden Künste, Karlsruhe
1978	Appointed Professor, Karlsruhe
1982	Appointed Professor, Hochschule für Bildende Künste, West Berlin. Lives and works in Schloss Derneburg, near Hildesheim.

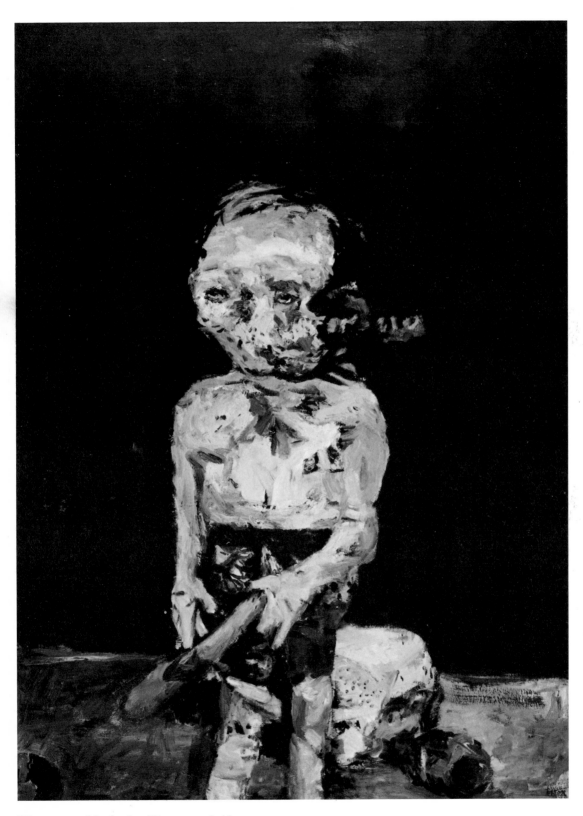

Die grosse Nacht im Eimer, 1962/63
(The Night of the Senses), oil on canvas,
250 x 180 cm, Museum Ludwig, Cologne

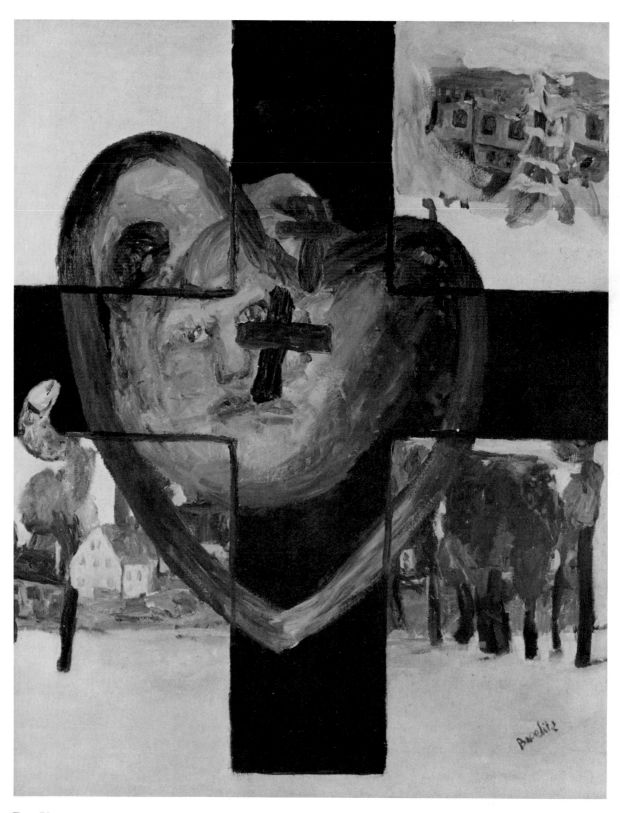

Das Kreuz, 1964
(The Cross), oil on canvas, 162 x 130 cm,
Private Collection

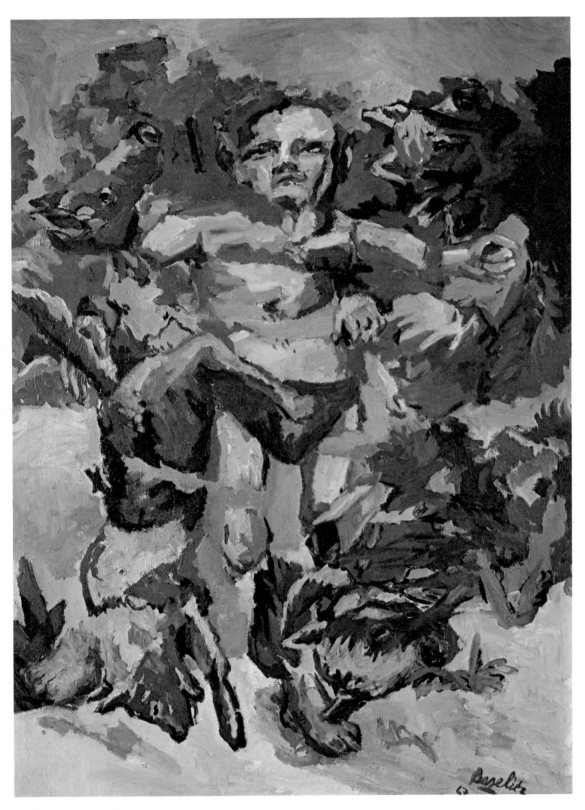

B. für Larry, 1967
(P.[ainting] for Larry), oil on canvas,
250 x 200 cm, Doris and Charles Saatchi, London

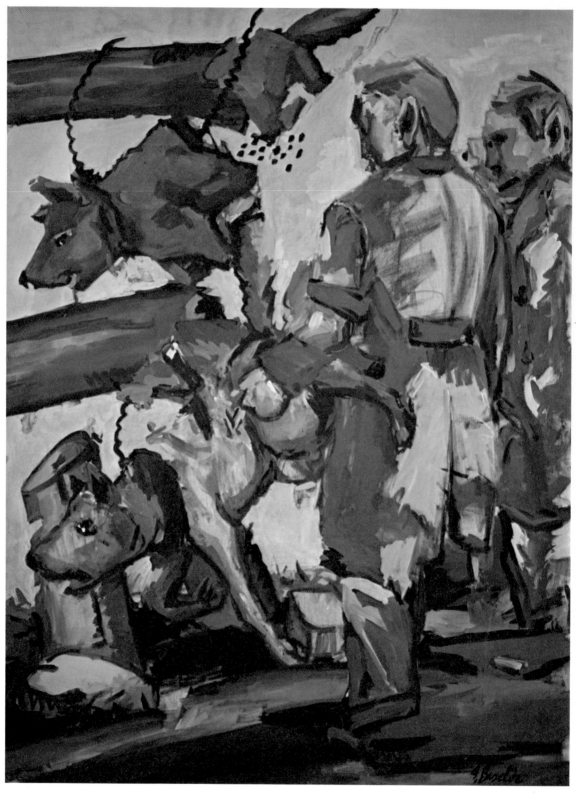

Zwei Meissener Waldarbeiter, 1967
(Two Meissen Woodcutters), oil on canvas,
250 x 200 cm, Doris and Charles Saatchi, London

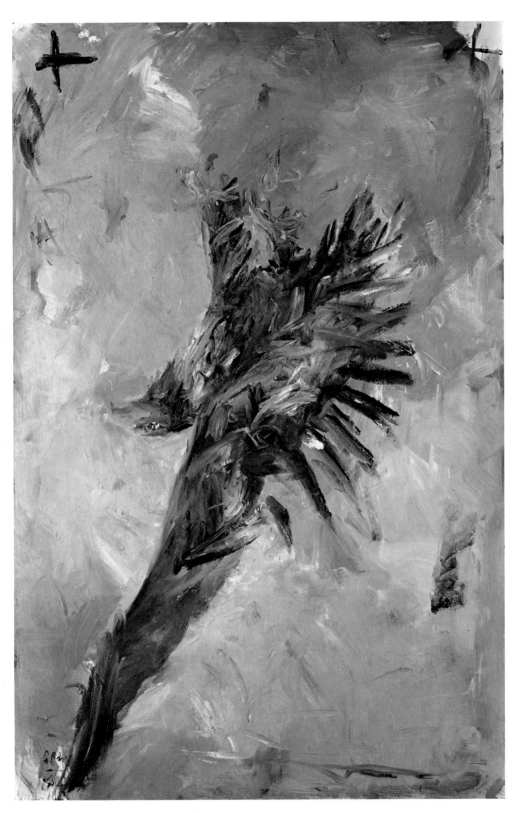

Adler (Fingermalerei 1), 1971/72
(Eagle – Fingerpainting 1), oil on canvas,
200 x 132 cm, Neue Galerie – Staatliche und Städ-
tische Kunstsammlung Kassel (on loan)

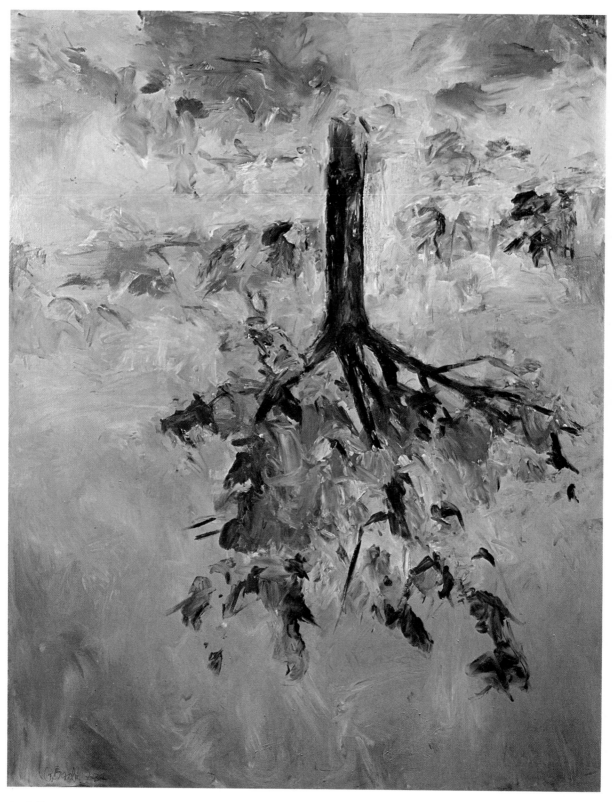

Apfelbaum, 1971/73
(Appletree), oil on canvas, 250 × 200 cm,
Ingrid and Hugo Jung, Aachen

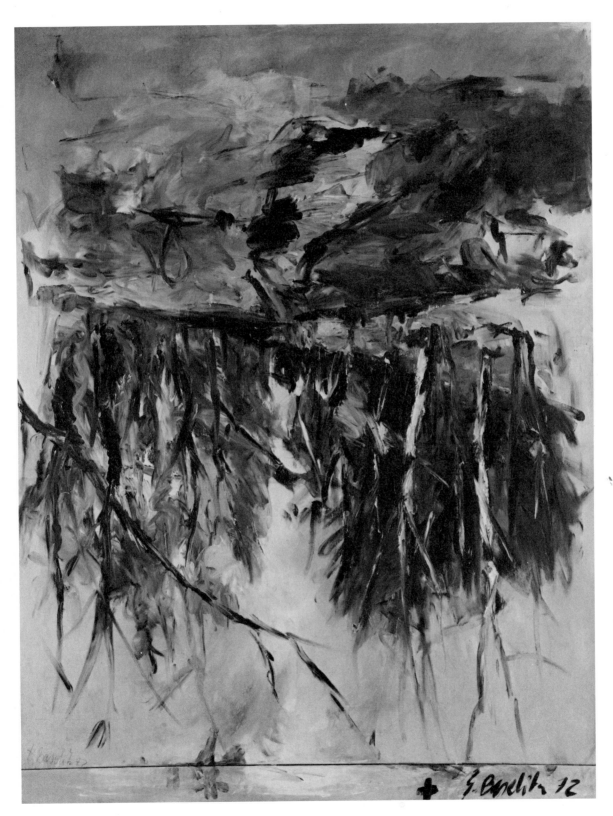

Birken (Fingermalerei), 1972
(Birches – Fingerpainting), oil on canvas,
180 x 140 cm

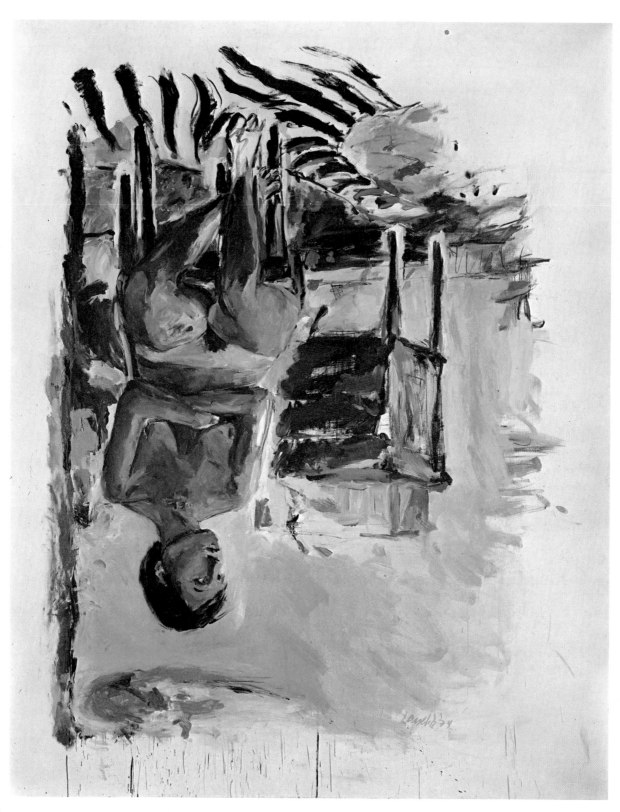

Elke, 1974
oil on canvas, 250 x 200 cm, Private Collection

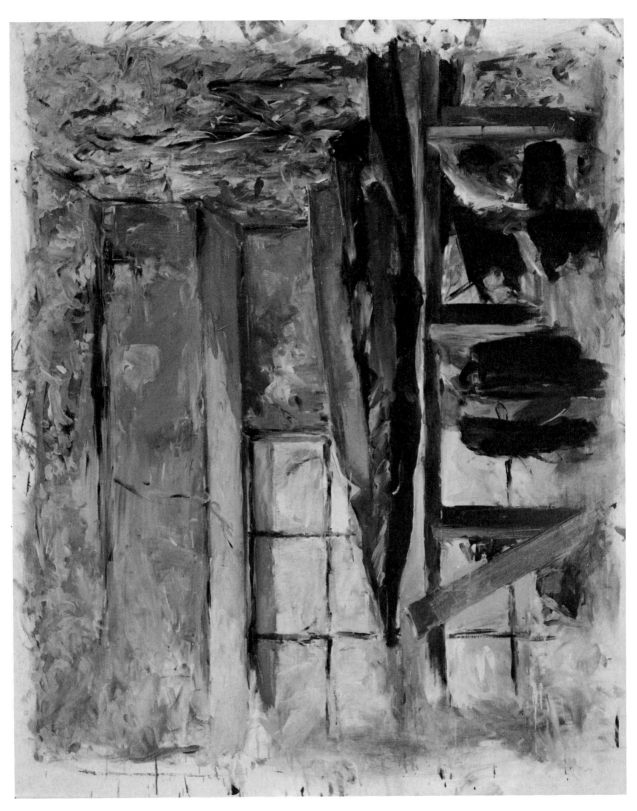

Interieur (Fingermalerei), 1973
(Interior – Fingerpainting), oil on canvas,
162 x 130 cm, Staatsgalerie Moderner Kunst,
Munich

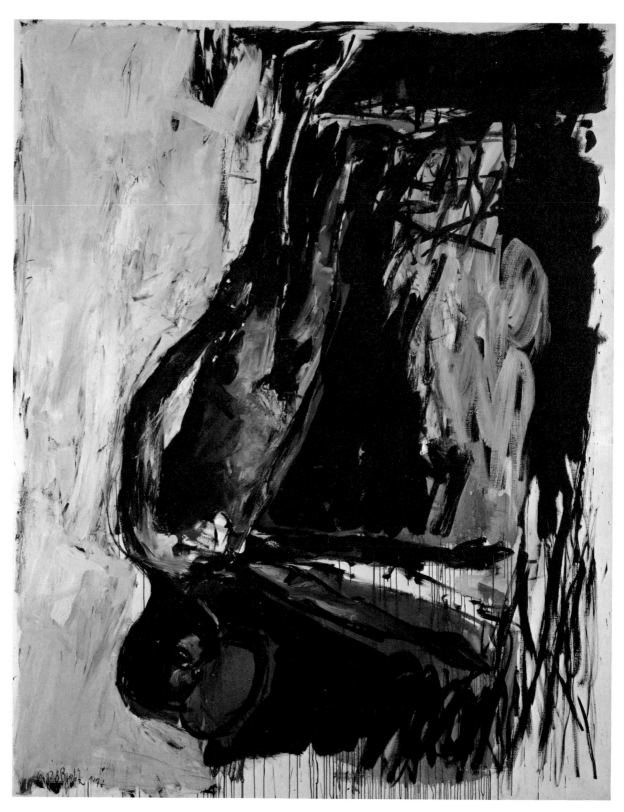

Dreieck zwischen Arm und Rumpf, 1977
(Triangle Between Arm and Body), oil on canvas, 250 x 200 cm, Doris and Charles Saatchi, London

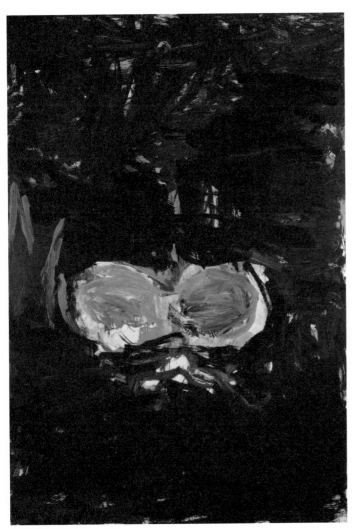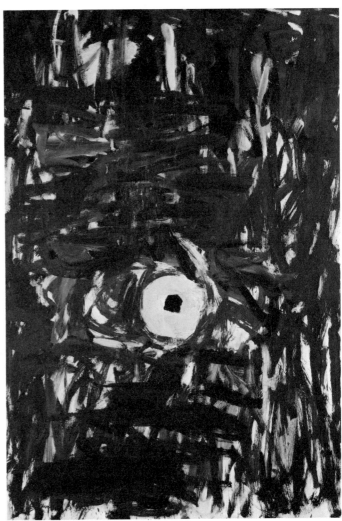

Birnbaum III, 1978
(Pear Tree), oil and tempera on wood, four
panels, each 250 x 170 cm, Georg Baselitz,
Derneburg

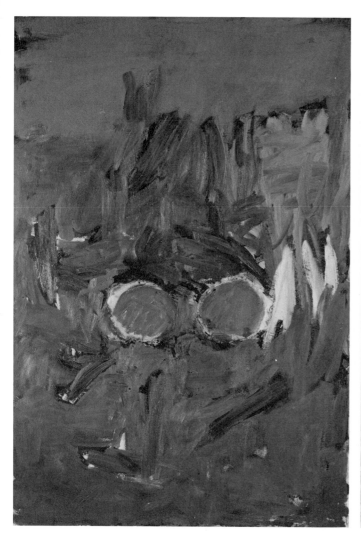 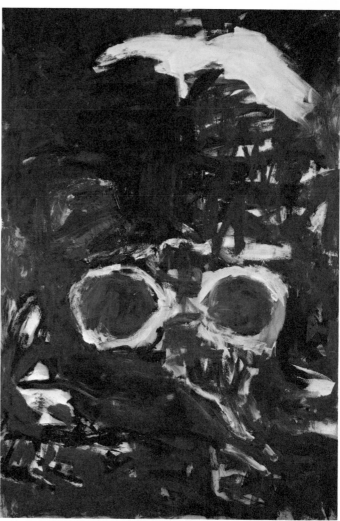

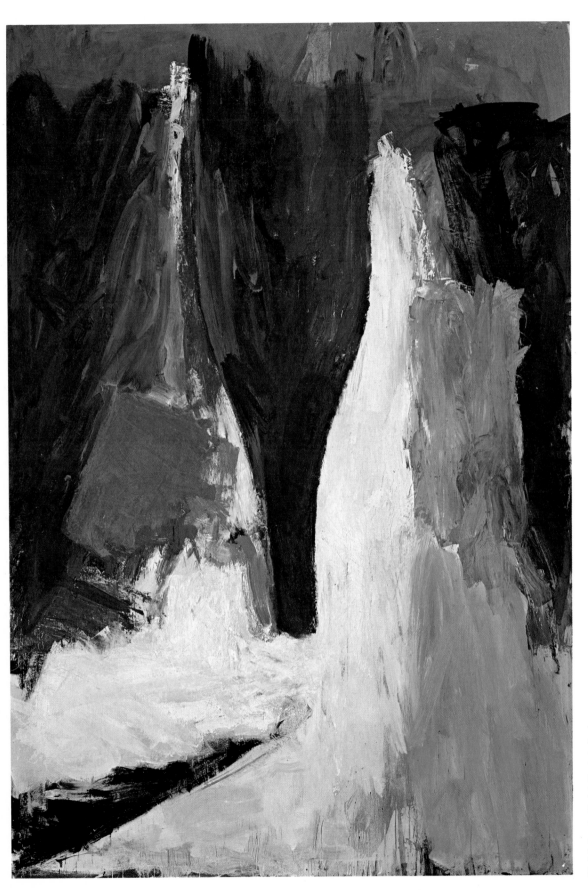

Akt und Flasche
– Diptychon,
Nr. 2, 1977
(Nude and Bottle –
Diptych, No. 2),
oil and tempera on
wood, two panels,
each 250 x 170 cm,
Doris and Charles
Saatchi, London

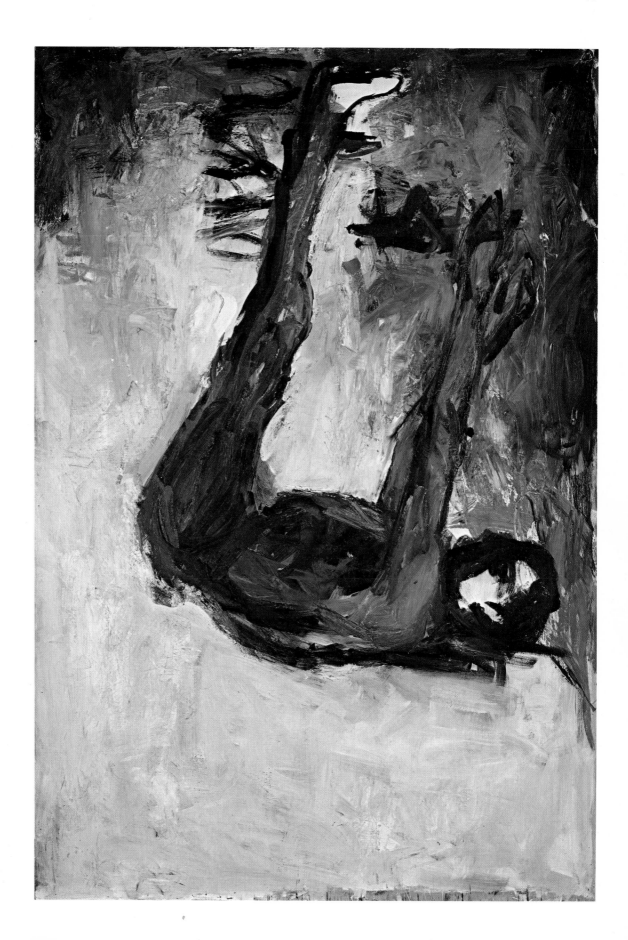

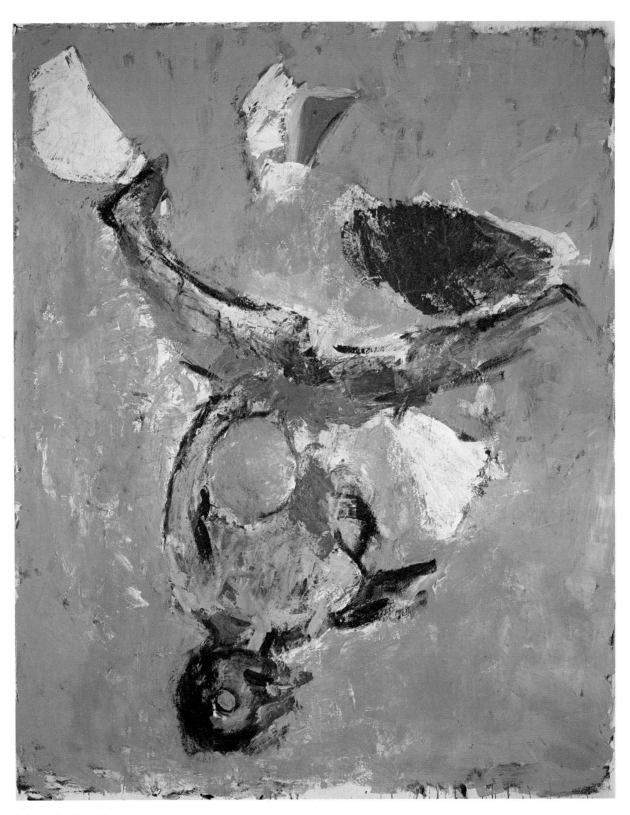

Maria in Knokke, 1980
oil on canvas, 250 x 200 cm, Graham Gund,
Boston

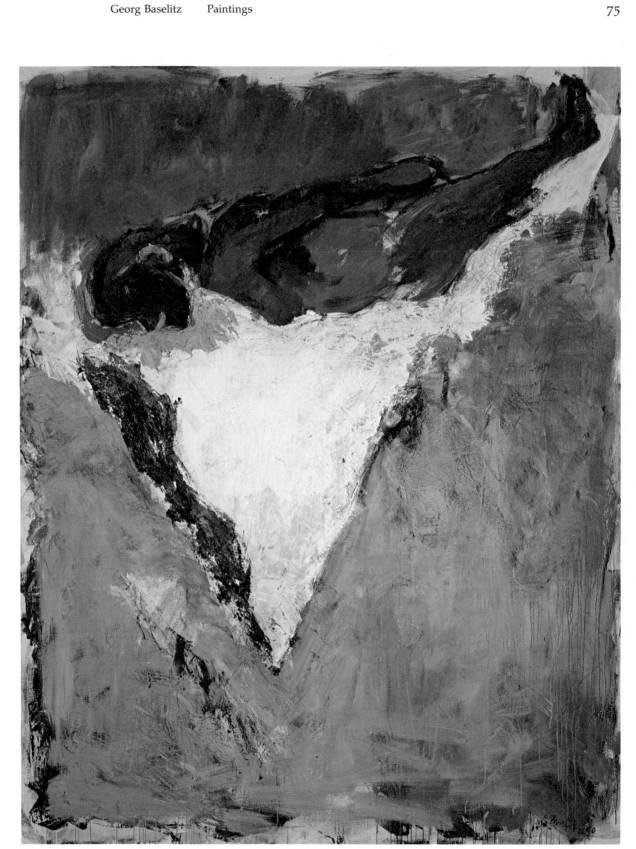

Night in Tunisia (Frau vorm Zelt), 1980
(Woman in Front of the Tent), oil on canvas,
250 x 200 cm, Stedelijk Museum, Amsterdam

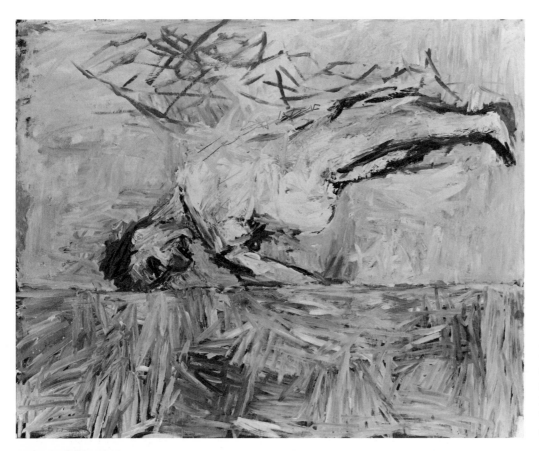

Frau am Strand, 1981
(Woman on the Beach), oil on
canvas, 200 x 250 cm, Mr. and
Mrs. Martin Sosnoff, New
York (Courtesy Sonnabend
Gallery, New York)

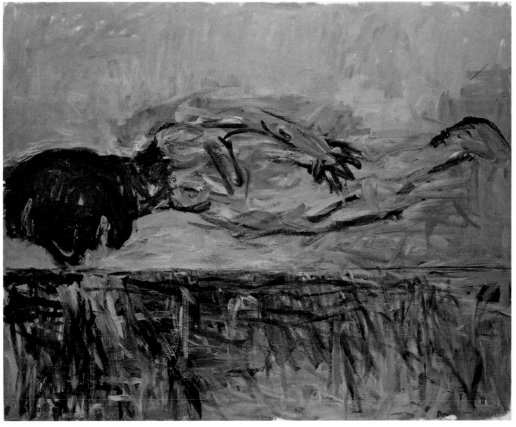

Frau am Strand, 1981
(Woman on the Beach), oil on
canvas, 200 x 250 cm, Gerald
Elliott, Chicago (Courtesy
Sonnabend Gallery,
New York)

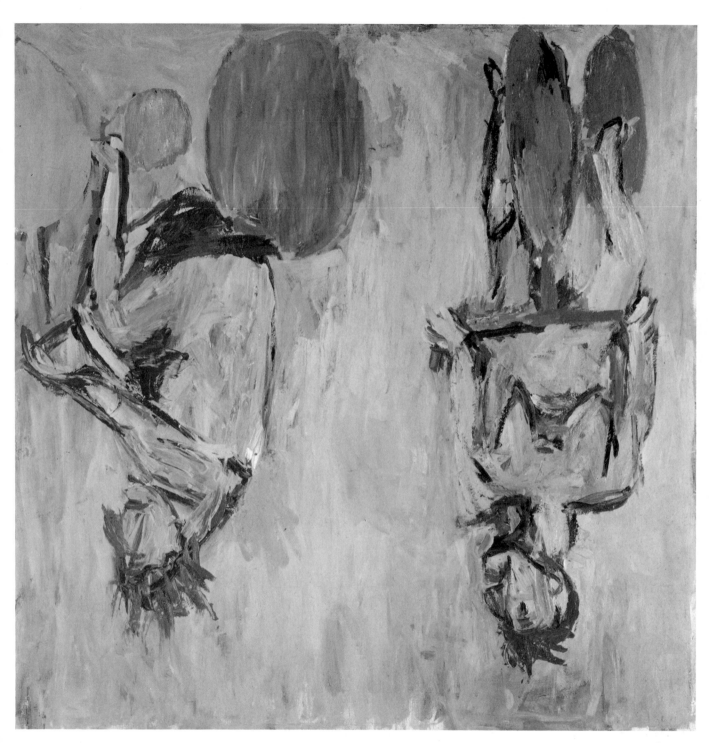

Die Mädchen von Olmo II, 1982
(The Girls from Olmo II), oil on canvas,
250 x 250 cm, Musée National d'Art Moderne,
Centre Georges Pompidou, Paris

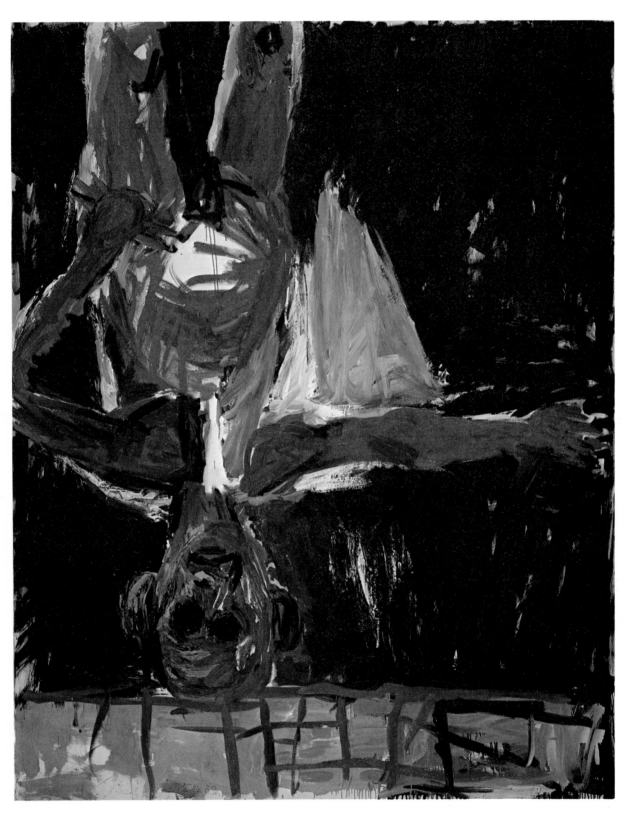

Maler mit Segelschiff (Munch), 1982
(Painter with Sailing Ship – Munch), oil on can-
vas, 250 x 200 cm, Private Collection, Ireland

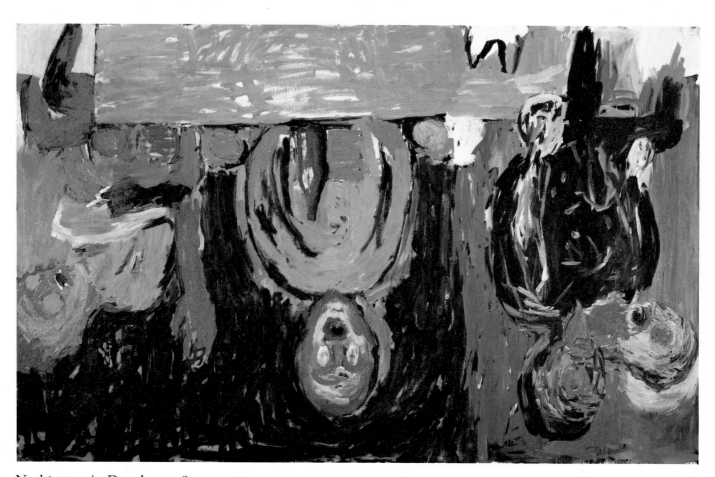

Nachtessen in Dresden, 1983
(Dinner in Dresden), oil on canvas, 280 x 450 cm,
Xavier Fourcade, Inc., New York

TOP LEFT: P. D. Zeichnung, 1962
(P. D. Drawing), tusche on paper, 61.5 x 43 cm,
Private Collection, Cologne

TOP RIGHT: Held, 1965
(Hero), watercolor and chalk on paper,
66 x 48 cm, Private Collection, Cologne

BOTTOM LEFT: Fichten, 1975
(Spruce Trees), tusche and watercolor on paper,
70 x 49.5 cm, Private Collection, Cologne

BOTTOM RIGHT: Gebückter, 1978
(Bent), tusche and charcoal on paper,
62.5 x 48 cm, Private Collection, Cologne

LEFT: Untitled, 1982
painted wood, 250 x 90 x 60 cm, Galerie Neuen-
dorf, Hamburg

BOTTOM: studio with Model for Sculpture
painted wood, 200 x 200 x 50 cm, in progress,
1979/80, now in Museum Moderner Kunst,
Vienna – Sammlung Ludwig

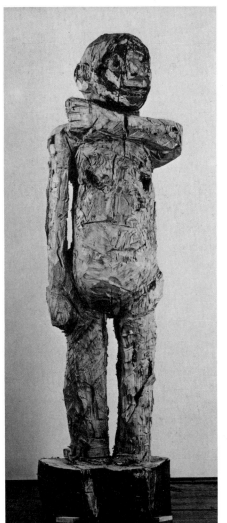

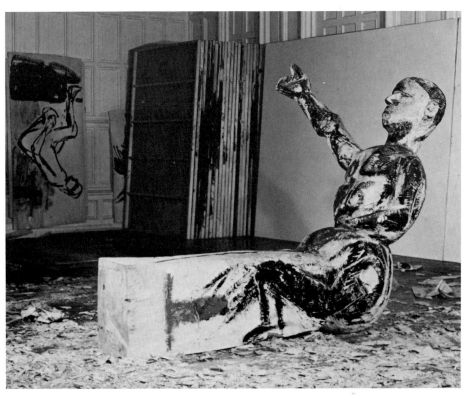

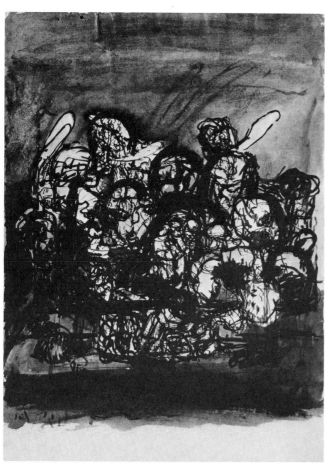 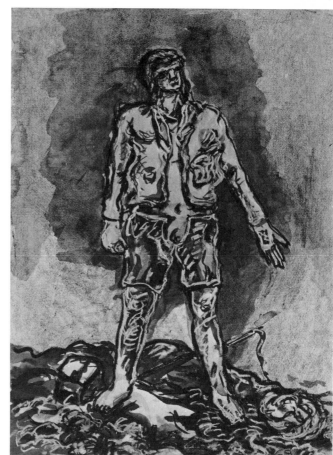

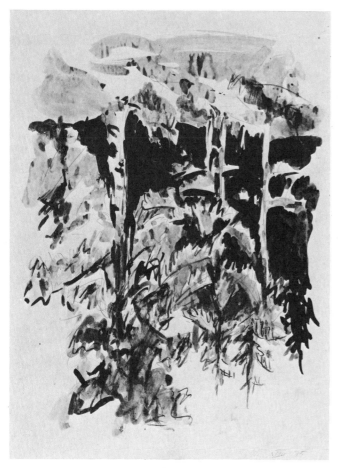 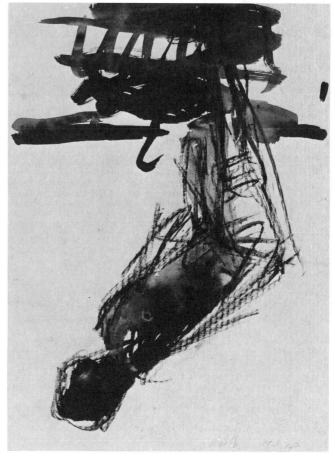

List of Exhibitions

One Man Exhibitions

1961 1. Pandämonium. Manifesto and exhibition, with Eugen Schönebeck, Schaperstraße 22, Charlottenburg, Berlin
1963 Galerie Werner & Katz, Berlin
1964 »1. Orthodoxer Salon«, Galerie Michael Werner, Berlin
Freie Galerie, Berlin
1965 Galerie Friedrich & Dahlem, Munich
Galerie Michael Werner, Berlin (drawings)
Galerie Krohn, Badenweiler
1966 »Kunstpreis der Jugend«, Kunsthalle, Baden-Baden
Galerie Springer, Berlin
Galerie Friedrich & Dahlem, Munich
1967 Kunsthalle, Baden-Baden
Kunsthalle, Nürnberg
Galerie Obere Zäune, Zürich (drawings)
Galerie Beck, Erlangen (drawings)
1969 Galerie Beck, Erlangen
1970 Kunstmuseum, Basel (drawings)
Galerie Heiner Friedrich, Munich
Galerie Berner, Stuttgart
»Franz Dahlem präsentiert Georg Baselitz«, Galeriehaus, Cologne
Wide White Space Gallery, Antwerp (drawings and paintings)
1971 Galerie G. Borgmann, Cologne (drawings)
Galerie Rothe, Heidelberg
1971 /72 Galerie Tobiès & Silex, Cologne
1972 Goethe-Institut/Provisorium, Amsterdam
Städtische Kunsthalle, Mannheim
Kunstverein, Hamburg
Staatliche Graphische Sammlungen, Munich (drawings and etchings)
Galerie Heiner Friedrich, Munich
Galerie Rudolf Zwirner, Cologne (with Heiner Friedrich, Cologne)
Galerie Loehr, Frankfurt
Galerie Grafikmeier, Karlsruhe
1973 Galerie Heiner Friedrich, Munich
Galerie Neuendorf, Hamburg
Galerie Grünangergasse, Vienna (drawings)
Galerie Loehr, Frankfurt
1974 Städtisches Museum/Schloß Morsbroich, Leverkusen (etchings and woodcuts)
Städtische Galerie Altes Theater, Ravensburg
Galerie Heiner Friedrich, Cologne
Galerie Loehr, Frankfurt

1975 Galerie Heiner Friedrich, Munich
Galerie Michael Werner, Cologne (drawings)
Galerie Loehr, Frankfurt
1976 Kunsthalle, Bern
Galerieverein München und Staatsgalerie moderner Kunst, Munich
Kunsthalle, Cologne
Haus der Kunst, Munich (drawings)
Galerie Heiner Friedrich, Cologne
1977 Galerie Heiner Friedrich, Cologne
Galerie Heiner Friedrich, Munich
1978 Galerie Helen van der Meij, Amsterdam
Galerie Heiner Friedrich, Cologne
1979 Stedelijk Van Abbemuseum, Eindhoven
Josef-Haubrich-Kunsthalle, Cologne (lino-cuts)
Groninger Museum, Groningen (drawings)
Galerie Gillespie/Laage, Paris
1980 Galerie Heiner Friedrich, Cologne
Galerie Gillespie/Laage, Paris
Galerie Springer, Berlin (lino-cuts)
1981 Kastrupgårdsamlingen, Kastrup
Stedelijk Van Abbemuseum, Eindhoven (lino-cuts)
Kunstverein Braunschweig, Braunschweig
Stedelijk Museum, Amsterdam
Kunsthalle, Düsseldorf, with Gerhard Richter
Galerie Michael Werner, Cologne
Galerie Annemarie Verna, Zürich (lino-cuts)
Galerie Fred Jahn, Munich
Xavier Fourcade, New York
Brooke Alexander, New York (lino-cuts and etchings)
1982 Stedelijk Museum, Amsterdam
Galerie Michael Werner, Cologne
Waddington Galleries, London
Galerie Fred Jahn, Munich
Galerie Rudolf Zwirner, Cologne
Anthony d'Offay, London (paintings 1966–69)
Galerie Helen van der Meij, Amsterdam
Xavier Fourcade, New York
Sonnabend Gallery, New York
Young Hoffman, Chicago
Galerie nächst St. Stephan, Vienna (drawings and prints)
1983 CAPC Entrepôt Lainé, Bordeaux
Marian Goodman, New York (monoprints and trial proofs)

Galerie Albert Baronian, Brussels (drawings and watercolors)
Galerie Michael Werner, Cologne (sculpture)
Gillespie-Laage-Salomon, Paris
Galerie Springer, Berlin
Xavier Fourcade, New York
Galerie Neuendorf, Hamburg

Group exhibitions

1964 »Deutscher Künstlerbund, 13. Ausstellung«, Hochschule für Bildende Künste, Berlin
1965 »Große Berliner Kunstausstellung«, Messehallen am Funkturm, Berlin
Villa Romana, Florence
1966 »Junge Generation«, Akademie der Künste, Berlin
»Ausstellung des deutschen Künstlerbundes«, Museum Folkwang, Essen
»Deutscher Kunstpreis der Jugend 1966, Malerei«, Staatliche Kunsthalle, Baden-Baden
»Labyrinthe«, Akademie der Künste, Berlin
»Die Berliner Freunde«, Galerie Stummer & Hubschmid, Zürich
1967 »Berlin–Berlin. Junge Berliner Maler und Bildhauer«, Zapeion, Athens
»Figurationen«, Württembergischer Kunstverein, Stuttgart
»Jacques Damase présente: Jeunes peintres de Berlin«, Galerie Motte, Geneva/Paris
1968 »14 mal 14/Junge deutsche Künstler«, Staatliche Kunsthalle, Baden-Baden
1969 »Sammlung 1968 – Karl Ströher«, Neue Nationalgalerie, Berlin
»Ars viva 69«, Schloß Charlottenburg/Orangerie, Berlin and Erholungshaus der Fabriken Bayer AG, Leverkusen
»Kunst und Kritik«, Museum Wiesbaden
»Zeichnungen I«, Galerie Rothe, Heidelberg
1970 »Zeichnungen«, Städtisches Museum/Schloß Morsbroich, Leverkusen
»Zeichnungen I«, Galerie Rothe, Heidelberg

1971 »d'après«, Rassegna internazionale delle arte e della cultura, Villa Ciani, Lugano
»20° premio del fiore«, Palazzo Strozzi, Florence

1972 documenta 5, Kassel
»Zeichen und Farbe«, Staatsgalerie, Stuttgart
»Zeichnungen der deutschen Avantgarde«, Galerie im Taxispalais, Innsbruck and Galerie nächst St. Stephan, Vienna

1972 /73 »Zeichnungen 2«, Städtisches Museum/Schloß Morsbroich, Leverkusen

1973 »Bilder, Objekte, Filme, Konzepte«, Städtische Galerie im Lenbachhaus, Munich
»PROSPECT 73 – Maler/Painters/Peintres«, Städtische Kunsthalle, Düsseldorf

1973 /74 »Bilanz einer Aktivität«, Goethe-Institut/Provisorium, Amsterdam

1975 XIII Bienal de São Paulo
»Deutscher Beitrag zur Biennale São Paulo 1975«, Kunstverein, Bonn

1977 documenta 6, Kassel
»Zum Beispiel Villa Romana, Florenz – Zur Kunstförderung in Deutschland I.«, Staatliche Kunsthalle, Baden-Baden and Palazzo Strozzi, Florence
Galerie Heiner Friedrich, Cologne
»Menschenbild, Menschenbilder«, Galerien Maximilianstraße, Munich

1978 »Werke aus der Sammlung Crex«, InK, Halle für internationale neue Kunst, Zürich
»Kunst des 20. Jahrhunderts aus Berliner Privatbesitz«, Akademie der Künste, Berlin

1979 »Zeichen setzen durch Zeichen«, Kunstverein, Hamburg
»Malerei auf Papier«, Badischer Kunstverein, Karlsruhe
»Staatliche Akademie der Bildenden Künste Karlsruhe zum 125jährigen Bestehen«, Karlsruhe

1980 »Forms of Realism Today«, Musée d'art contemporain, Montreal
»Der gekrümmte Horizont: Kunst in Berlin 1945-1967«, Akademie der Künste, Berlin
Biennale di Venezia, Venice
Whitechapel Art Gallery, London (with Max Beckmann)

»300 Dessins 1945-1978, Collection Ludwig«, CAPC Entrepôt Lainé, Bordeaux (with Penck and Beuys)
»Zeichen des Glaubens, Geist der Avantgarde: religiöse Tendenzen in der Kunst des 20. Jahrhunderts«, Schloß Charlottenburg, Große Orangerie, Berlin
»Lex nouveaux fauves – die neuen Wilden«, Neue Galerie – Sammlung Ludwig, Aachen

1980 /81 »Après le classicisme«, Musée d'Art et d'Industrie et Maison de la Culture, Saint-Etienne
»2. Biennale der europäischen Grafik Baden-Baden«, Baden-Baden

1981 »Art Allemagne aujourd'hui«, ARC/Musée d'art moderne de la ville de Paris, Paris
»A New Spirit in Painting«, Royal Academy of Arts, London
»Schilderkunst in Duitsland 1981«, Vereniging voor Tentoonstellingen van het Paleis voor Schone Kunsten te Brussel, Brussels
»Die Professoren der Staatlichen Akademien der Bildenden Künste Karlsruhe und Stuttgart«, Staatliche Kunsthalle, Baden-Baden
»Westkunst: zeitgenössische Kunst seit 1939«, Cologne
»Tendenzen der modernen Kunst, Sammlung Ingrid und Hugo Jung«, Suermondt-Ludwig-Museum und Museumverein, Aachen
Galerie Christian Stein, Turin
Galerie Ehrhardt, Madrid (prints)
Galerie Gillespie-Laage-Salomon, Paris

1982 »'60-'80: Attitudes, Concepts, Images«, Stedelijk Museum, Amsterdam
documenta 7, Kassel
»Mythe, drame, tragédie«, Musée d'art et d'industrie et Maison de la culture, Saint-Etienne
»Zeitgeist«, Martin-Gropius-Bau, Berlin
»New Figuration from Europe«, Milwaukee Art Museum
»Homo Sapiens: The Many Images«, Aldrich Museum of Contemporary Art, Ridgefield, Connecticut
»Painting and Sculpture Today 1982«, Indianapolis Museum of Art, Indiana
»German Drawings of the '60s«, Yale University Art Gallery, New Haven, Connecticut

»4th Biennale of Sydney: Vision in disbelief«, Sydney, Australia
»Avanguardia transavanguardia«, Mura Aureliane da Porta Metronia a Porta Latina, Rome
»La transavanguardia Tedesca«, Galleria Nazionale d'arte moderna, San Marino
»La nuova pittura tedesca«, Studio Marconi, Milan
»9. Internationale Triennale für farbige Originalgraphik«, Haldenschulhaus, Grenchen
»Pressure to Paint«, Marlborough Gallery, New York
»Painting: American/European«, L. A. Louver, Venice, California
Galerie Annemarie Verna, Zürich
»Erste Konzentration«, Galerie Friedrich & Knust, Munich
Roger Ramsay Gallery, Chicago (works on paper)

1983 Museum Haus Ester, Krefeld (prints)
»New Figuration. Contemporary Art from Germany«, Frederick S. Wight Art Gallery, University of California, Los Angeles
Städtische Galerie am Markt, Schwäbisch Hall
»Mensch und Landschaft in der zeitgenössischen Malerei und Graphik der Bundesrepublik Deutschland«, Moscow and Leningrad
»EXPRESSIONS: New Art from Germany«
The Saint Louis Art Museum

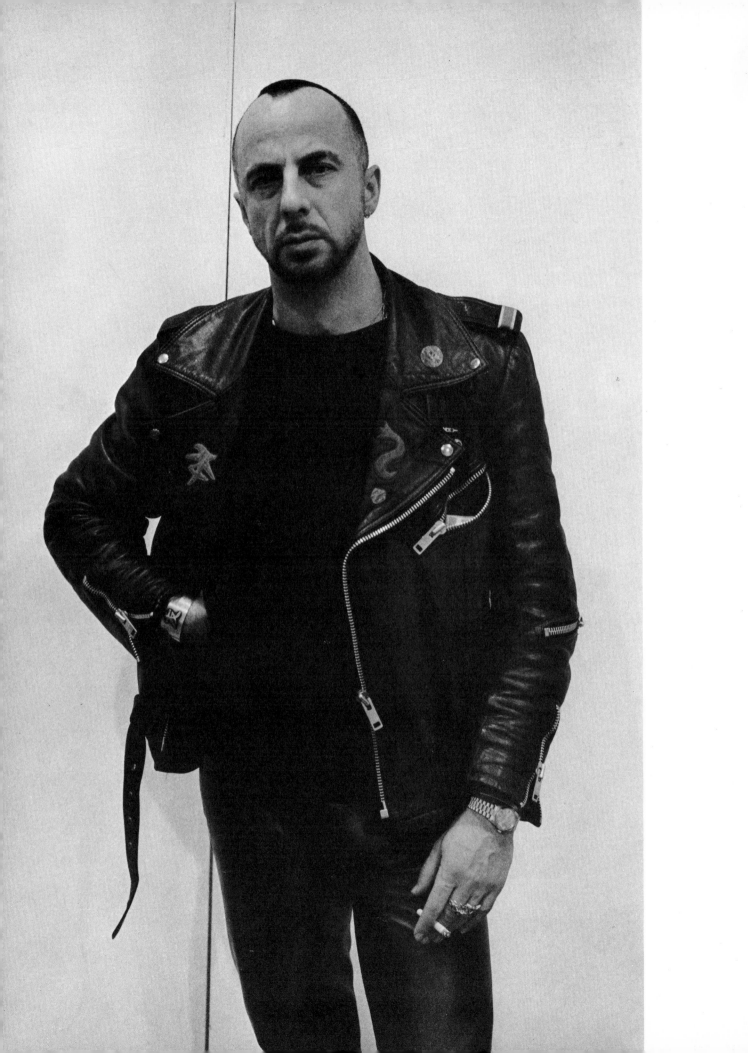

Jörg Immendorff

Biography

1945	Born June 14, in Bleckede, on the west bank of the Elbe near Lüneburg, West Germany
1963-64	Three semesters of stage set design with Professor Teo Otto at the Kunstakademie, Düsseldorf
1964	Enters classes of Professor Josef Beuys, Staatliche Kunstakademie, Düsseldorf
1965-66	Participates in various art activities, manifestations at the Kunstakademie
1968-70	Involved in so-called *Lidl* activities in Düsseldorf and other German cities, »Lidl« being a nonsense word derived from baby sounds
1968-80	Art teacher at a Hauptschule (Secondary School) in Düsseldorf
1977	Meets A. R. Penck (Ralf Winkler) in East Berlin
1978	Begins work on *Café Deutschland* theme
1981	Guest professor in the Konsthögskolan, Stockholm
1982	Guest professor in Hamburg. Lives and works in Düsseldorf

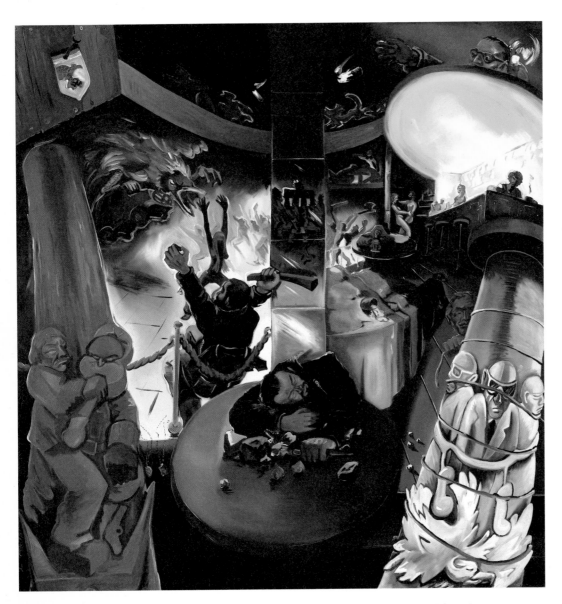

Café Deutschland III, 1978
(Café Germany III), synthetic resin on canvas,
285 x 273 cm, Gillespie/Laage/Salomon, Paris

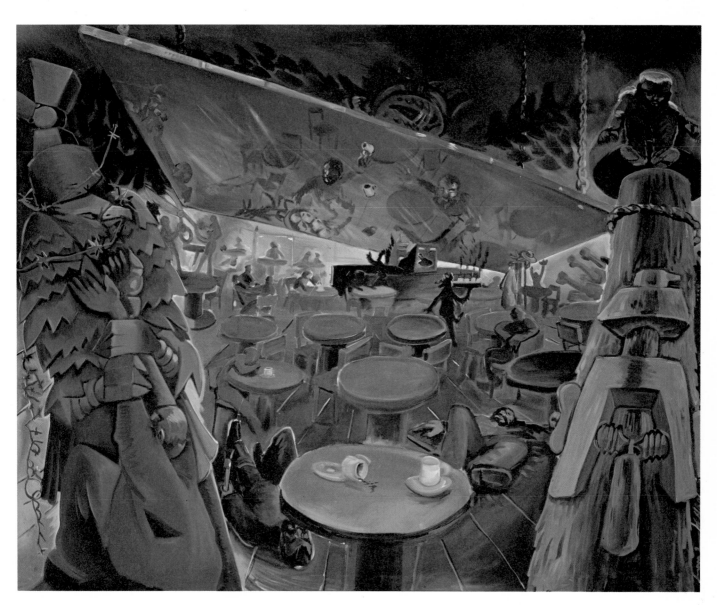

Café Deutschland vi / Caféprobe, 1980
(Café Germany vi / Café-Rehearsal), synthetic
resin on canvas, 280 x 350 cm, Courtesy Galerie
Templon, Paris

Café Deutschland x / Parlament 1, 1981
(Café Germany x / Parliament 1), synthetic resin
on canvas, 280 x 350 cm, Hedendaagse Kunst,
Utrecht

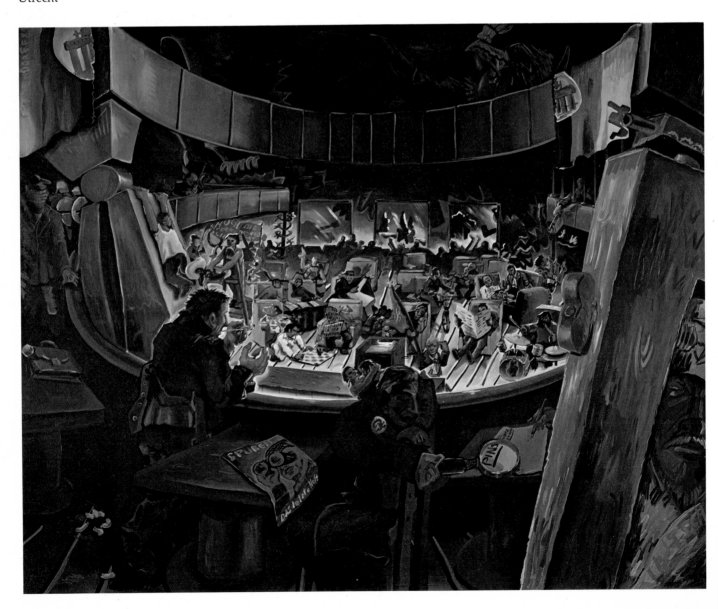

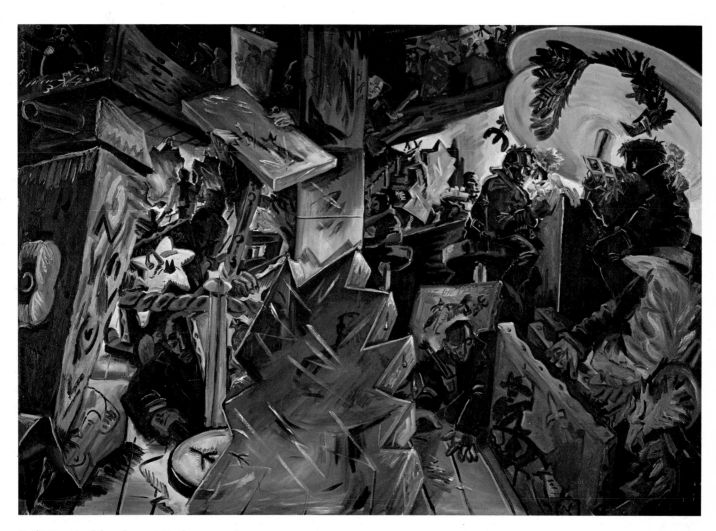

Café Deutschland XIII / Rede an meine
Bilder, 1982
(Café Germany XIII / Speaking to My Pictures),
oil on canvas, 282 x 400 cm, Max Ulrich Hetzler
GmbH, Stuttgart

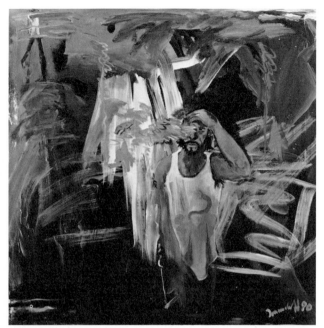

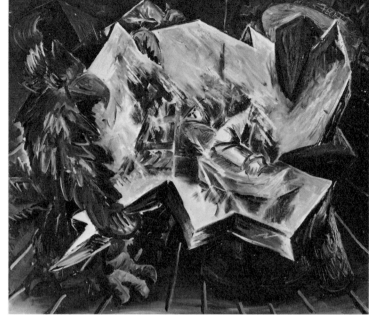

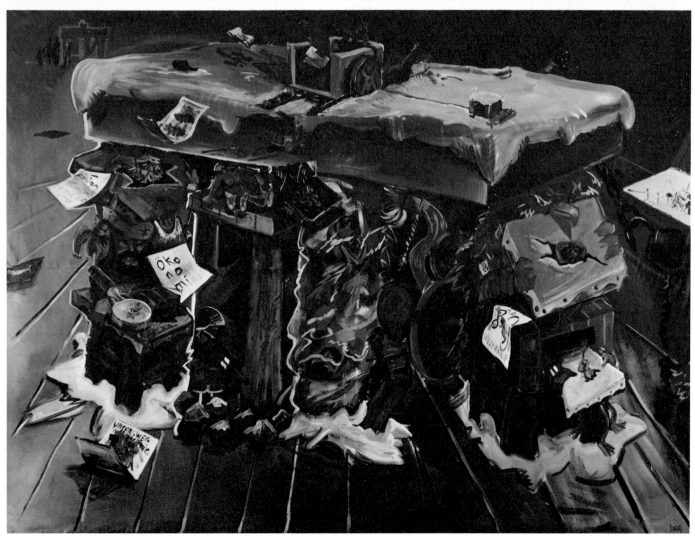

TOP LEFT: Selbstbildnis, 1980
(Self-portrait), synthetic resin on canvas,
150 x 150 cm

TOP RIGHT: Mischtechnik 2, 1982
(Mixed Media), oil on canvas, 150 x 180 cm

BOTTOM: Tor II, 1981
(Gate II), synthetic resin on canvas, 305 x 420 cm,
Galerie Neuendorf, Hamburg

Ölige Freunde, 1982
(Unctuous Friends), oil on canvas, 250 x 310 cm

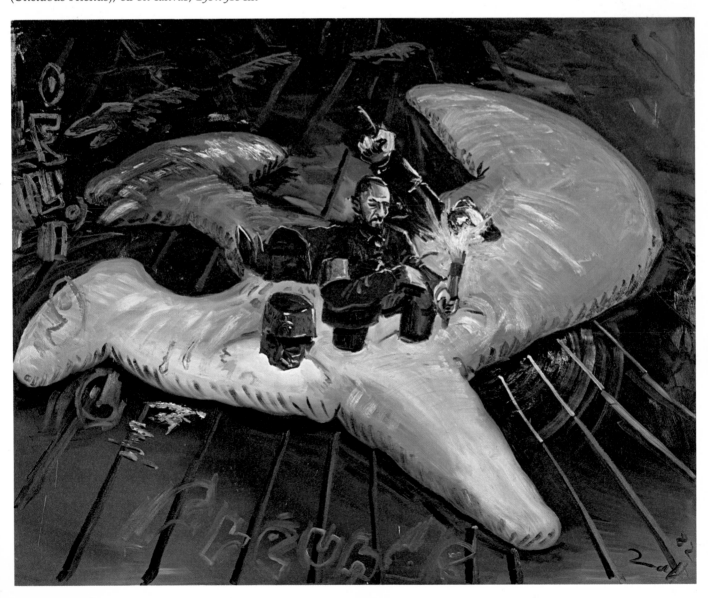

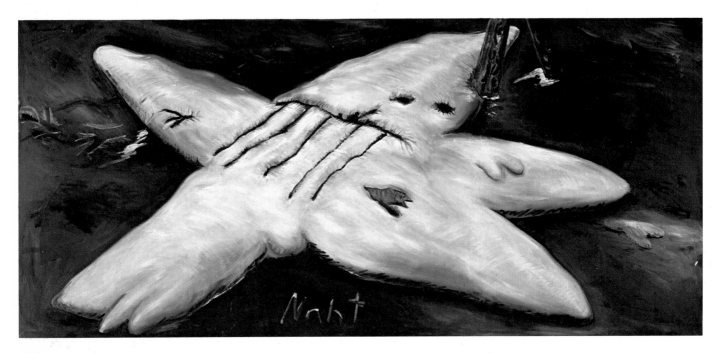

Naht, 1981
(Seam), oil on canvas, 180 x 400 cm, Private
Collection, Cologne

TOP: Café Deutschland xiv / Quadriga,
1982
(Café Germany xiv / Quadriga), oil on canvas,
282 x 400 cm

BOTTOM: Café Deutschland xv / Schwarzer
Stern, 1982
(Café Germany xv / Black Star), oil on canvas,
282 x 400 cm, Courtesy Galerie Templon, Paris

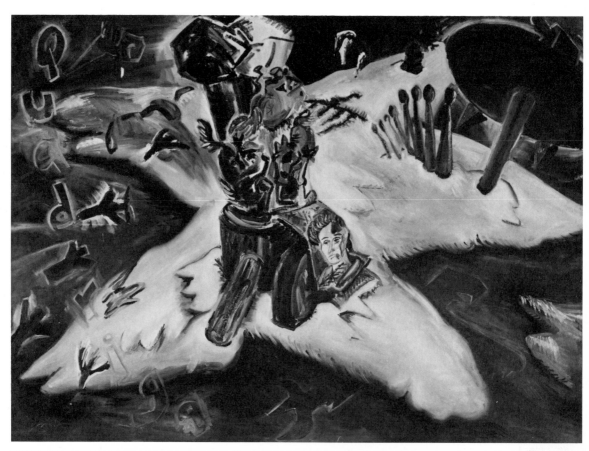

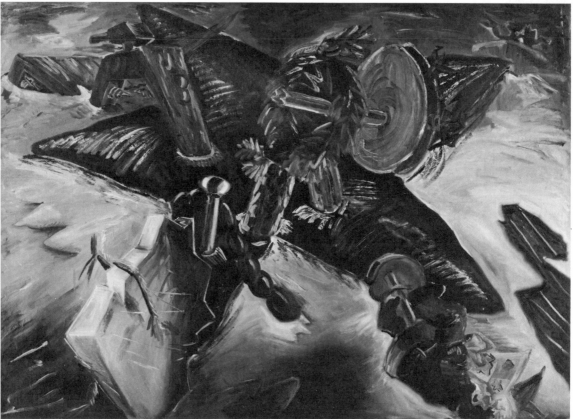

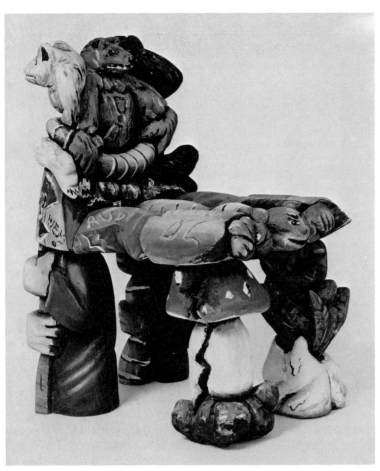

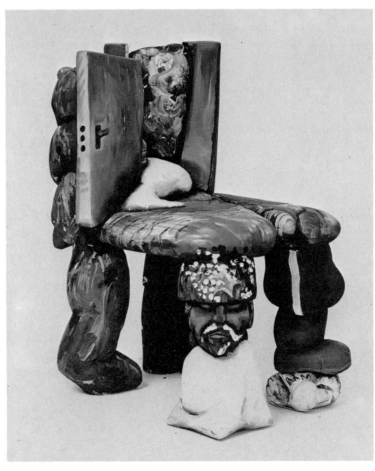

TOP: Position 7 (Stuhl der Zukunfts-fragen), 1979
(Position 7 – Chair of Future Questions), painted Lindenwood, 86 x 48 x 62 cm, Private Collection, Cologne

BOTTOM: Position 4 (Russland-Stuhl), 1979
(Position 4 – Russia Chair), painted Linden-wood, 85 x 65 x 50 cm, Private Collection, Cologne

RIGHT: Position 2 (Lupenadler), 1979
(Position 2 – Eagle with Magnifying Glass), painted Lindenwood, 86 x 50 x 63 cm, Private Collection, Cologne

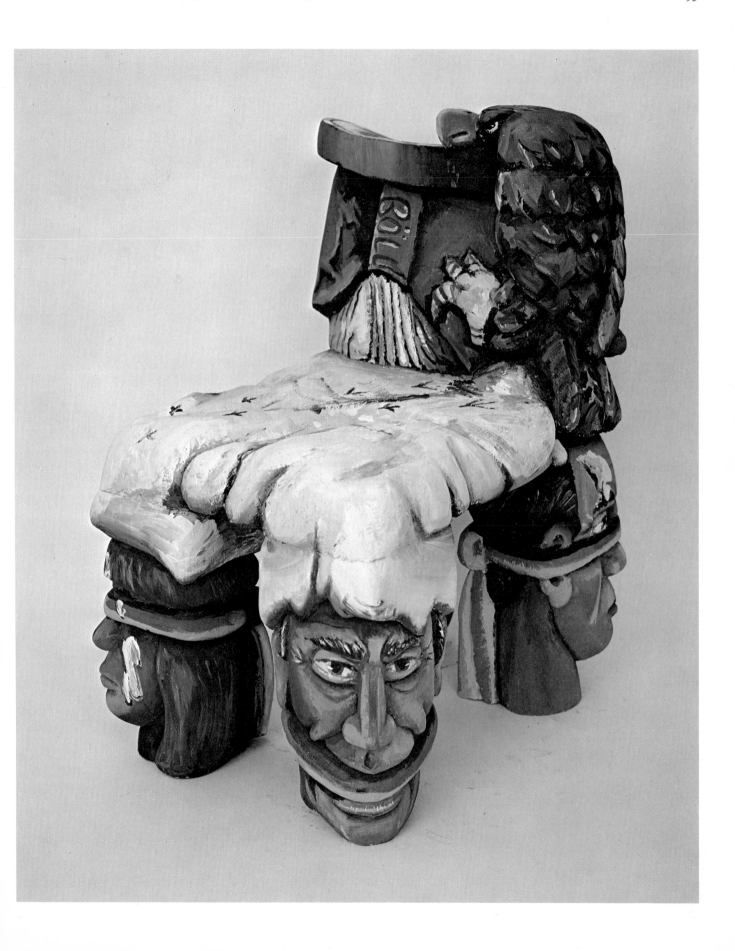

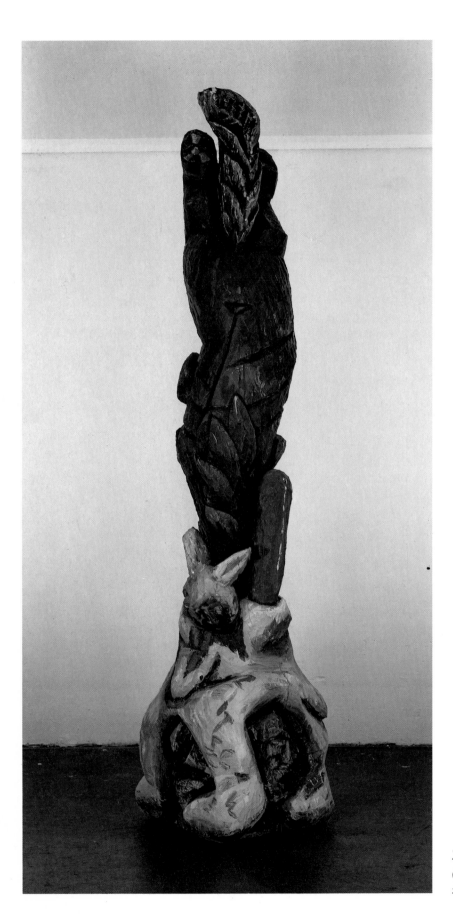

Zeitschweiss, 1982
(»Time Sweat«), painted Lindenwood,
265 x 60 x 60 cm

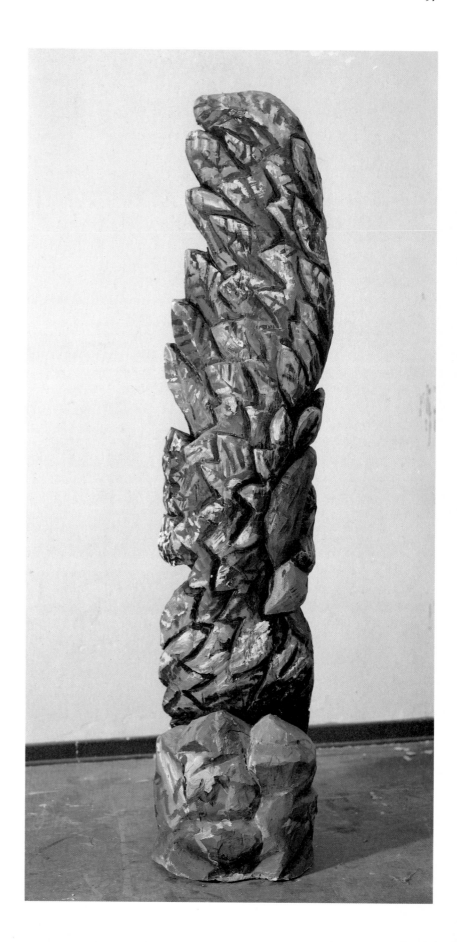

Adler, 1981
(Eagle), painted Lindenwood, 206 x 37 x 43 cm

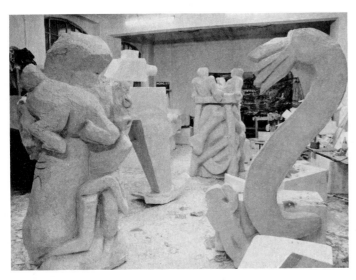

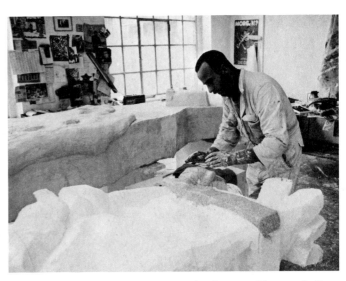

TOP LEFT AND RIGHT: Studio with Branden-
burger Tor
plaster models, in progress

BOTTOM: Brandenburger Tor, 1981/82
(Brandenburg Gate), painted bronze, ca.
320 x 150 x 500 cm, installed beside Friederi-
cianum, Kassel, during documenta 7

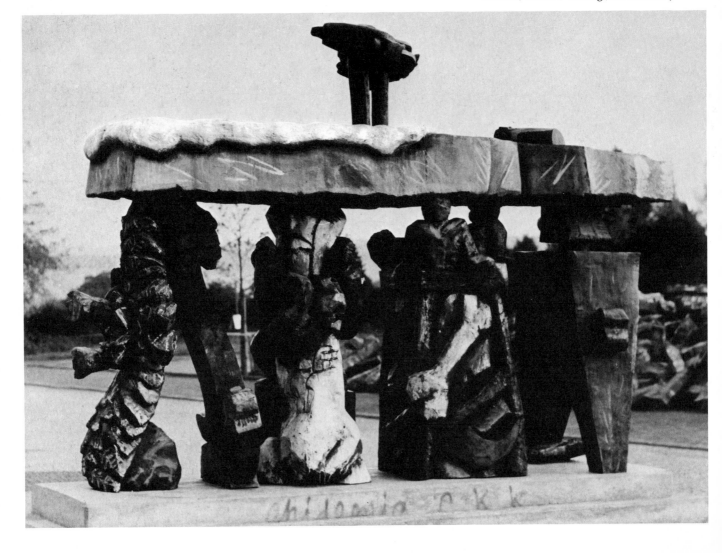

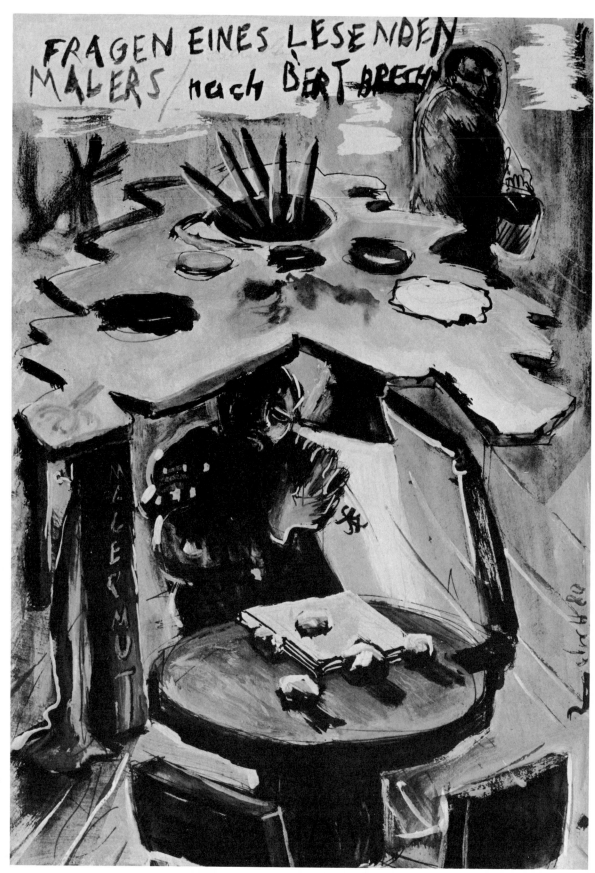

Malermut, 1980
(Painter's
Courage),
gouache and ink
on paper,
29.5 × 21 cm

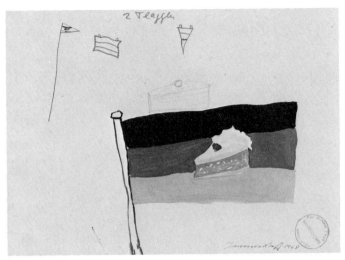

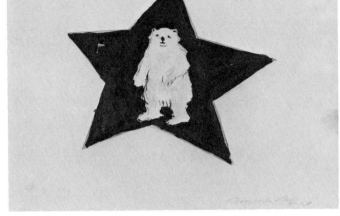

TOP LEFT: 2 Flaggen, 1968
(2 Flags), graphite and watercolor on
paper, 21 x 29.5 cm

TOP RIGHT: Untitled, 1968
graphite and watercolor on paper,
21 x 29.5 cm

BOTTOM LEFT: Teilbau (Böll), 1978
(Building Part – Böll), gouache on paper,
29.5 x 21 cm

BOTTOM RIGHT: Zu »Weltfrage«, 1982
(From »Universal Question«), tusche,
graphite and watercolor on paper,
23 x 19 cm

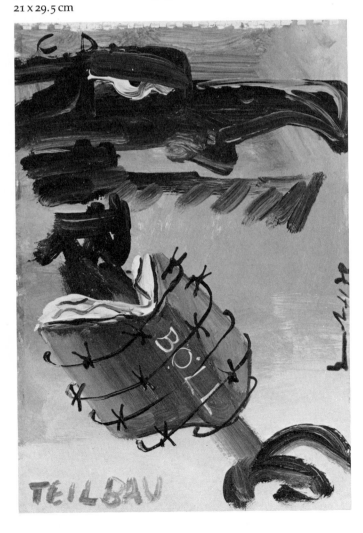

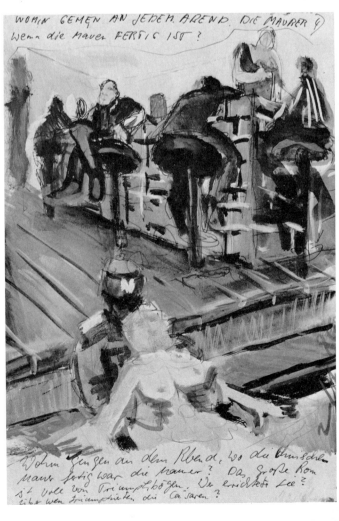

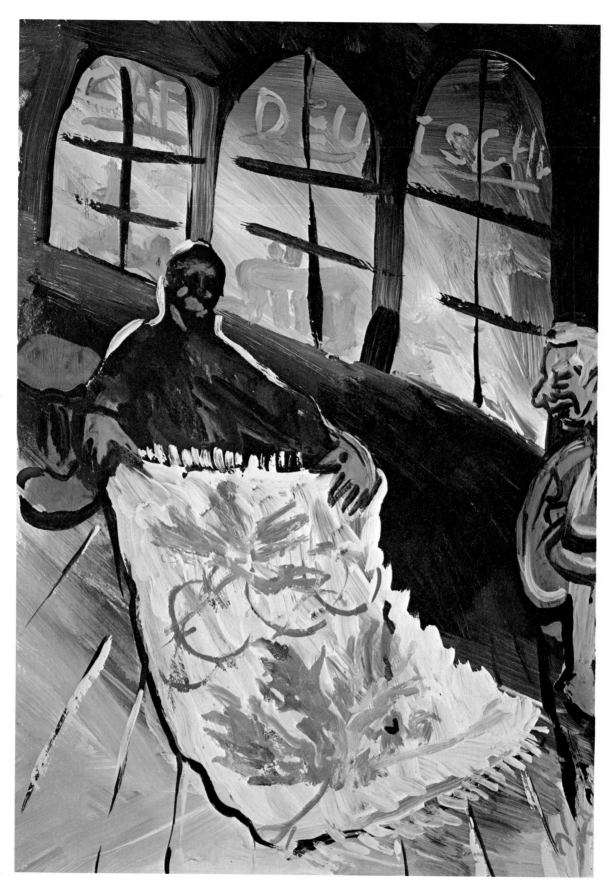

I. zeigt G. einen
Teppich, 1978
(I. Shows G. a Car-
pet), gouache on
paper, 29.5 x 21 cm

List of Exhibitions

One-Man Exhibitions

1961 New Orleans-Club, Bonn
1966 Galerie Schmela, Düsseldorf
Galerie Fulda, Fulda
Galerie Aachen, Aachen
1967 Galerie Art Intermedia, Cologne
1968 Galerie Patio, Frankfurt
1969 Galerie Lichter, Frankfurt
Galerie Michael Werner, Cologne
Eine Wanderausstellung
1971 Galerie Michael Werner, Cologne
Arbeit an der Hauptschule
Galerie Heiner Friedrich, Munich
1972 Galerie Michael Werner, Cologne
1973 Westfälischer Kunstverein, Munster
Hier und jetzt: Das tun was zu tun ist
Galerie Michael Werner, Cologne
Galerie Loehr, Frankfurt
Galerie Cornels, Baden-Baden
1974 Daner Galleriet, Copenhagen
Galerie Michael Werner, Cologne
1975 Galerie am Savignyplatz, Berlin
Galerie Michael Werner, Cologne
Galerie Nächst St. Stephan, Vienna
1976 Galerie Seriaal / Helen van der Meij,
Amsterdam
1977 Hedendaagse Kunst, Utrecht
Galerie Michael Werner, Cologne
*Penck mal Immendorff, Immendorff mal
Penck*
1978 Galerie Maier-Hahn, Düsseldorf
Galerie Michael Werner, Cologne
Café Deutschland
1979 Kunstmuseum Basel *Café Deutschland*
Galerie Helen van der Meij, Amsterdam
Galerie Michael Werner, Cologne
Situationen-Positionen Plastiken
Bleckede an der Elbe *Teilbau,* a permanent open-air exhibition
1980 Kunsthalle Bern *Malermut rundum*
1981 Stedelijk Van Abbemuseum, Eindhoven *Pinselwiderstand (4×)*
Stedelijk Van Abbemuseum, Eindhoven *Eisende* (with Jannis Kounellis)
Galerie Hans Neuendorf, Hamburg
Tielbau
Galerie Heinrich Ehrhard, Madrid
1982 Kunsthalle Düsseldorf *Café Deutschland/Adlerhälfte*
Galerie Michael Werner, Cologne
Kein Licht für wen?
Galerie Fred Jahn, Munich *Grüsse von der Nordfront*
Galerie Hans Strelow, Düsseldorf
(paintings)
Galerie Daniel Templon, Paris

Sonnabend Gallery, New York
Galerie Rudolf Springer, Berlin
Verenining Aktuele Kunst vzw
GEWAD
1983 Kastrupgårdsamlingen, Kastrup
(paintings and drawings)

Group Exhibitions

1967 »Deutsch-Dänische Wochen«, Galerie Aachen, Aachen
»Hommage à Lidice«, Galerie René Block, Berlin
1969 »Düsseldorfer Szene«, Kunstmuseum, Lucerne
1970 »Jetzt«, Kunsthalle, Cologne
1972 dokumenta 5, Kassel
»Zeichnungen der deutschen Avantgarde«, Galerie im Taxispalais, Innsbruck
1972 »Zeichnungen 2«, Städtisches Museum / Schloss Morsbroich, Leverkusen
73
1973 »Bilder/Objekte/Filme/Konzepte«, Städtische Galerie im Lenbachhaus, Munich
1974 »xx. Internationales Kunstgespräch«, Galerie Nächst St. Stephan, Vienna
1975 »Jahrgang 45«, Galerie René Block, Berlin
»Je/nous–ik/wij«, Musée d'Ixelles, Brussels
1976 La Biennale di Venezia, Venice
1977 »Zeitgenössische Kunst aus der Sammlung des Stedelijk Van Abbemuseum Eindhoven«, Kunsthalle, Bern
1979 »Solidaritätsaktion für Jochen Hiltmann«, Stedelijk Van Abbemuseum, Eindhoven
»Malerei auf Papier«, Badischer Kunstverein, Karlsruhe
1980 »Les nouveaux fauves – die neuen Wilden«, Neue Galerie – Sammlung Ludwig, Aachen
La Biennale di Venezia, Venice
»Après le classicisme«, Musée d'Art et d'Industrie et Maison de la Culture, Saint-Etienne
»Der Hund stösst im Laufe der Woche zu mir«, Moderna Museet, Stockholm
»Finger für Deutschland«, Immendorff-Studio, Düsseldorf
1981 »Art d'allemagne aujourd'hui«, ARC/Musée d'art moderne de la Ville de Paris
»Schilderkunst in Duitsland 1981«, Vereniging voor Tentoonstellingen van het Paleis voor Schone Kunsten te Brussel, Brussels
»Der Hund stösst im Laufe der Woche zu mir«, Moderna Museet, Stockholm
»Le Moderna Museet de Stockholm«,

Palais des Beaux-Arts, Brussels
»Westkunst: zeitgenössische Kunst
seit 1939«, Cologne
Galerie Gillespie/Laage/Salomon,
Paris

1982 »German Drawings of the 60's«, Yale
University Art Gallery, New Haven,
Connecticut
»La nuova pittura tedesca«, Studio
Marconi, Milan
»9. Internationale Triennale für far-
bige Originalgraphik«, Haldenschul-
haus, Grenchen
»Avanguardia transavanguardia«,
Mura Aureliane da Porta Metronia a
Porta Latina, Rome
»4th Biennale of Sydney, Vision in
Disbelief«, Sydney
»Neue Skulptur«, Galerie Nächst
St. Stephan, Vienna
»La Transavanguardia Tedesca«, Gal-
lerie nazionale d'Arte modena, San
Marino
documenta 7, Kassel
»Vergangenheit, Gegenwart,
Zukunft: zeitgenössische Kunst und
Architektur«, Württembergischer
Kunstverein, Stuttgart
»Zeitgeist« Martin-Gropius-Bau,
Berlin
»Erste Konzentration«, Galerie Fried-
rich und Knust, Munich
Annemarie Verna, Zurich

1983 »New Figuration. Contemporary Art
from Germany«, Frederick S. Wight
Art Gallery, University of California,
Los Angeles
»Mensch und Landschaft in der
zeitgenössischen Malerei und
Graphik der Bundesrepublik
Deutschland«, Moscow and Lenin-
grad
Galerie Rolf Ricke, Cologne (sculp-
ture)
»EXPRESSIONS: New Art from Ger-
many«, The Saint Louis Art Museum

Anselm Kiefer

Biography

1945	Born March 8, in Donaueschingen, Bavaria
1965	Attends university to study law and French
1966-68	Studies painting with Peter Dreher, Freiburg
1969	Studies painting with Horst Antes, Karlsruhe
1970-72	Studies with Josef Beuys, Düsseldorf Lives and works in Hornbach/Odenwald

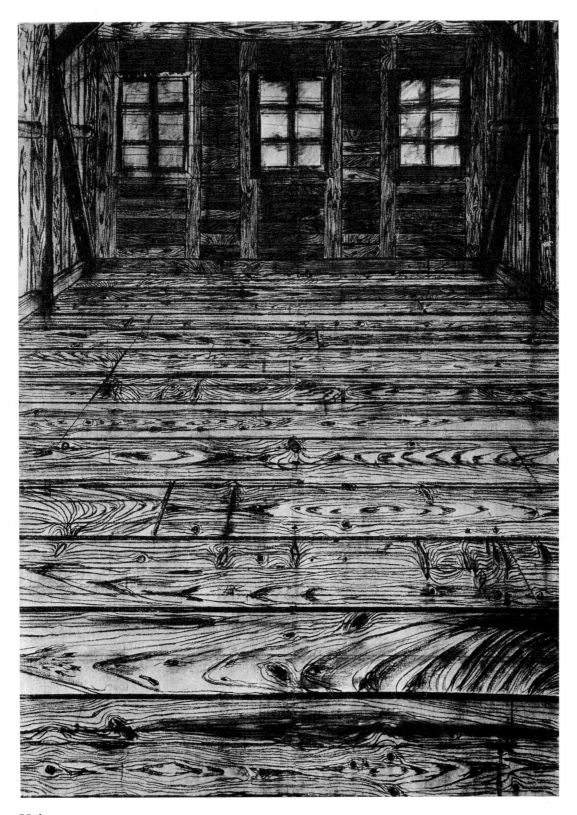

Holzraum, 1972
(Wooden Room), oil and charcoal on burlap
300 x 220 cm, Georg Baselitz, Derneburg

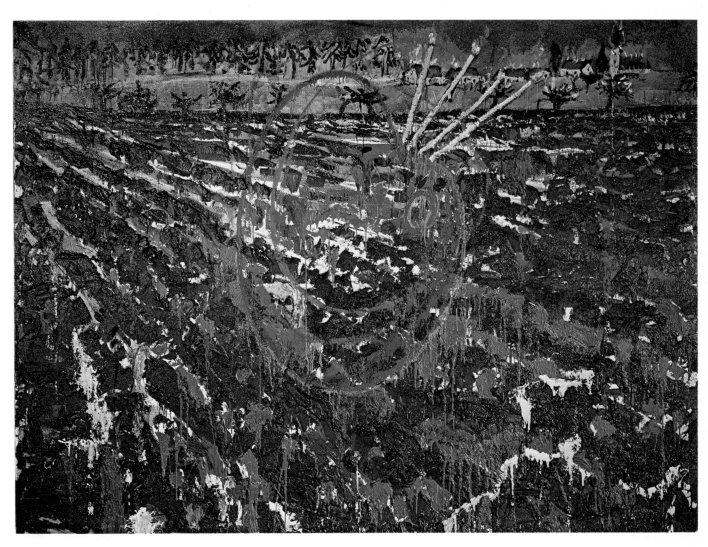

Nero malt, 1974
(Nero Painting), oil on canvas, 220 x 300 cm,
Private Collection, Munich

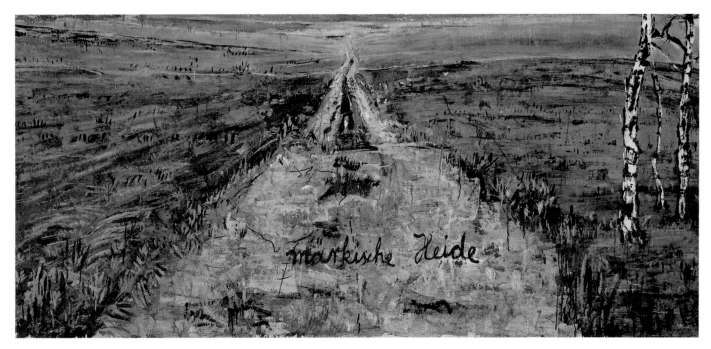

Märkische Heide, 1974
(Mark Heath), oil on canvas, 117 x 254 cm,
Stedelijk Van Abbemuseum, Eindhoven

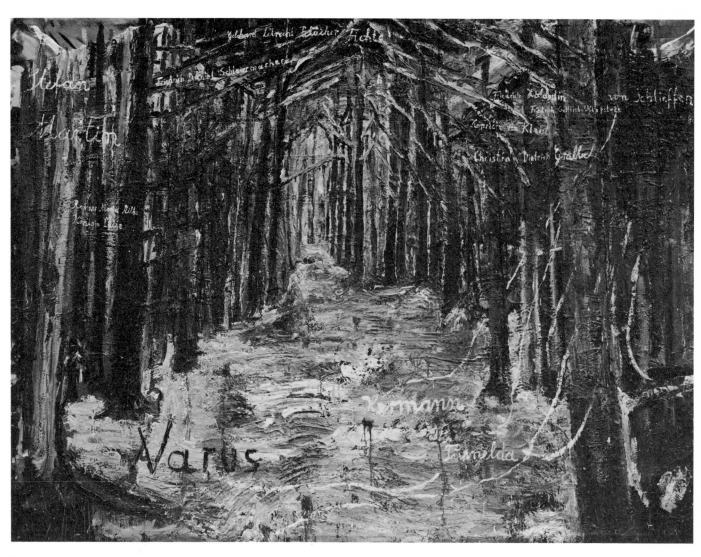

Varus, 1976
oil on canvas, 200 x 270 cm, Stedelijk Van Abbe-
museum, Eindhoven

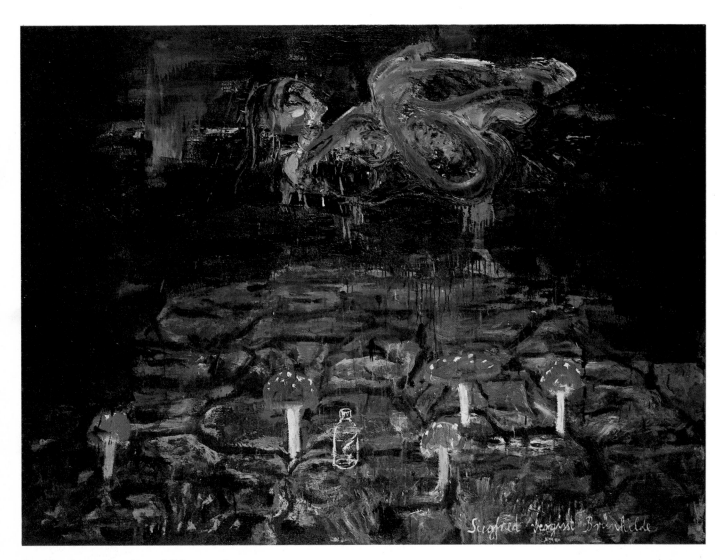

Siegfried vergisst Brünhilde, 1976
(Siegfried Forgetting Brunhilde), oil on burlap,
200 x 270 cm, Martijn and Jeanette Sanders, Amsterdam

Unternehmen »Seelöwe«, 1975
(Operation »Sea-Lion«), oil on canvas,
220 x 300 cm, Private Collection, Bonn

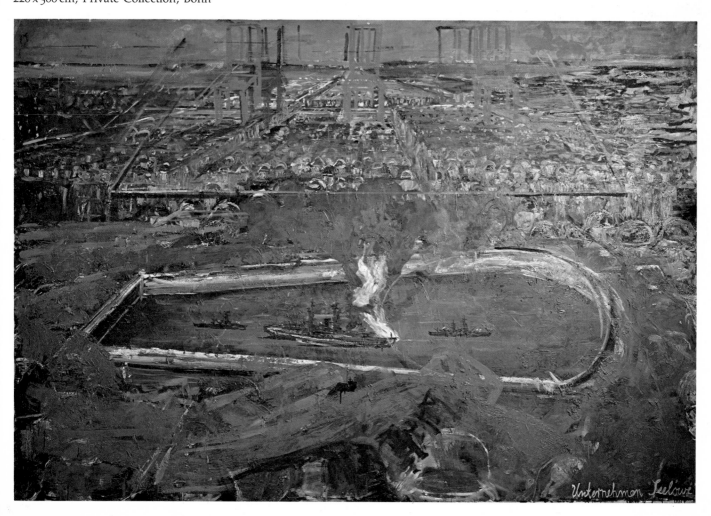

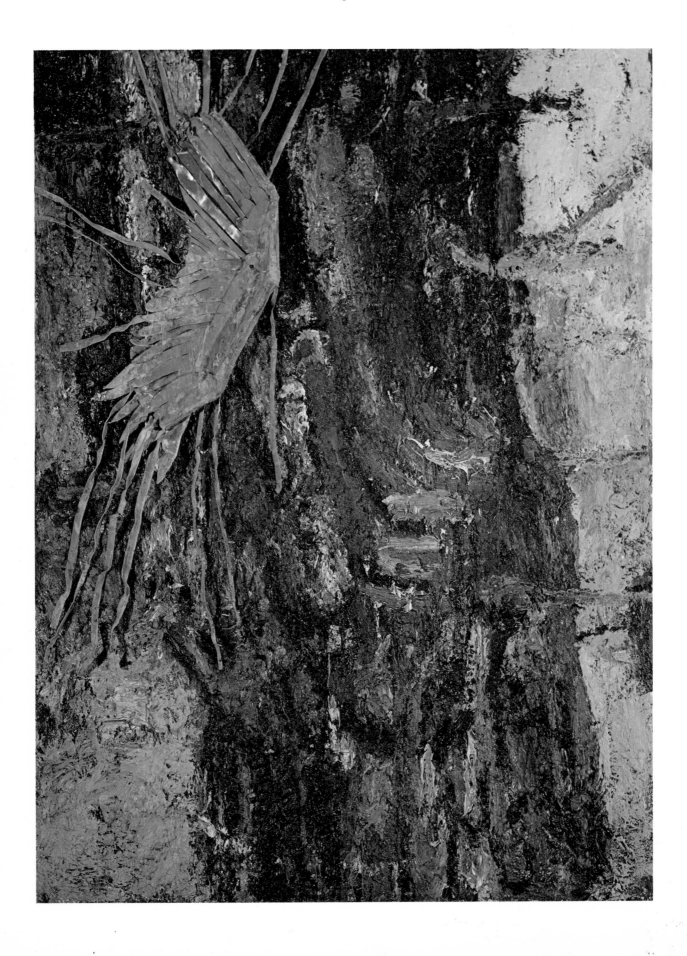

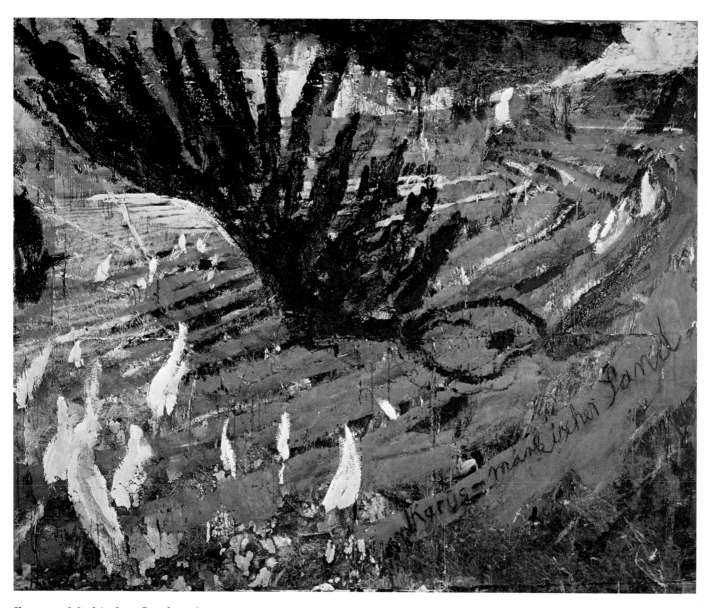

Ikarus – Märkischer Sand, 1981
(Icarus – Sand in Mark), oil, sand and photo-
graph on canvas, 290 x 360 cm, Doris and
Charles Saatchi, London

LEFT: Baum mit Flügel, 1979
(Tree with Wing), oil and straw on canvas, lead
sculpture, 285 x 190 cm, Stadt Aachen, Neue
Galerie – Sammlung Ludwig

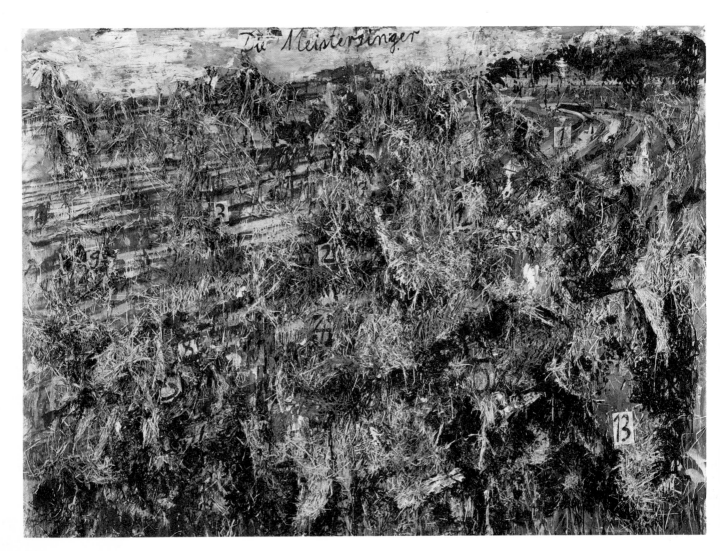

Meistersinger, 1982
oil and straw on canvas, 280 x 380 cm, Doris and
Charles Saatchi, London

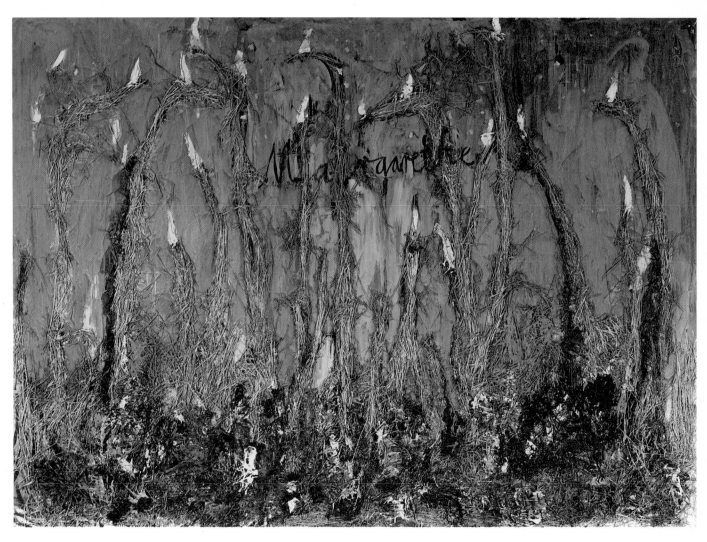

Margarete, 1981
oil and straw on canvas, 280 x 380 cm, Doris and
Charles Saatchi, London

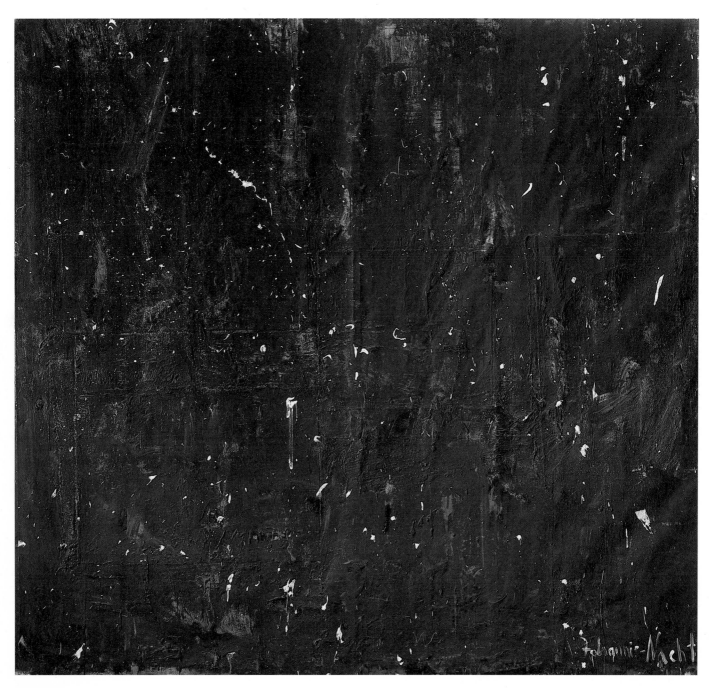

Johannisnacht, 1981
(Mid-Summer's Night), oil and mixed media on
canvas, 330 x 350 cm, Estelle Schwartz, New
York (Courtesy Marian Goodman Gallery, New
York)

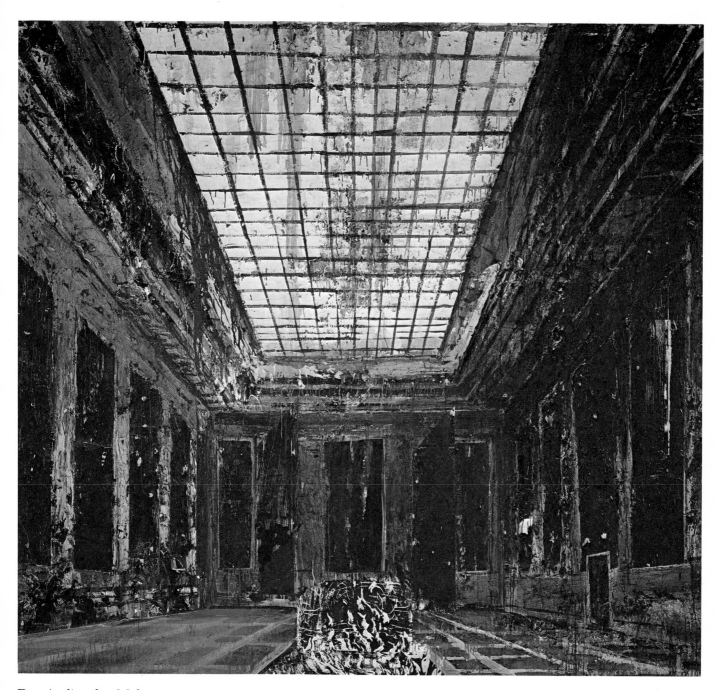

Das Atelier des Malers,
Innenraum, 1981
(Painter's Studio, Inner Room), oil and mixed
media on canvas, 287 x 310 cm, Stedelijk Mu-
seum, Amsterdam

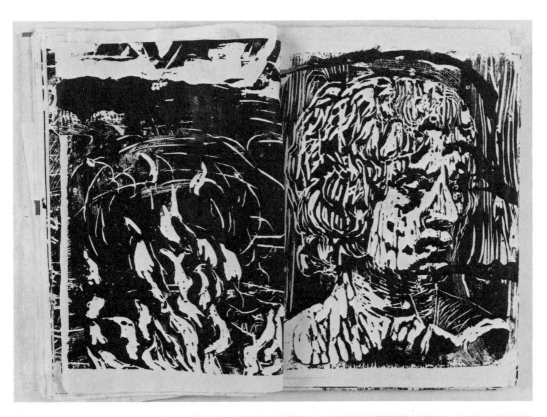

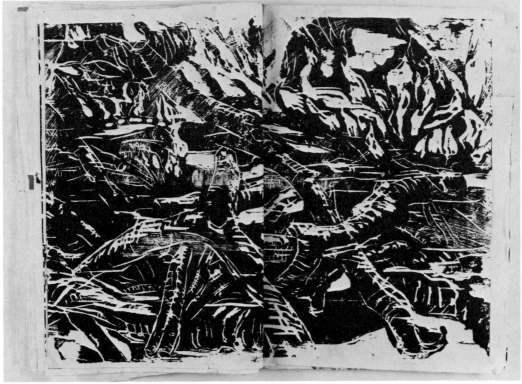

Wege der Weltweisheit: Die Hermannschlacht, 1978
(Ways of World Wisdom – Hermann's Battle),
artist's book, woodcut, each page 62 x 42 cm

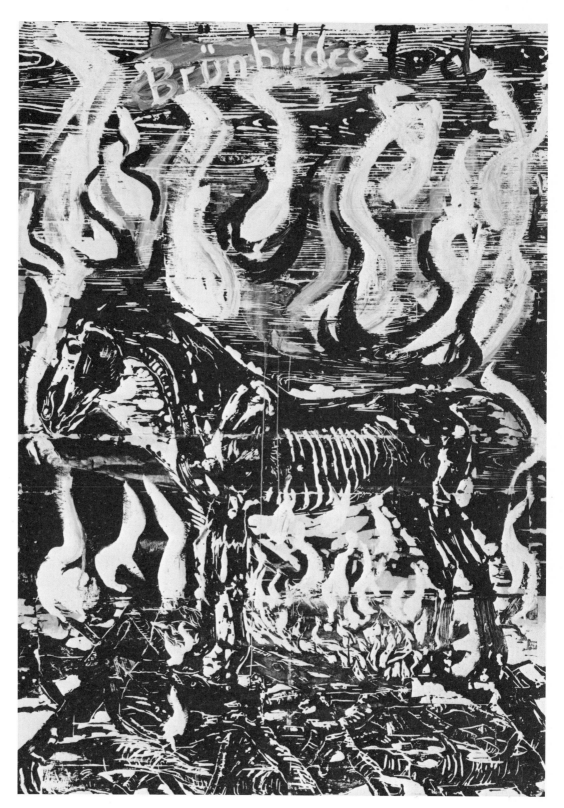

Brünhildes Tod, 1978
(Brunhilde's Death), woodcut and oil paint on
papers, 220 x 158 cm, Private Collection, New
York (Courtesy Sonnabend Gallery New York)

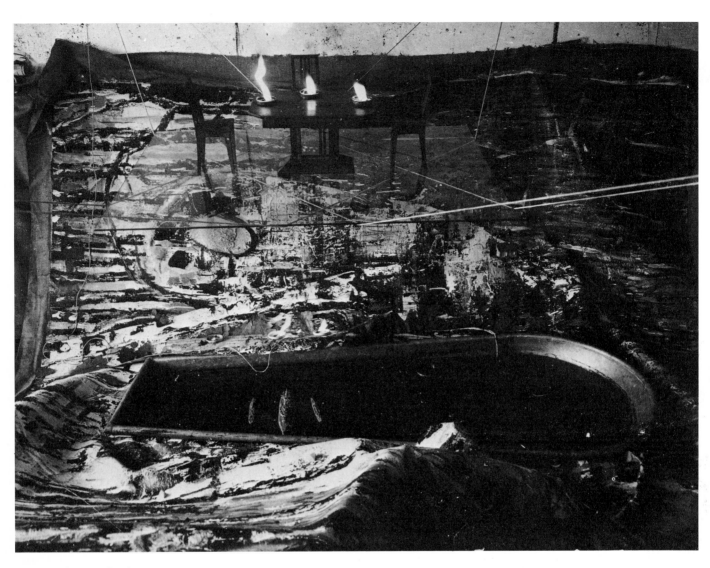

Unternehmen Seelöwe, 1975
(Operation »Sea-Lion«), artist's book, photo-
graphs, double page 62 x 84 cm, The Minnea-
polis Institute of Arts, Gift of Anne Dayton
(Courtesy Marian Goodman Gallery, New York)

Kyffhäuser, 1981

oil paint on photograph, 109 x 76 cm, Chase
Manhattan Bank, N. A. (Courtesy Marian Good-
man Gallery, New York)

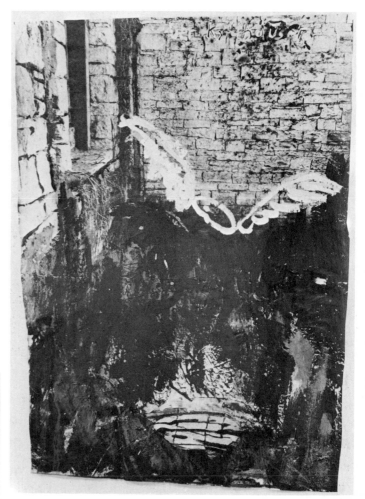

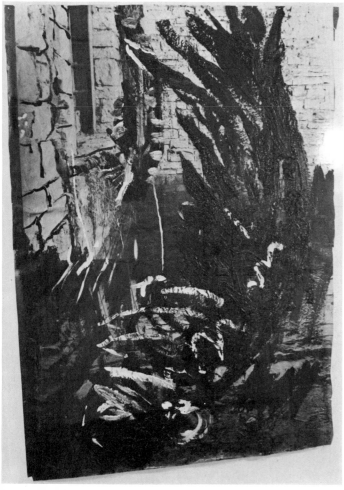

Flügel, 1981

(Wing), oil paint on photograph, 112 x 79 cm,
Jerry und Emily Spiegel New York (Courtesy
Marian Goodman Gallery, New York)

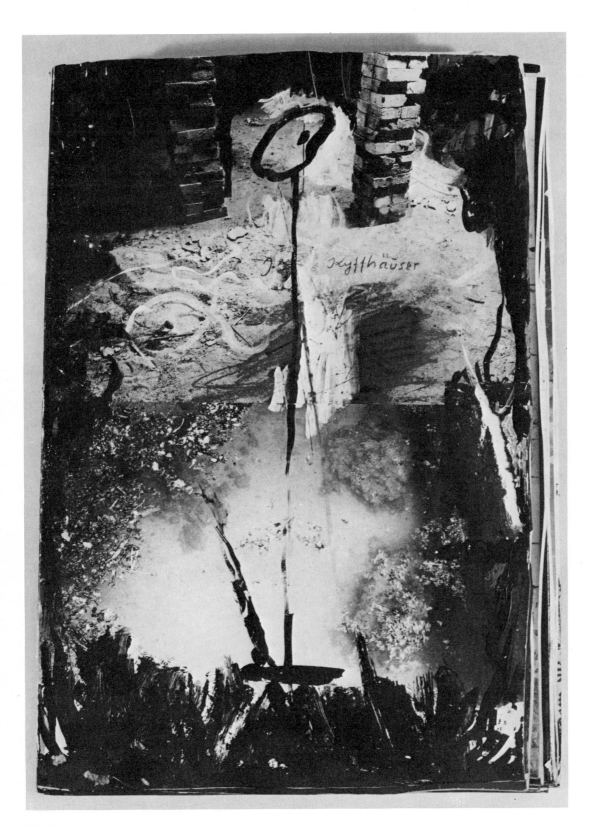

Kyffhäuser, 1980
artist's book, oil paint on photograph, book
cover, 60 x 43 cm, Francesco Clemente, New York
(Courtesy Marian Goodman Gallery, New York)

List of Exhibitions

One-Man Exhibitions

1969 Galerie am Kaiserplatz, Karlsruhe
1973 Galerie Michael Werner, Cologne
Nothung
Goethe-Institut/Provisorium,
Amsterdam *Der Niebelungen Lied*
1974 Galerie Felix Handschin, Basel
Alarichs Grab
Galerie t'Venster / Rotterdam Arts
Foundation, Rotterdam *Heliogabal*
Galerie Michael Werner, Cologne
Malerei der verbrannten Erde
1975 Galerie Michael Werner, Cologne
Unternehmen Seelöwe
1976 Galerie Michael Werner, Cologne
Siegfried vergisst Brünhilde
1977 Bonner Kunstverein, Bonn *Retrospektive*
Galerie Helen van der Meij, Amsterdam *Heroische Sinnbilder*
Galerie Michael Werner, Cologne *Ritt
an die Weichsel*
1978 Galerie Maier-Hahn, Düsseldorf
Wege der Weltweisheit – Hermannsschlacht
Kunsthalle Bern (paintings and
books)
Galerie Michael Werner, Cologne
Die Donauquelle
1979 Stedelijk Van Abbemuseum, Eindhoven
Galerie Helen van der Meij, Amsterdam (books)
1980 Mannheimer Kunstverein, Mannheim *Bilderstreit*
Württembergischer Kunstverein,
Stuttgart
Groninger Museum, Groningen
(woodcuts and books)
Galerie Helen van der Meij,
Amsterdam
Galerie Friedrich und Knust, Munich
(paintings and drawings)
Stedelijk Van Abbemuseum, Eindhoven
1981 Galerie Paul Maenz, Cologne *Urd,
Werdandi, Skuld*
Kunstverein Freiburg, Freiburg
(Watercolors 1970-1980)
Museum Folkwang, Essen and
Whitechapel Art Gallery London
Margarete-Sulamith
Marian Goodman Gallery, New York
Galleria Salvatore Ala, Milan
Galerie Friedrich und Knust, Munich
(books)
1982 Mary Boone Gallery, New York
Galerie Paul Maenz, Cologne

Group Exhibitions

1969 »Klasse Antes«, Galerie »Zelle«,
Reutlingen
»Deutscher Künstlerbund 17. Ausstellung«, Hannover
1970 »Klasse Antes in Ravensburg«, Galerie Altes Theater, Ravensburg
Deutscher Künstlerbund, Bonn
»100 Artistes dans la Ville«, Montpellier
1973 »14 mal 14« Staatliche Kunsthalle,
Baden-Baden
1973 »Bilanz einer Aktivität«, Goethe-
74 Institut/Provisorium, Amsterdam
1976 »Beuys und seine Schüler«, Frankfurter Kunstverein, Frankfurt
»Zeichnungen – Tekeningen«, Galerie Seriaal, Amsterdam
1977 »Peiling af Tysk Kunst: 21 kunstnere
fra Tyskland«, Louisiana Museum,
Humlebaek
documenta 6, Kassel
10e Biennale de Paris, Musée d'art
moderne de la ville de Paris
1978 The Book of the Art of Artist's Books,
Teheran Museum of Contemporary
Art, Teheran
1979 »Malerei auf Papier«, Badischer
Kunstverein, Karlsruhe
1980 La Biennale di Venezia, Venice
»Les nouveaux fauves, die neuen
Wilden«, Neue Galerie – Sammlung
Ludwig, Aachen
1981 »A New Spirit in Painting«, Royal
Academy of Arts, London
»Art d'allemagne aujourd'hui«,
ARC/Musée d'art moderne de la ville
de Paris
»Schilderkunst in Duitsland 1981«,
Vereniging voor Tentoonstellingen
van het Paleis voor Schone Kunsten
te Brussel, Brussels
»Westkunst – Zeitgenössische Kunst
seit 1939«, Cologne
»Tendenzen der modernen Kunst.
Sammlung Ingrid und Hugo Jung«,
Suermondt-Ludwig-Museum und
Museumsverein, Aachen
»Après le classicisme«, Musée d'art et
d'Industrie et Maison de la Culture,
Saint-Etienne
»Schnabel/Kiefer«, Boymans van
Beuningen Museum, Rotterdam
1982 documenta 7, Kassel
»Zeitgeist«, Martin-Gropius-Bau,
Berlin
»60/80: Attitudes, Concepts,

Images«, Stedelijk Museum,
Amsterdam
»Mythe, drame, tragédie«, Musée
d'art et d'Industrie et Maison de la
Culture, Saint-Etienne
»Vergangenheit, Gegenwart, Zukunft: zeitgenössische Kunst und Architektur«, Württembergischer
Kunstverein, Stuttgart
»Avanguardia transavanguardia«,
Mura Aureliane da Porta Metronia a
Porta Latina, Rome
»De la catastrophe«, Centre d'art
Contemporain, Geneva
»New Figuration from Europe«, Milwaukee Art Museum
»La nuova pittura tedesca«, Studio
Marconi, Milan
Roger Ramsay Gallery, Chicago
(works on paper)
Galerie Christian Stein, Turin
Rosa Esman Gallery, New York
Galerie Paul Maenz, Cologne
1983 »New Figuration. Contemporary Art
from Germany«, Frederick S. Wight
Art Gallery, University of California,
Los Angeles
»EXPRESSIONS: New Art from Germany«, The Saint Louis Art Museum

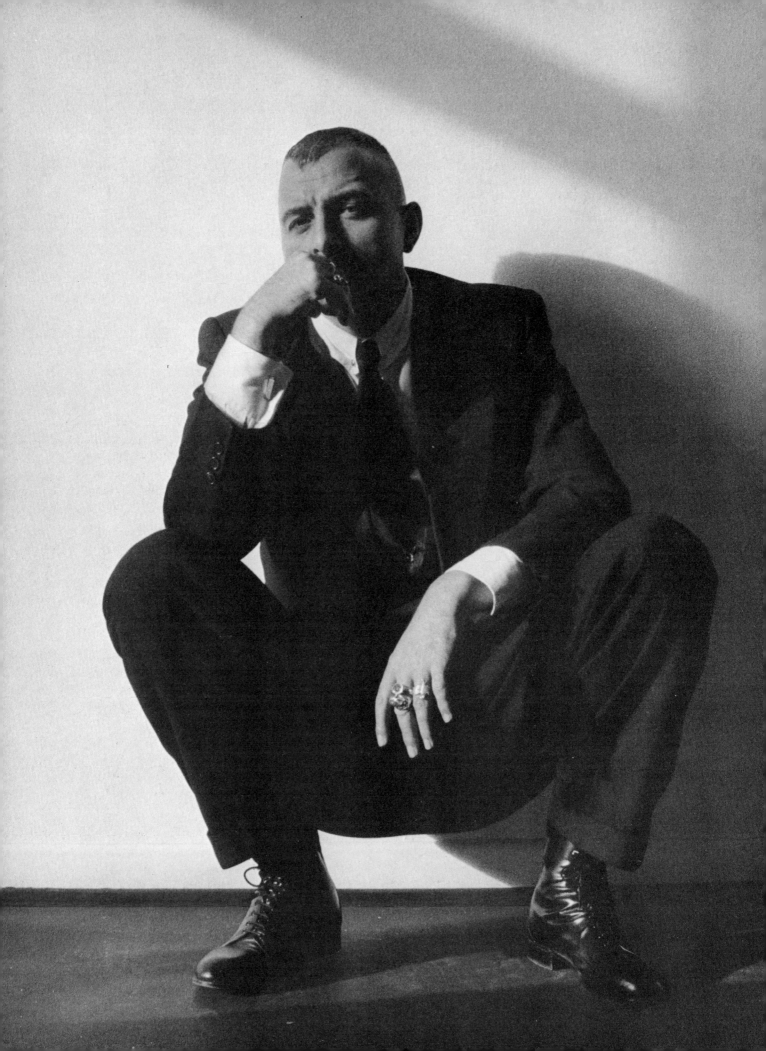

Markus Lüpertz

Biography

1941	Born April 25, in Liberec, Bohemia (now Czechoslovakia)
1948	Flees with his familiy from Bohemia to the Rhineland
1956-61	Begins studies at the Werkkunstschule, Krefeld with Laurens Goosens. Study-visit to Maria Laach monastery, where he begins a series of Crucifixion paintings. Works for one year in Hibernia coal mine. Further studies in Krefeld and at the Kunstakademie, Düsseldorf. Works on a road-building crew.
1961	Becomes an independent artist.
1962-66	Hochschule für Bildende Künste, Berlin
1963	Settles in Berlin. Founds *Dithyrambe im 20. Jahrhundert*
1964	Founds Galerie Grossgörschen 35, an artists' cooperative, West Berlin
1966	Manifesto of the Dithyramb: »The grace of the twentieth century will be made visible by the Dithyramb founded by myself«.
1970	Villa Romana prize, one year stay in Florence
1971	German art critics prize (Deutscher Kritikerverband)
1974	Guest lecturer Staatliche Akademie der Bildenden Künste, Karlsruhe
1976	named Professor, Karlsruhe Lives and works in Karlsruhe and West Berlin

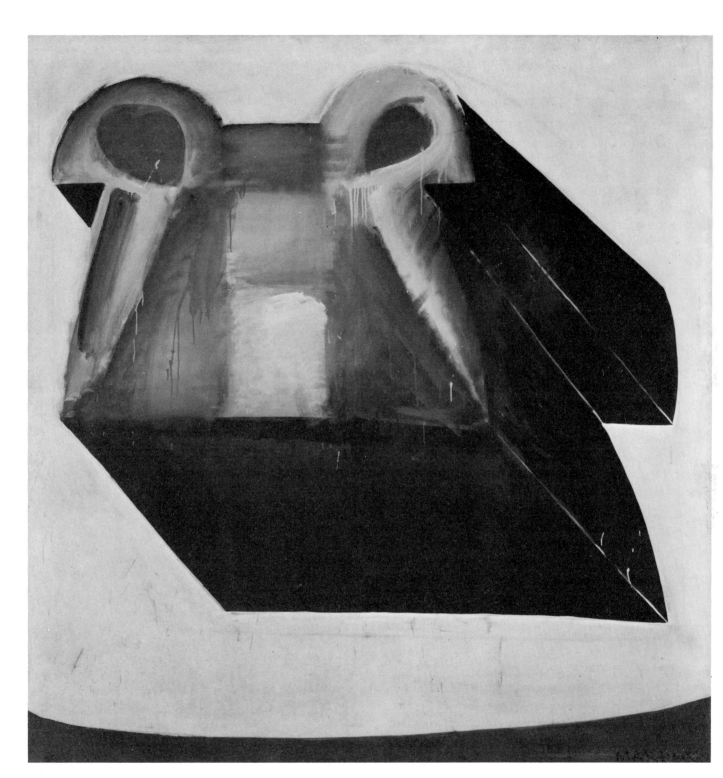

Dithyrambe schwebend, 1964
(Hovering Dithyramb), distemper on canvas,
200 x 195 cm

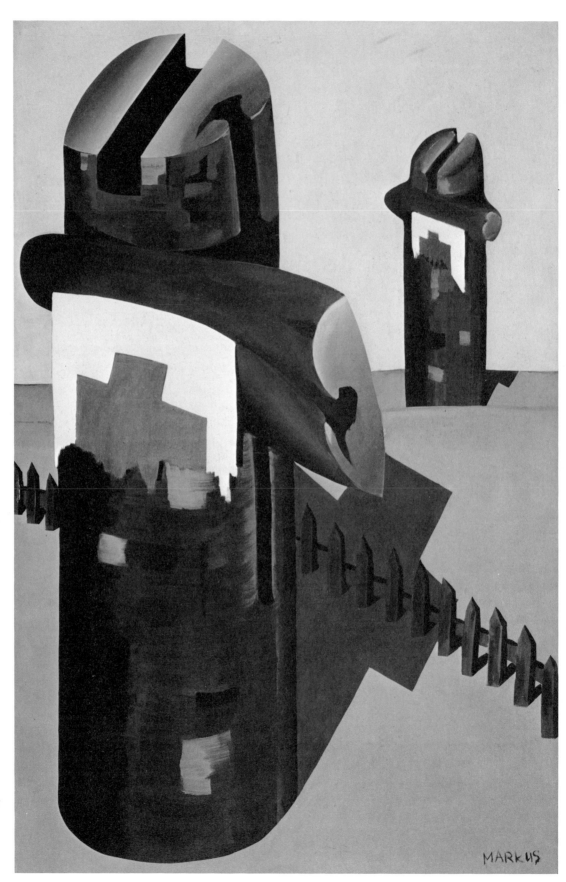

Rote Kreuze –
dithyrambisch, 1967
(Red Crosses –
Dithyrambic),
distemper on canvas,
303 x 198 cm

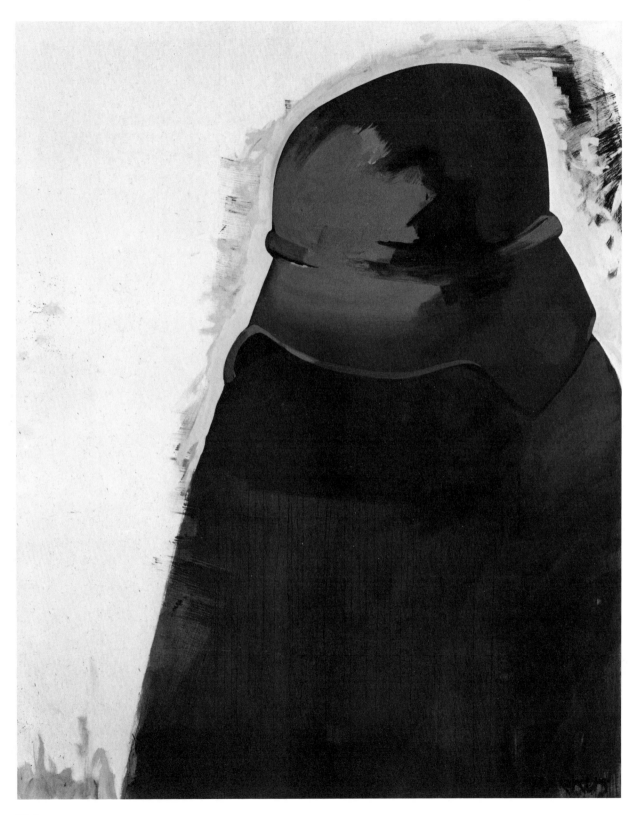

Helm IV, 1970
(Helmet IV), distemper on canvas, 235 x 190 cm

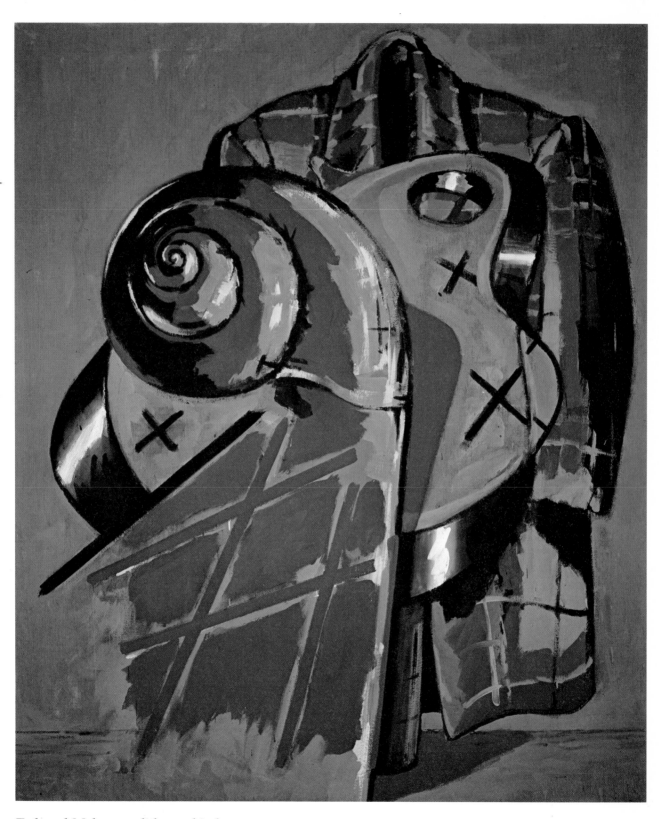

Tod und Maler II – dithyrambisch, 1973
(Death and Painter II – Dithyrambic), distemper
on canvas, 214 x 180 cm

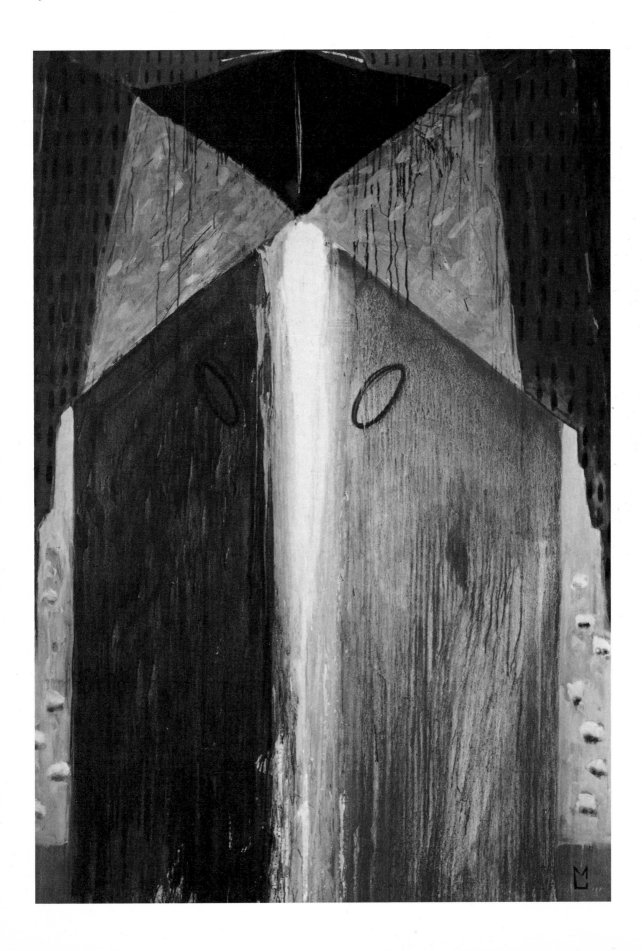

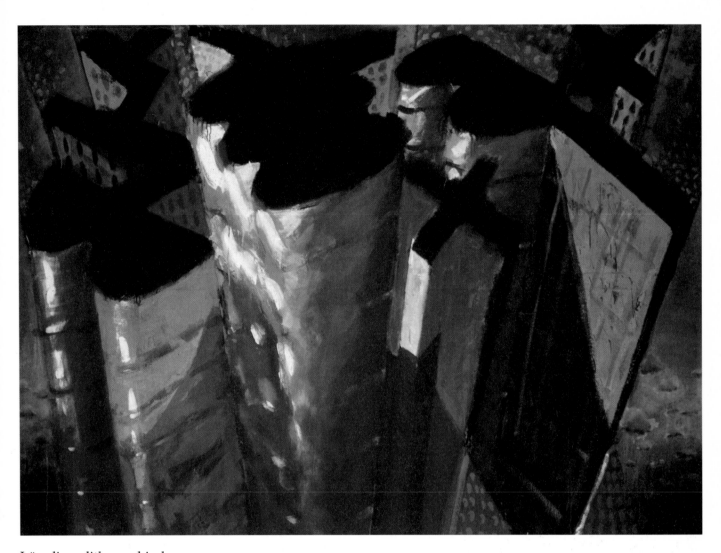

Lüpolis – dithyrambisch, 1975
(Lüpolis – Dithyrambic), mixed media on
canvas, 183 x 250 cm

LEFT: Stilmalerei – Schiff, 1977
(Style Painting – Ship), oil and distemper on
canvas, 247 x 173 cm, Collection Crex, Zürich

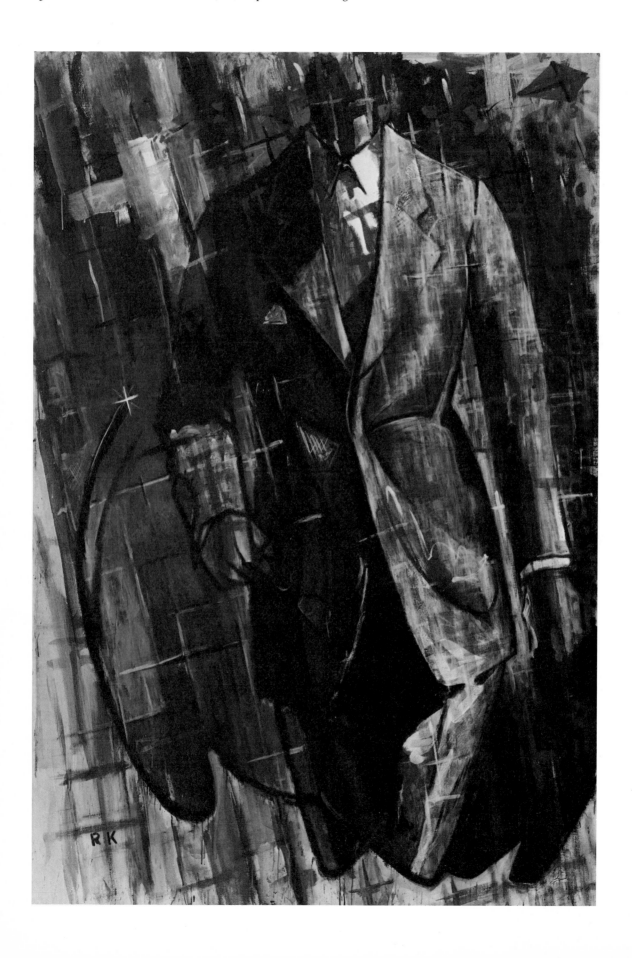

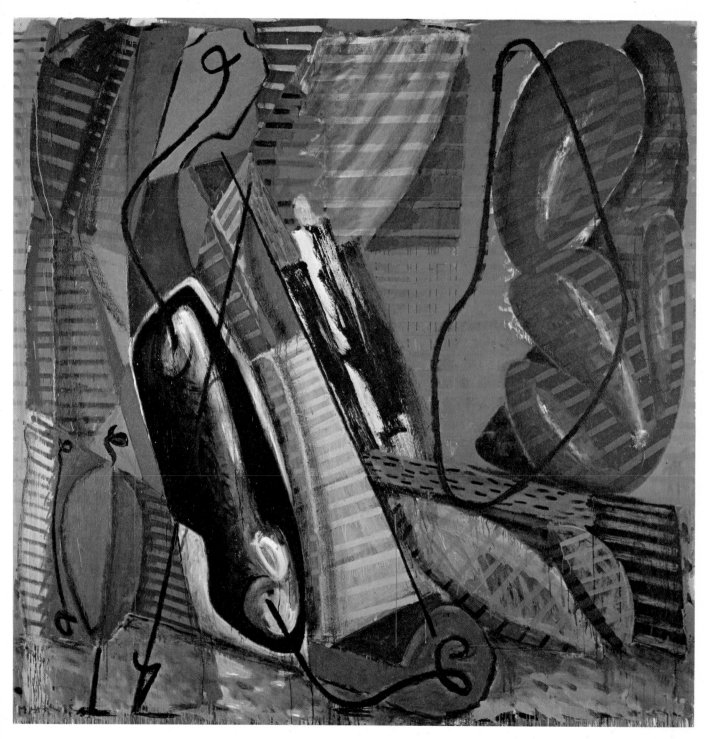

Amor und Psyche I, 1978/79
(Cupid and Psyche I), mixed media on canvas,
285 x 285 cm, Courtesy Waddington Galleries,
London

LEFT: Mann im Anzug – dithyrambisch, 1976
(Man in a Suit – Dithyrambic), distemper on canvas,
240 x 186 cm, Gillespie/Laage/Salomon, Paris

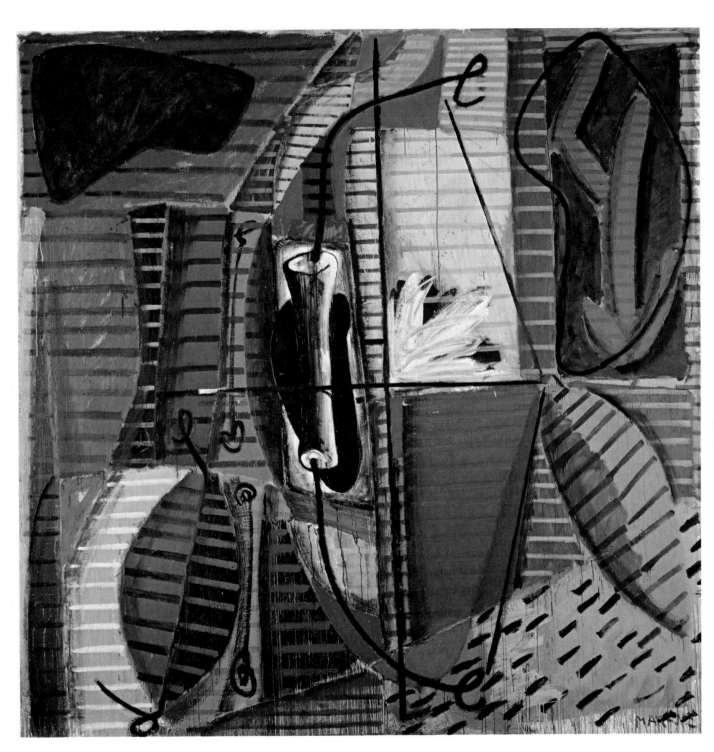

Amor und Psyche II, 1978/79
(Cupid and Psyche II), mixed media on canvas,
285 x 285 cm, Courtesy Waddington Galleries,
London

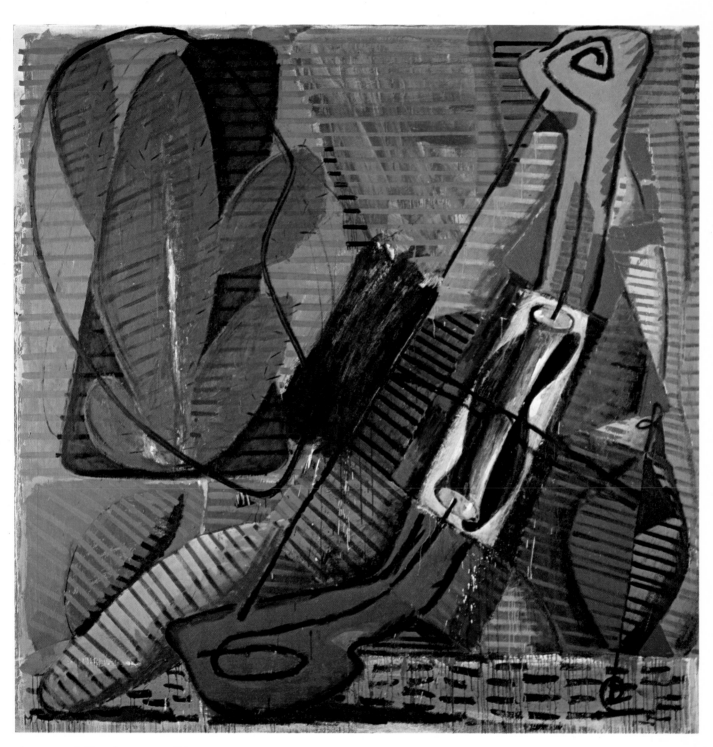

Amor und Psyche III, 1978/79
(Cupid and Psyche III), mixed media on canvas,
285 x 285 cm, Courtesy Waddington Galleries,
London

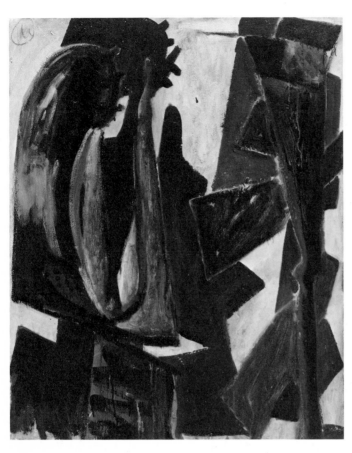

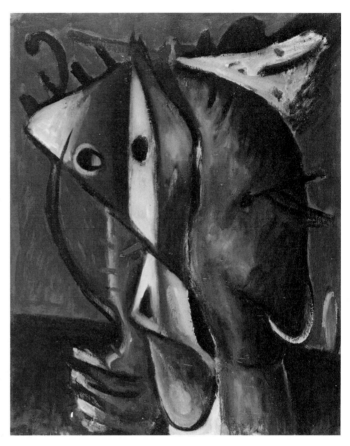

Alice in Wonderland: »Ob Katzen eigentlich
Fledermäuse fressen?«, 1980/81

(»Whether cats actually eat bats?«), oil on canvas,
100 x 81 cm, Private Collection, Brussels

Alice in Wonderland: »Die falsche Suppen-
schildkröte gab . . .«, 1980/81

(»The mock soup-turtle gave . . .«), oil on canvas,
100 x 81 cm, Private Collection, Brussels

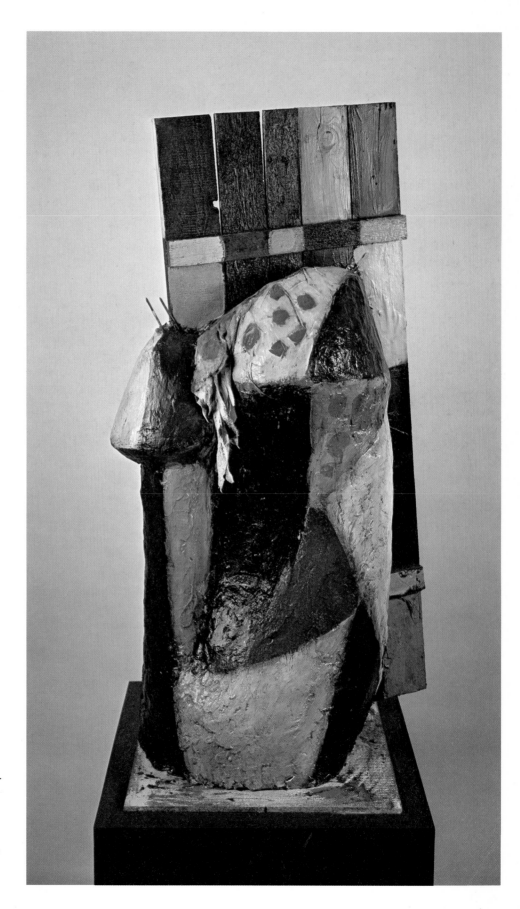

Alice in Wonderland: »Ob Kat-
zen eigentlich Fledermäuse
fressen?«, 1981
(»Whether cats actually eat bats?«),
painted plaster, wood, paper, cloth
and iron, 124 x 65 x 42 cm, Marian
Goodman Gallery, New York

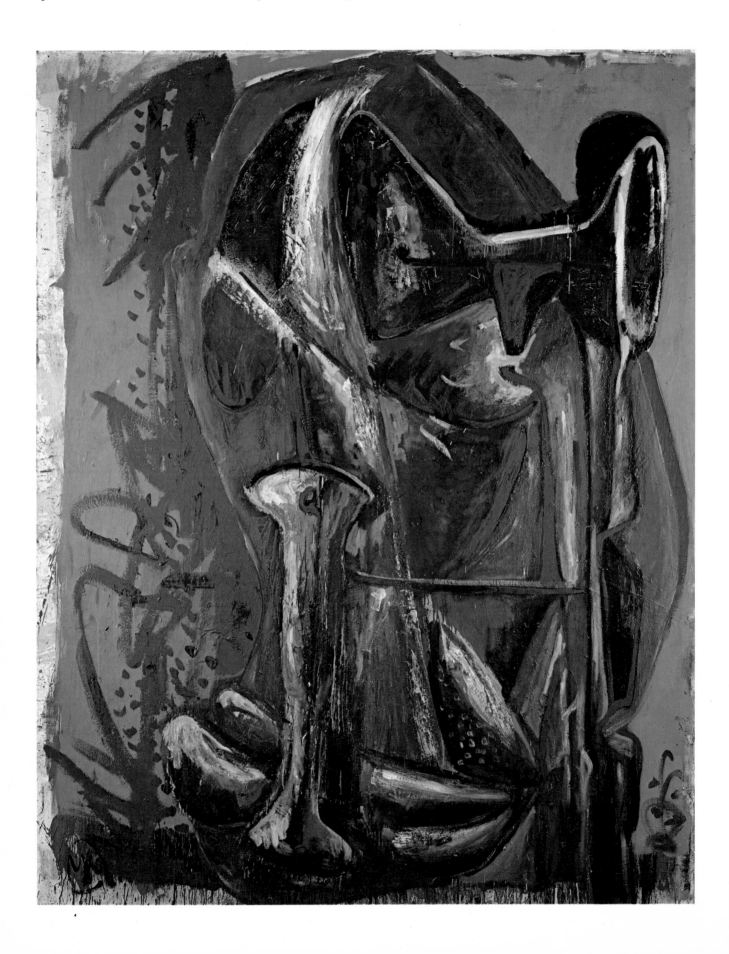

8 Bilder über Orpheus / Irrlichter, 1982
(8 Paintings about Orpheus / Disorienting
Flickering Lights), oil on canvas, 200 x 162 cm,
Private Collection (Courtesy Marian Goodman
Gallery, New York)

LEFT: 5 Bilder über Faschismus / Haus der
Kunst, 1980
(5 Paintings about Fascism / Haus der Kunst),
oil on canvas, 254 x 203 cm

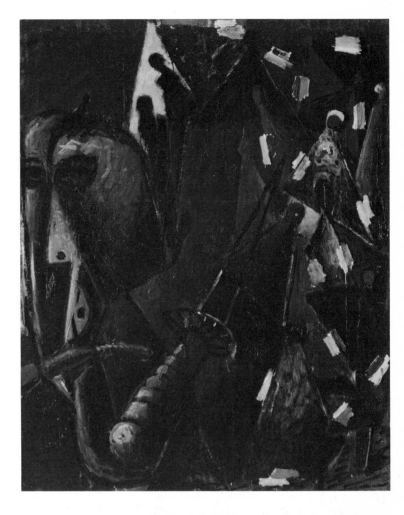

Der Triumph, 1980
oil on canvas, 280 x 560 cm

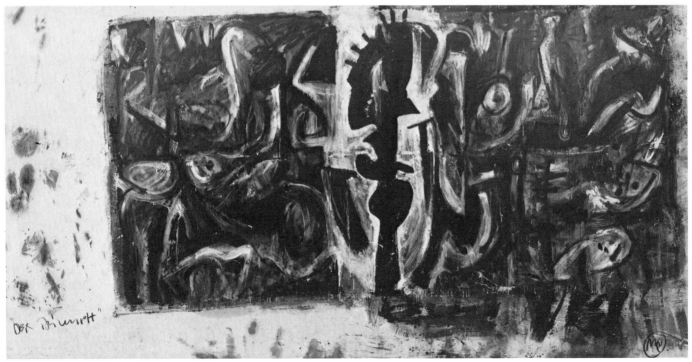

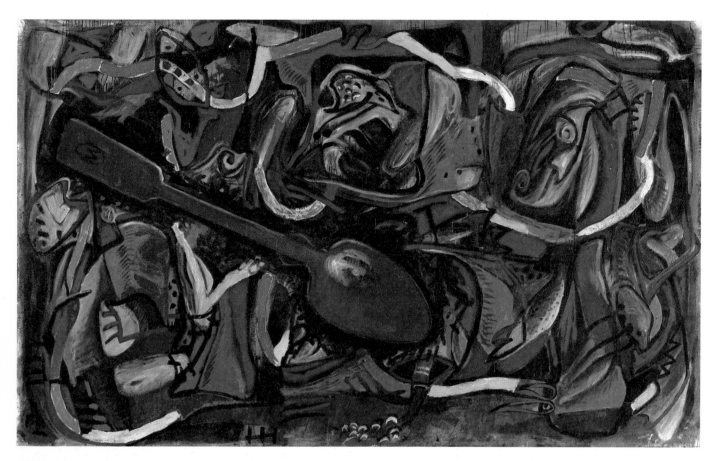

Der grosse Löffel, 1982
(The Large Spoon), oil on canvas, 200 x 300 cm

RIGHT: 8 Bilder über Orpheus / Orpheus
in der Unterwelt, 1982
(8 Paintings About Orpheus / Orpheus in Hell),
wood, sheet metal and oil on canvas,
200 x 162 cm, Courtesy Marian Goodman
Gallery, New York

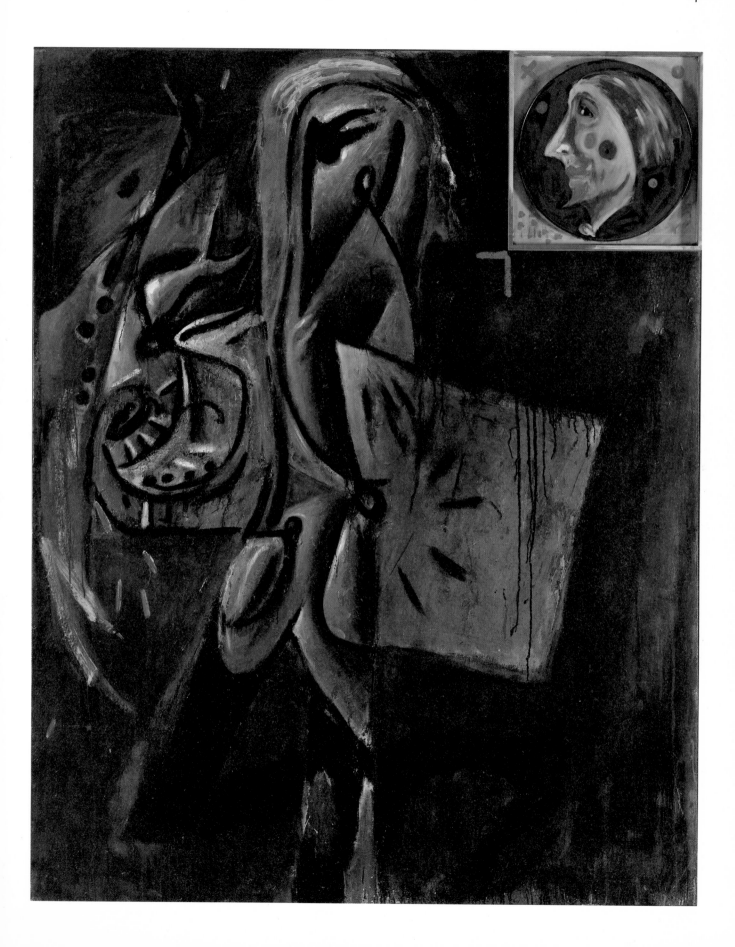

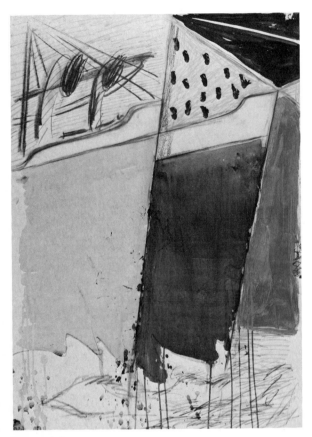

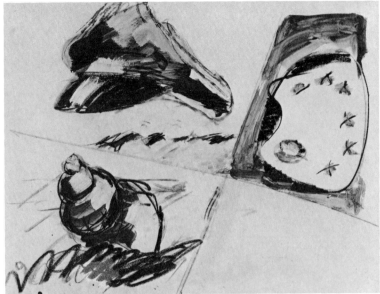

Zu »Arrangement für eine Mütze – dithyrambisch«, 1973
(From »Arrangement for a Cap – Dithyrambic«),
watercolor, chalk and charcoal on paper, 60 x 80 cm

LEFT: Zu »Stilmalerei – Schiff«, 1977
(From »Style Painting – Ship«), watercolor,
chalk and charcoal on paper, 85 x 60 cm

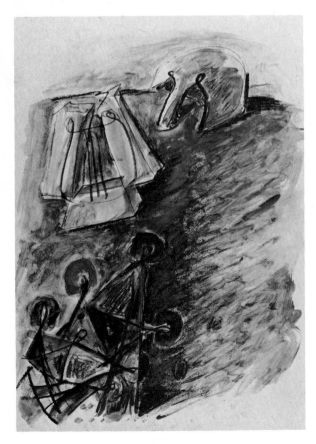

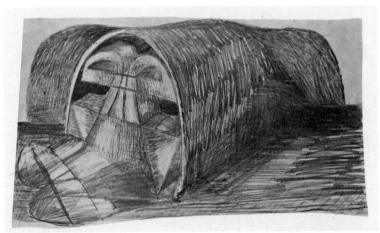

Dithyrambe, 1964
chalk and pencil on paper, ca. 38 x 67 cm

LEFT: Zu »Über Orpheus«, 1982
(From »About Orpheus«), watercolor and chalk
on paper, 70 x 50 cm

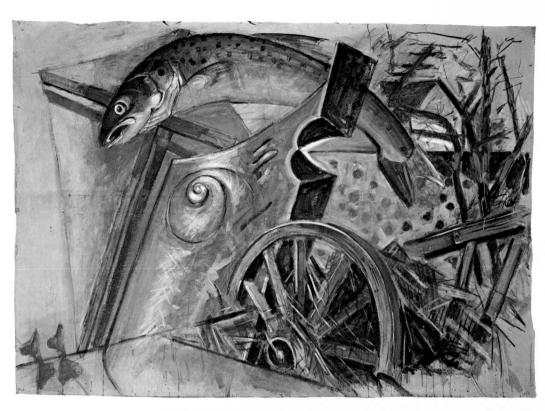

TOP: Legende – dithyrambisch, 1975
(Legend – Dithyrambic), mixed media, gouache on paper, 190 x 275 cm, Stadt Aachen, Neue Galerie – Sammlung Ludwig

BOTTOM RIGHT: Schwarz-Rot-Gold – dithyrambisch, 1974
(Black-Red-Gold – Dithyrambic), pastel on papers, 260 x 200 cm, Hamburger Kunsthalle, Hamburg

BOTTOM LEFT: Untitled, 1975
mixed media on paper, 85.5 x 61 cm, Collection Altenburg, Cologne

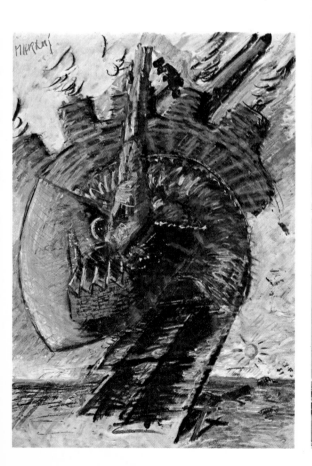

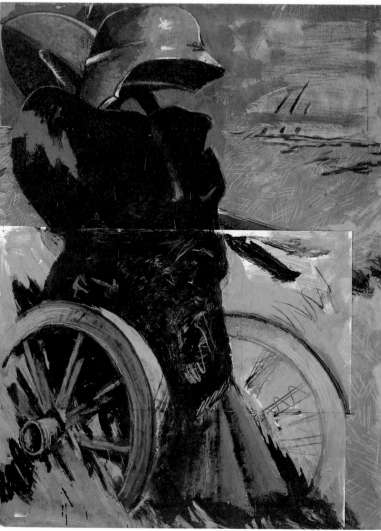

List of Exhibitions

One-Man Exhibitions

1964 Galerie Grossgörschen 35, Berlin
1966 Galerie Grossgörschen 35, Berlin
Galerie Potsdamer, Berlin
1968 Galerie Rudolph Springer, Berlin
Galerie Michael Werner, Berlin
Galerie Hake, Cologne
1969 Galerie Gerda Bassenge, Berlin
Galerie Benjamin Katz, Maison de France, Berlin
Galerie Hake, Cologne
1972 Galerie Der Spiegel, Cologne
1973 Staatliche Kunsthalle, Baden-Baden
Goethe-Institut/Provisorium, Amsterdam
1974 Galerie Michael Werner, Cologne
1975 Galerie Michael Werner, Cologne
Galerie Rudolph Zwirner, Cologne
Galerie Hans Neuendorf, Hamburg
1976 Galerie Michael Werner, Cologne
Galerie Rudolph Zwirner, Cologne
Galerie Seriaal, Amsterdam
1977 Hamburger Kunsthalle, Hamburg (drawings)
Kunsthalle Bern (*Dithyrambische* and *Stil* paintings)
Stedelijk Van Abbemuseum, Eindhoven
Galerie Hans Neuendorf, Hamburg
Galerie Michael Werner, Cologne
1978 Galerie Michael Werner, Cologne
Galerie Heiner Friedrich, Munich
Kunstmarkt, Bologna
Galerie Helen van der Meij, Amsterdam
Galerie Gillespie/Laage, Paris
1979 Whitechapel Art Gallery, London (*Stil* paintings, 1977-79)
Gallery Barry Barker, London
1979/ Josef-Haubrich Kunsthalle,
80 Cologne
1980 Galerie Michael Werner, Cologne
Galerie Helen van der Meij, Amsterdam
Galerie Rudolph Springer, Berlin
Stober, Berlin (lithographs)
1981 Kunstverein Freiburg (*Wieder in Gedanken*)
Galerie Rijs, Oslo
Galerie Michael Werner, Cologne
Galerie Rudolph Springer, Berlin
Marian Goodman Gallery, New York
Waddington Galleries, New York
Galerie Fred Jahn, Munich
1982 Galerie Rudolph Springer, Berlin
Onnasch Galerie, Berlin
(*Grüne Bilder*)

Marian Goodman Gallery, New York
Galerie Michael Werner, Cologne
(*Acht Plastiken*)
Galerie Gillespie/Laage/Salomon, Paris
Galerie Fred Jahn, Munich
1983 Stedelijk Van Abbemuseum, Eindhoven
Musée d'art moderne, Strasbourg

Group Exhibitions

1965 »Retrospective 1964-65«, Galerie Grossgörschen 35, Berlin
1966 »Deutscher Künstlerbund 14. Ausstellung«, Gruga Park, Essen
1967 »Jacques Damase présente: Jeunes peintres de Berlin«, Galerie Motte, Geneva/Paris
»Berlin, Berlin – Junge Berliner Maler und Bildhauer«, Zapeion, Athens
1968 »Retrospektive Grossgörschen 35«, Berlin
1969 »Sammlung 1968 – Karl Ströher«, Neue Nationalgalerie, Berlin
»Vierzehn mal Vierzehn: Eskalation«, Staatliche Kunsthalle, Baden-Baden
»It's Grossgörschen 35's Birthday«, Galerie René Block, Berlin
1970 Villa Romana, Florence
1971 »Aktiva 71: Kunst der Jungen in Westdeutschland«, Haus der Kunst, Munich
»Zeichnungen«, Galerie René Block, Berlin
»20 Deutsche«, Onnasch-Galerie, Berlin, Cologne
1972 »Berlin Scene 1972. Work by 17 Artists Living in Berlin«, Gallery House, London
1972/ »Zeichnungen 2«, Städtisches
73 Museum / Schloss Morsbroich, Leverkusen
1973 »PROSPECT 73 – Maler/Painters/ Peintres«, Städtische Kunsthalle, Düsseldorf
»8e Biennale de Paris«, Musée d'art moderne de la ville de Paris, Paris
1973/ »Bilanz einer Aktivität«, Goethe-
74 Institut/Provisorium, Amsterdam
1974 »Erste Biennale Berlin« (organized by Lüpertz)
1975 »Primeira Bienal Berlin 1974«, Museu de arte, Rio de Janeiro
1976 »Zeitgenössische Kunst aus der Sammlung des Stedelijk Van Abbemuseum Eindhoven«, Kunsthalle Bern
»Zeichnungen – Tekeningen«, Galerie Seriaal, Amsterdam
1977 documenta 6 (withdrawal of works with Baselitz as a protest against the presentation of works in the paintings section)
»Zum Beispiel Villa Romana, Florenz – Zur Kunstforderung in Deutschland I«, Staatliche Kunsthalle, Baden-Baden and Palazzo Strozzi, Florence

1978 »13° East – Eleven Artists Working in Berlin«, Whitechapel Art Gallery, London
»Werke aus der Sammlung Crex, Zurich«, InK, Zurich, Humlebaek, Munich and Eindhoven
»Kunst des 20. Jahrhunderts aus Berliner Privatbesitz«, Akademie der Künste, Berlin

1979 »Malerei auf Papier«, Badischer Kunstverein, Karlsruhe
»Staatliche Akademie der Bildenden Künste Karlsruhe, zum 125jährigen Bestehen«, Karlsruhe
»Figuration«, Galerie Schurr, Stuttgart
Galerie Gillespie/Laage/Salomon, Paris

1980 La Biennale di Venezia, Venice (withdrew)
»Der gekrümmte Horizont: Kunst in Berlin 1945-1967«, Akademie der Künste, Berlin
»Les nouveaux fauves, die neuen Wilden«, Neue Galerie – Sammlung Ludwig, Aachen
»Zeichen des Glaubens, Geist der Avantgarde: religiöse Tendenzen in der Kunst des 20. Jahrhunderts«, Schloss Charlottenburg, Grosse Orangerie, Berlin

1980/ 81 »Après le classicisme«, Musée d'Art et d'Industrie et Maison de la Culture, Saint-Etienne

1981 »Die Professoren der Staatlichen Akademien der Bildenden Künste Karlsruhe und Stuttgart«, Staatliche Kunsthalle, Baden-Baden
»Schilderkunst in Duitsland 1981, peinture en Allemagne 1981«, Vereniging voor Tentoonstellingen van het Paleis voor Schone Kunsten te Brussel, Brussels
»A New Spirit in Painting«, Royal Academy of Arts, London
»Tendenzen der modernen Kunst – Sammlung Ingrid und Hugo Jung«, Suermondt-Ludwig-Museum und Museumsverein, Aachen
»Art d'Allemagne aujourd'hui«, ARC/Musée d'art moderne de la ville de Paris
»Der Hund stösst im Laufe der Woche zu mir«, Moderna Museet, Stockholm

»Die Professoren der Staatlichen Akademien der Bildenden Künste Karlsruhe und Stuttgart«, Staatliche Kunsthalle, Baden-Baden
Galerie Gillespie/Laage/Salomon, Paris

1982 documenta 7, Kassel
»Mythe, drame, tragèdie«, Musée d'Art et d'Industrie et Maison de la Culture, Saint-Etienne
»Avanguardia transavanguardia«, Mura Aureliane da Porta Metronia a Porta Latina, Rome
»La Transavanguardia Tedesca«, Galleria Nazionale d'arte moderna, San Marino
»Zeitgeist«, Martin-Gropius-Bau, Berlin
»Pressure to Paint«, Marlborough Gallery, New York
»9. Internationale Triennale für farbige Originalgraphik«, Haldenschulhaus, Grenchen
»German Drawings of the 60's«, Yale University Art Gallery, New Haven Connecticut
»Berlin – la rage de peindre«, Musée cantonal des Beaux-Arts, Lausanne
»La nuova pittura tedesca«, Studio Marconi, Milan
»4th Biennale of Sydney: Vision in Disbelief«, Sydney
Annemarie Verna, Zurich
»Painting: American/European«, L. A. Louver, Venice, California
Marian Goodman Gallery, New York
»Erste Konzentration«, Galerie Friedrich und Knust, Munich
»Kölner Herbstsalon 1982«, Josef-Haubrich-Kunsthalle, Cologne
Waddington Galleries, London

1983 »New Figuration. Contemporary Art from Germany«, Frederick S. Wight Art Galleries, University of California, Los Angeles
»Mensch und Landschaft in der zeitgenössischen Malerei und Graphik der Bundesrepublik Deutschland«, Moscow and Leningrad
Galerie Rolf Ricke, Cologne (sculpture)
»EXPRESSIONS: New Art from Germany«, The Saint Louis Art Museum

A. R. Penck

Biography

1939 Born, Ralf Winkler, October 5, in Dresden (now in East Germany)

1974 International Triennale Prize, Switzerland

1976 Will Grohmann Prize

1977 Meets Jörg Immendorff in East Berlin

1980 Emigrates from East Berlin to Cologne
Winkler is a self-taught artist who has referred to himself as »A. R. Penck«, »T. M.« (Tancred Mitchell or Theodor Marx) »Alpha« and »Y«(psilon). The pseudonym »Penck« is from the 19th-century scientist Albrecht Penck who studied the geomorphology of the glacial epoch
Lives and works in Schloss Lörsfeld, near Cologne

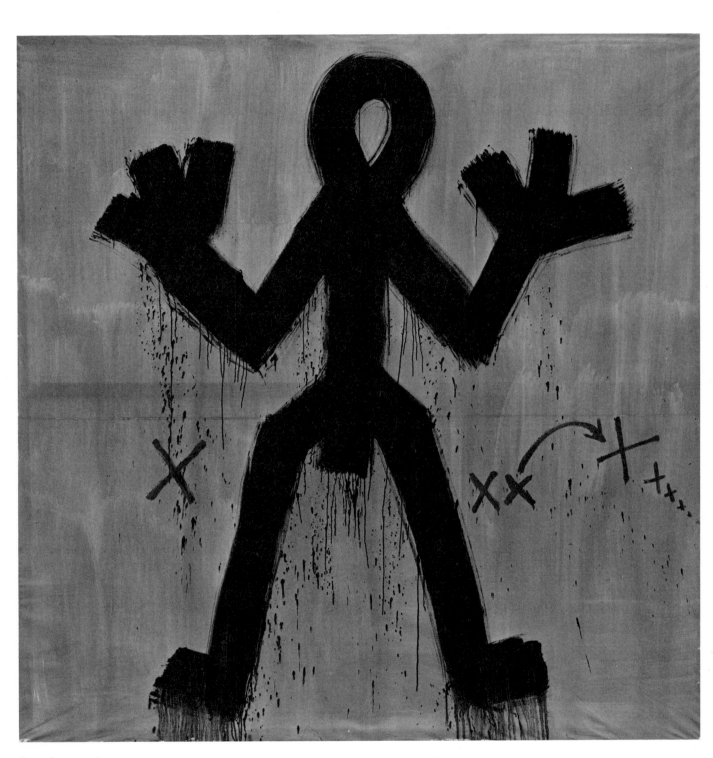

Standart, 1969
acrylic on canvas, 285 x 285 cm, Private
Collection

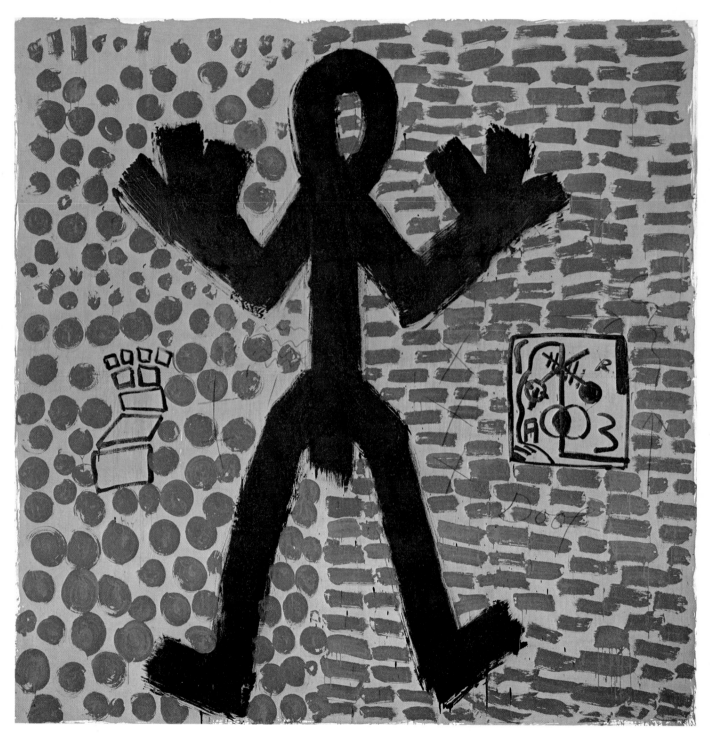

Standart, 1971
acrylic on canvas, 285 x 285 cm

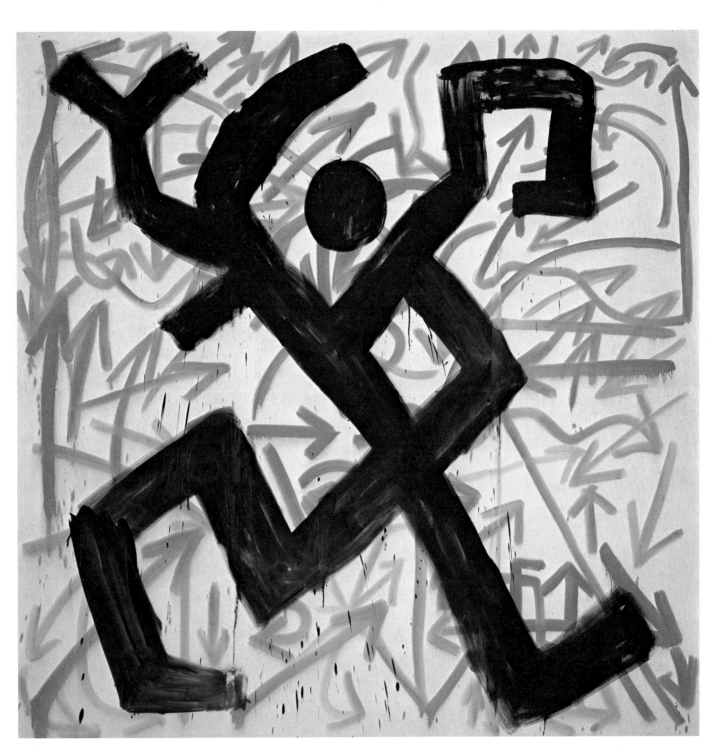

Untitled, ca. 1970/74
synthetic resin on canvas, 285 x 285 cm

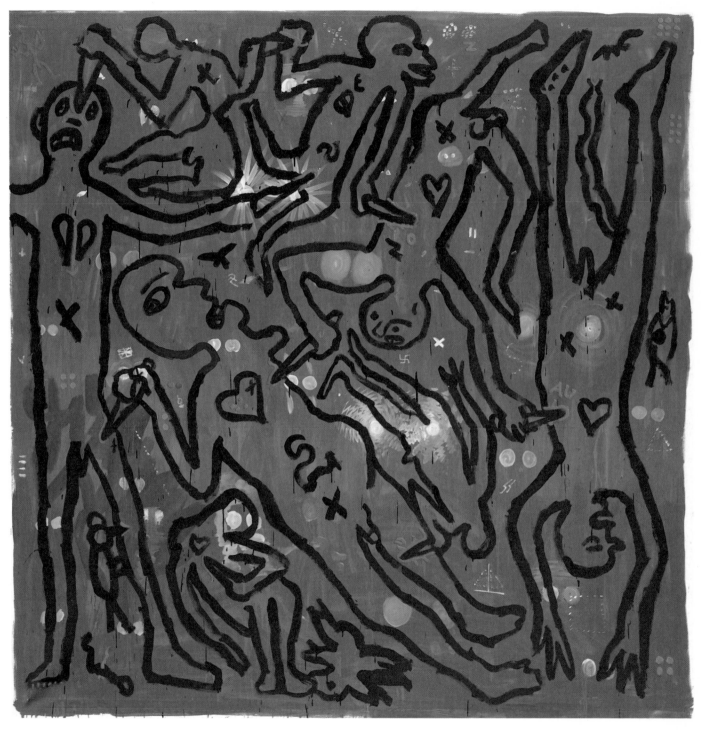

Untitled, ca. 1973

synthetic resin on canvas, 285 x 285 cm, Marl-
borough Gallery, New York

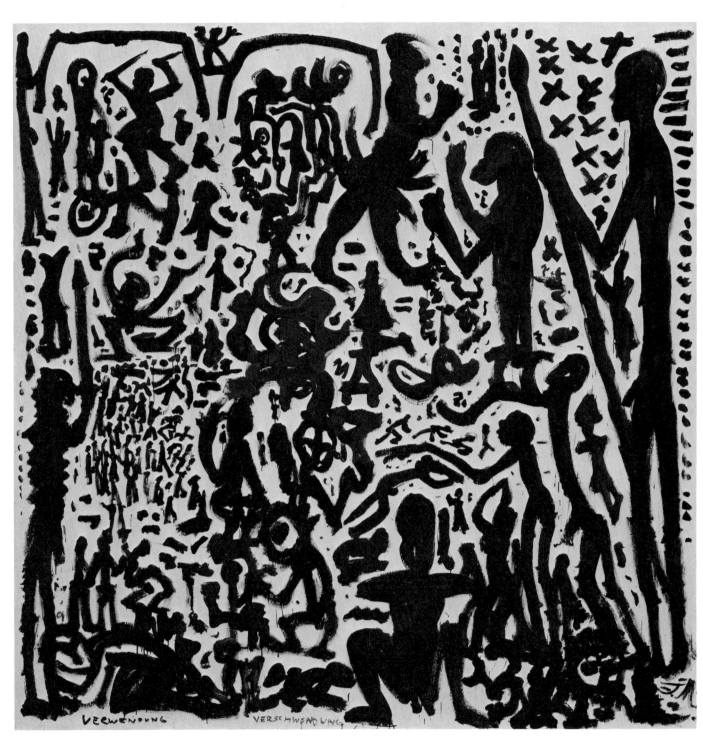

Verwendung – Verschwendung, 1974
(Making Use – Squandering), synthetic resin on
canvas, 285 x 285 cm, Private Collection,
Cologne

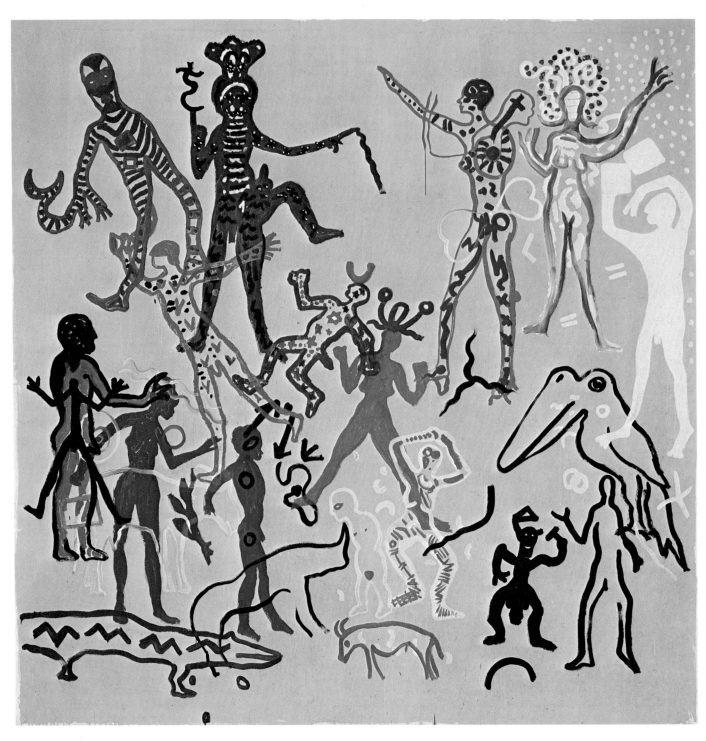

Untitled (Fest), 1974
(Festival), oil on canvas,
285 x 285 cm, Ingrid and Hugo Jung,
Aachen

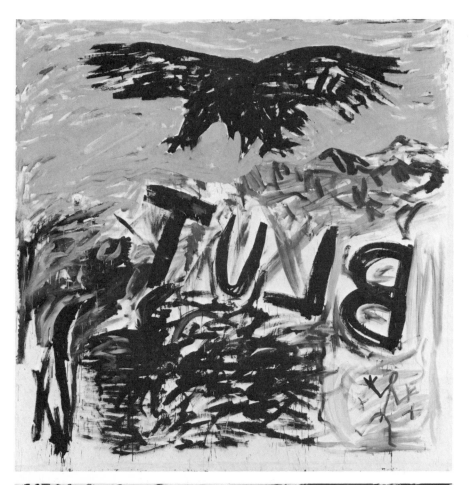

Blut, 1976
(»TUJ8«: Blood), acrylic on cloth,
285 x 285 cm, Private Collection, Cologne

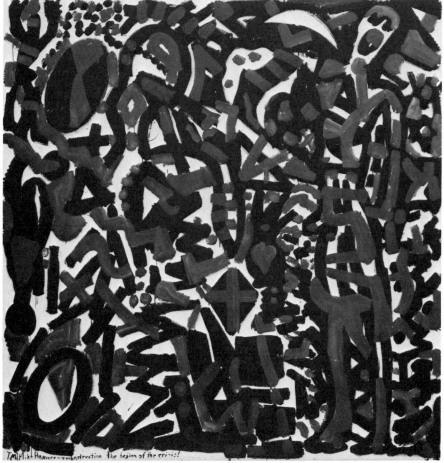

T. M. Mike Hammer – reconstruction
the beginn of the crisis!, 1974
synthetic resin on canvas, 285 x 285 cm

Geburtstagsfeier, 1977
(Birthday Celebration), acrylic on canvas,
144 x 179 cm, Georg Baselitz, Derneburg

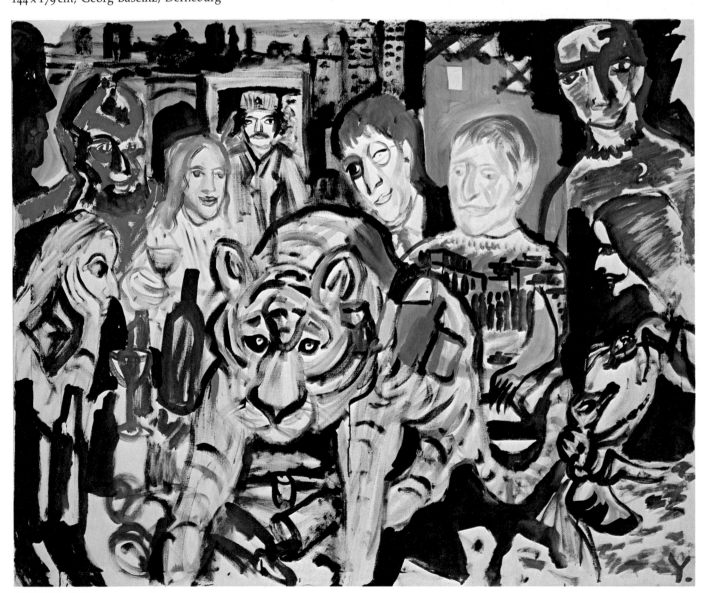

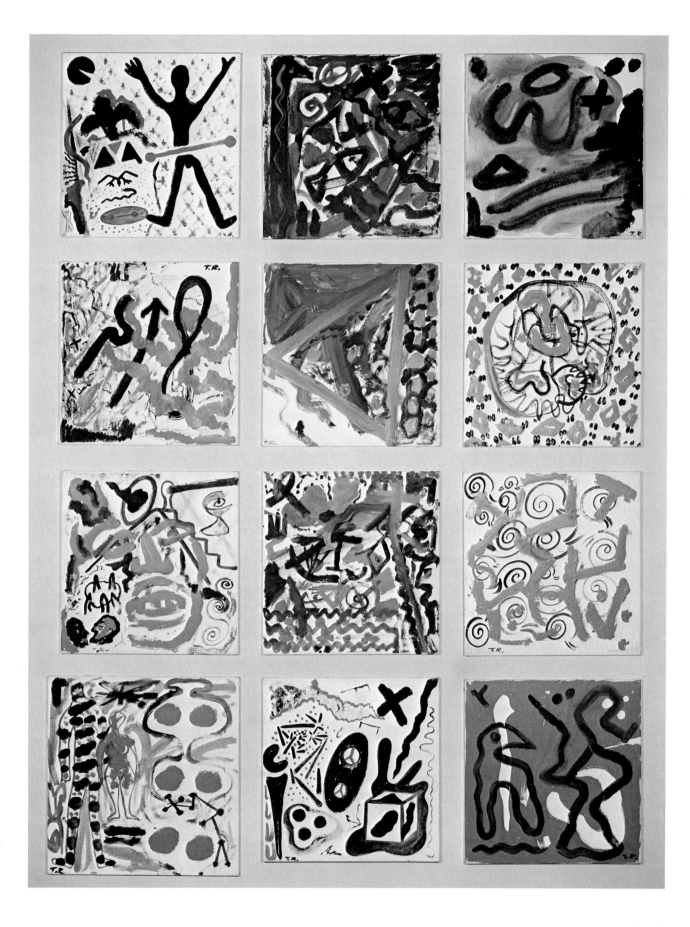

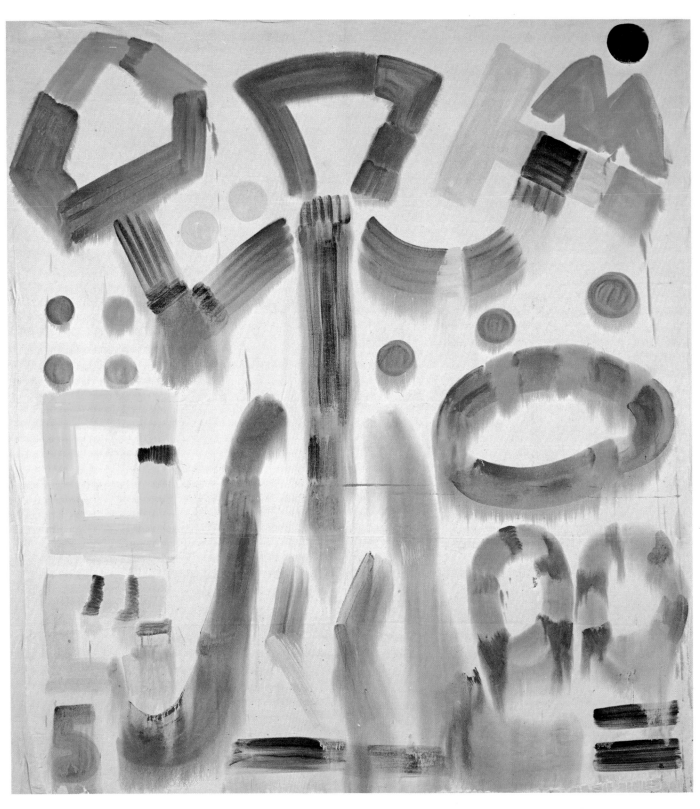

Standart 5, 1980
latex on canvas, 248 x 228 cm, Private Collection,
Geneva (Courtesy Gillespie/Laage/
Salomon, Paris)

LEFT: Untitled (»documenta series«), 1977
acrylic on canvas, 11 paintings 60 x 60 cm,
1 painting 65 x 65 cm

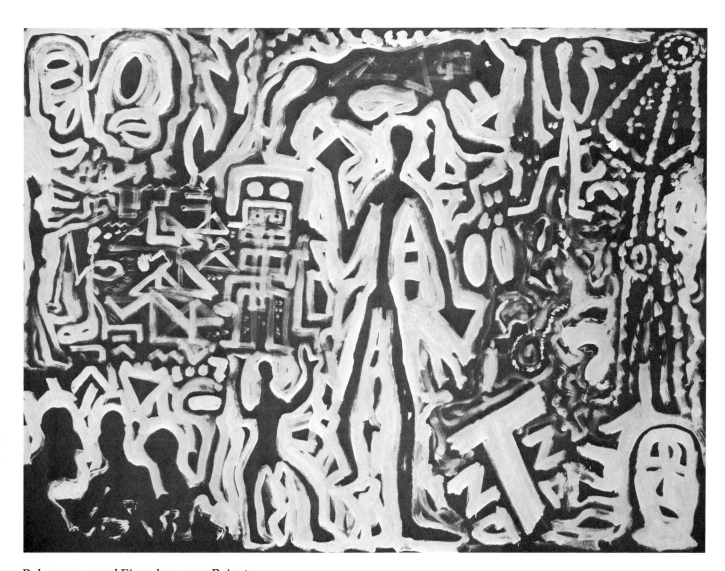

Belagerung und Einnahme von Beirut 3,
1982
(Siege and Taking of Beirut 3), synthetic resin on
canvas, 260 x 350 cm, Private Collection,
Cologne

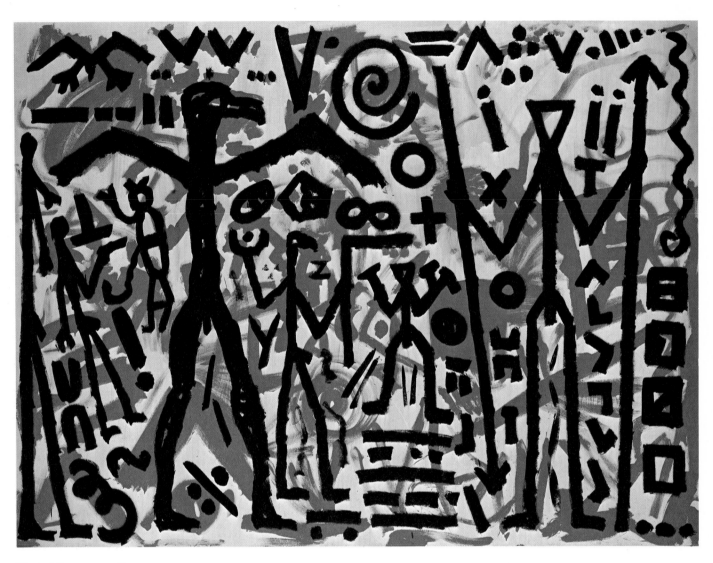

Verteidigung, 1982
(Vindication), synthetic resin on canvas,
260 x 350 cm, Estelle Schwartz, New York
(Courtesy Sonnabend Gallery, New York)

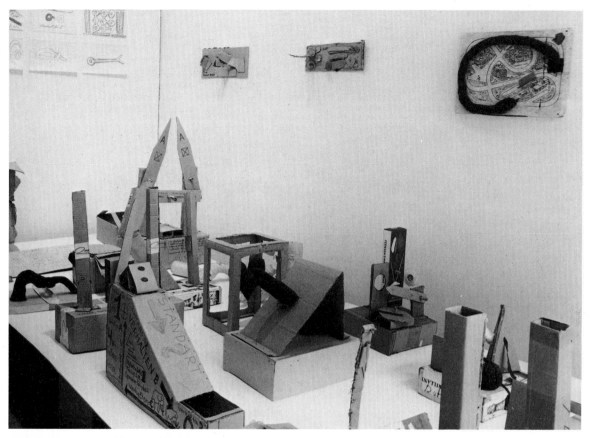

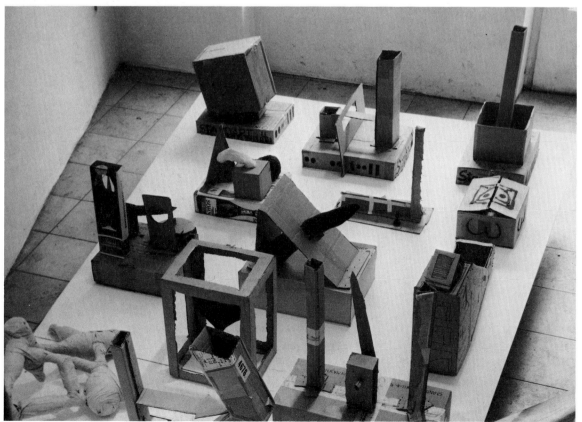

LEFT: Cardboard construction sculptures
installation Galerie Michael Werner, Cologne,
1970

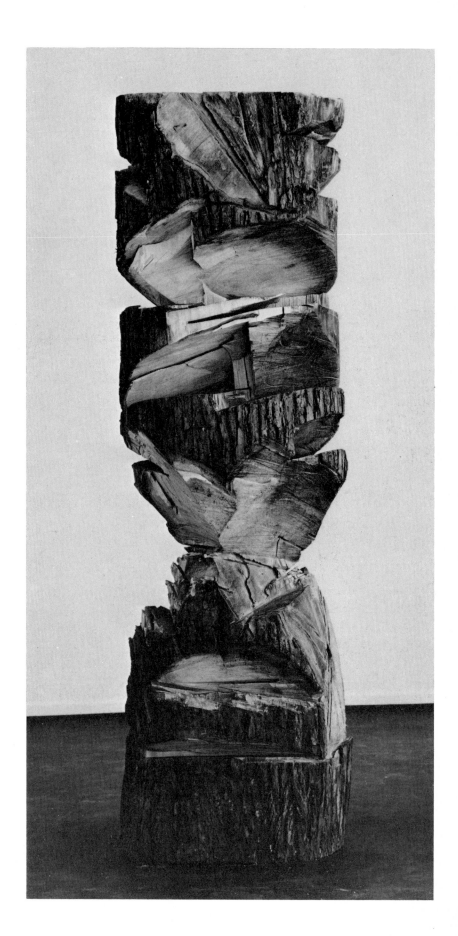

Kopf, 1982
(Head), wood, 258 x 82 x 78 cm, Private Collec-
tion, on deposit Kröller-Müller Museum,
Otterlo

List of Exhibitions

One-Man Exhibitions

1969 Galerie Michael Werner, Cologne
1970 Kölner Kunstmarkt, Galerie Michael
Werner, Cologne
Galerie Michael Werner, Cologne
1971 Museum Haus Lange, Krefeld
Galerie Heiner Friedrich, Munich
Galerie Michael Werner, Cologne
1972 Wide White Space Gallery, Antwerp
Kunstmuseum, Basel
Galerie Michael Werner, Cologne
Galerie Beck, Erlangen
Galerie Stampa, Basel
Goethe-Institut/Provisorium,
Amsterdam
Galerie Grafikmeyer, Karlsruhe
1973 Nova Scotia College of Art and
Design, Halifax
Galleria L'Uomo e l'Arte, Milan
Daner Galleriet, Copenhagen
Wide White Space Gallery, Antwerp
Galerie Loehr, Frankfurt
1974 Städtische Galerie »Altes Theater«,
Ravensburg
Galerie Michael Werner, Cologne
Galerie Heiner Friedrich, Munich
Galerie Stampa, Basel
Galerie Nächst St. Stephan, Vienna
Wide White Space Gallery, Antwerp
1975 Kunsthalle Bern and Stedelijk Van
Abbemuseum, Eindhoven
»Penck mal TM«
Galerie Hans Neuendorf, Hamburg
Galerie Michael Werner, Cologne
1977 Galerie Seriaal, Amsterdam
Galerie Fred Jahn, Munich
1978 Kunstmuseum Basel, »Zeichnungen
bis 1975«
Mannheimer Kunstverein, Mann-
heim
Museum Ludwig, Cologne
Galerie Helen van der Meij,
Amsterdam
Galerie Springer, Berlin
Galerie Fred Jahn, Munich
Galerie Michael Werner, Cologne
1979 Boymans van Beuningen Museum,
Rotterdam »Concept conceptruimte«
Groninger Museum, Groningen,
»A. R. Penck. Sanfte Theorie über
Arsch, Arsche und Vegetation«
Galerie Michael Werner, Cologne
1980 Städtisches Museum / Schloss Mors-
broich, Leverkusen
Galerie Fred Jahn, Munich
Galerie Michael Werner, Cologne
1981 Kunstmuseum Basel

Josef-Haubrich-Kunsthalle, Cologne
Kunsthalle, Bern
Galerie Helen van der Meij,
Amsterdam
GEWAD, Ghent
Galerie Hans Neuendorf, Hamburg
1982 Sonnabend Gallery, New York
Galerie Lucio Amelio, Naples
Galerie Toselli, Milan
Studio d'Arte Cannaviello, Milan
Galerie Gillespie/Laage/Salomon,
Paris
Waddington Galleries, London
Young-Hoffman Gallery, Chicago
1983 Edition Sabine Knust, Munich (early
prints)
Galerie Lucio Amelio, Naples

Group Exhibitions

1971 »Prospect 71 – Projection«, Kunst-
halle Düsseldorf
1972 documenta 5, Kassel
»Zeichnungen der deutschen Avant-
garde«, Galerie im Taxispalais, Inns-
bruck
1972/ »Zeichnungen 2«, Städtisches
73 Museum / Schloss Morsbroich, Le-
verkusen
1973 »Bilder/Objekte/Filme/Konzepte«,
Städtische Galerie im Lenbachhaus,
Munich
»6. Internationale Trieannale für far-
bige Druckgraphik«, Grenchen, Swit-
zerland
Neue Staatsgalerie/Pinakothek,
Munich (with Beuys)
»PROSPECT 73 – Maler/Painters/
Peintres«, Städtische Kunsthalle,
Düsseldorf
»Medium Fotografie.« Städtisches
Museum / Schloss Morsbroich,
Leverkusen
1973/ »Bilanz einer Aktivität«, Goethe-
74 Institut/Provisorium, Amsterdam
1974 »Kunst bleibt Kunst – Projekt '74
Aspekte internationaler Kunst am
Anfang der 70er Jahre«, Kunsthalle,
Cologne
»Kunst na 1960 int het Kunstmuseum
Basel«, Nijmeegs Museum,
Nijmegan, Netherlands
1975 »Je/nous – ik/wij«, Musée d'Ixelles,
Brussels
»Funkties van tekenen«, Rijks-
museum Kröller-Müller, Otterlo
»Zeichnungen«, Kunsthalle, Bern
»Zeichnungen«, Wide White Space
Gallery, Antwerp
»Europalia 1975«, Palais voor Schone
Kunsten, Brussels
1976 »Bis heute«, Kunsthalle Basel
»Zeichnen/Bezeichnen«, Kunst-
museum Basel
La Biennale di Venezia, Venice
»Zeichnungen«, Galerie Seriaal,
Amsterdam
1977 »Penck mal Immendorff – Immen-
dorff mal Penck«, Galerie Michael
Werner, Cologne
»Photos der Maler«, Galerie Maier-
Han, Düsseldorf
documenta 6, Kassel
1978 »Werke aus der Sammlung Crex«,
InK, Halle für internationale neue
Kunst, Zurich, Humlebaek, Eind-
hoven, Munich

»13° East. Eleven artists working in Berlin«, Whitechapel Art Gallery, London
»Kunst des 20. Jahrhunderts aus Berliner Privatbesitz«, Akademie der Künste, Berlin
1979 »Zeichen setzen durch Zeichnen«, Kunstverein, Hamburg
»Malerei auf Papier«, Badischer Kunstverein, Karlsruhe
»3rd Biennale of Sydney: European Dialogue«, Sydney
Groninger Museum, Groningen (with Ria van Eyk)
»Y. 35 Objekte aus Holz«, InK, Zurich
1980 »Zeichnungen«, Museum Haus Lange, Krefeld
»Der gekrümmte Horizont – Kunst in Berlin 1945-1967«, Akademie der Künste, Berlin
»Après le classicisme«, Musée d'Art et d'Industrie et Maison de la Culture, Saint-Etienne
CAPC, Entrepôt Lainé Bordeaux (Ludwig Collection)
La Biennale di Venezia, Venice
»Les nouveaux fauves – die neuen Wilden«, Neue Galerie – Sammlung Ludwig, Aachen
1981 »A New Spirit in Painting«, Royal Academy of Arts, London
»Art d'allemagne aujourd'hui«, ARC/Musée d'art moderne de la ville de Paris
»Der Hund stösst im Laufe der Woche zu mir«, Moderna Museet, Stockholm
»Westkunst: zeitgenössische Kunst seit 1939«, Cologne
»2. Biennale der europäischen Graphik Baden-Baden«, Baden-Baden
»Schilderkunst in Duitsland 1981«, Vereniging voor Tentoonstellingen van het Paleis voor Schone Kunsten te Brussel, Brussels
»Tendenzen der modernen Kunst. Sammlung Ingrid und Hugo Jung«, Suermondt-Ludwig-Museum und Museumsverein, Aachen
Christion Stein, Turin
Annemarie Verna, Zurich
Galerie Gillespie/Laage/Salomon, Paris
1982 »German Drawings of the 60's«, Yale University Art Gallery, New Haven, Connecticut

»Mythe, drame, tragédie«, Musée d'Art et d'Industrie et Maison de la Culture, Saint-Etienne
»New Work on Paper 2«, The Museum of Modern Art, New York
»Vergangenheit, Gegenwart, Zukunft: zeitgenössische Kunst und Architektur«, Württembergischer Kunstverein, Stuttgart
documenta 7, Kassel
»Zeitgeist«, Martin-Gropius-Bau, Berlin
»New Figuration from Europe«, Milwaukee Art Museum
»4th Biennale of Sydney: Vision in Disbelief«, Sydney
»Avanguardia transavanguardia«, Mura Aureliane da Porta Metronia a Porta Latina, Rome
»La Transavanguardia Tedesca«, Galleria Nazionale d'Arte Moderna, San Marino
»La nuova pittura tedesca«, Studio Marconi, Milan
»9. Internationale Triennale für farbige Originalgraphik«, Haldenschulhaus, Grenchen
Sonnabend Gallery, New York
Annemarie Verna, Zurich
»Pressure to Paint«, Marlborough Gallery, New York
»Künstlerbildnisse vom 16. bis 20. Jahrhundert«, Wallraf-Richartz-Museum and Museum Ludwig, Cologne
»Portraits et figures, faces and figures, Gesichter und Gestalten«, Galerie Beyeler, Basel
Roger Ramsay Gallery, Chicago (prints)
»Erste Konzentration«, Galerie Friedrich und Knust, Munich
1983 Museum Haus Ester, Krefeld (prints)
»New Figuration. Contemporary Art from Germany«, Frederick S. Wight Art Gallery, University of California, Los Angeles
»Mensch und Landschaft in der zeitgenössischen Malerei und Graphik der Bundesrepublik Deutschland«, Moscow and Leningrad
Galleria Lucio Amelio, Naples
Galerie Rolf Ricke, Cologne (sculpture)
Galleria Franco Toselli, Milan
»EXPRESSIONS: New Art from Germany«, The Saint Louis Art Museum

Renate Winkler # Critical Bibliography

Editor's Note: This chronological bibliography is the first comprehensive listing of the numerous exhibition catalogues, books and articles pertinent to these artists, their influences in Europe and America and the current developments in figurative art. The extensive art libraries at the *Staatliche Akademie der Bildenden Künste*, Karlsruhe, *Kunst- und Museumbibliothek*, Cologne; with additions from The Saint Louis Art Museum (for the American and English press) have been used. The table of organization is as follows:

Each artist's individual section contains: I. Artist's Writings, Artist's Books; II. One-Man Exhibition Catalogues; III. Group Exhibition Catalogues; IV. Exhibition Reviews; V. Articles; VI. Catalogues of Museum and Private Collections; VII. Monographs (as needed).

The concluding common bibliographic section contains: VIII. Common Group Exhibition Catalogues; IX. Exhibition Reviews; X. Articles on Contemporary German Art; XI. Monographs on Modern and Contemporary German Art; XII. Catalogues of Museum and Private Collections; XIII. Lexicons.

Whenever possible the artist's last name initial is included to specify the reference.

A. Georg Baselitz

I. Artist's Writings, Artist's Books

1966 Georg Baselitz. *Warum das Bild »Die großen Freunde« ein gutes Bild ist.* (Manifesto) Berlin

1972 Georg Baselitz. *1. Pandämonium 1961, 2. Pandämonium 1962, Brief »Lieber Herr W.« 1963. Die Schastrommel* (Ed. Günter Brus), No. 6, March, Berlin, Bolzano

1976 Comte de Lautréamont (Isidore Ducasse). *Die Gesänge des Maldoror.* With 20 gouaches by Georg Baselitz. Rogner & Bernhard, Munich (Supplement: 1. and 2. Pandämonium, Berlin 1961 and 1962)

II. One-Man Exhibition Catalogues

1963 *Georg Baselitz.* Foreword Herbert Read. Text Martin G. Buttig, Edouard Roditi. Galerie Werner & Katz, Berlin

1965 *Baselitz.* Text Georg Baselitz. Galerie Friedrich & Dahlem, Munich

1966 *Georg Baselitz.* Ölbilder und Zeichnungen. Galerie Friedrich & Dahlem, Munich

1970 *Georg Baselitz: Zeichnungen.* Text Dieter Koepplin, Georg Baselitz. Kunstmuseum Basel
Georg Baselitz. Tekeningen en Schilderijen. Text Dieter Koepplin. Wide White Space Gallery, Antwerp

1971 -72 *Georg Baselitz. Bilder 1962-1970.* Galerie Tobiès & Silex, Cologne

1972 *Georg Baselitz: Gemälde und Zeichnungen.* Foreword Heinz Fuchs. Kunsthalle Mannheim
Georg Baselitz. Text Günther Gercken. Kunstverein Hamburg (Second edition Galerie Rudolf Zwirner, Heiner Friedrich, Cologne)
Georg Baselitz. Zeichnungen und Radierungen, 1960-1970. Text Herbert Pée. Staatliche Graphische Sammlungen, Munich

1973 *Georg Baselitz. Ein neuer Typ, Bilder 1965/66.* Text Günther Gercken. Galerie Neuendorf, Hamburg

1974 *Georg Baselitz: Radierungen, 1963-1974, Holzschnitte, 1966-1967* (Œuvre Catalogue). Text Rolf Wedewer, Fred Jahn, Mircea Eliade. Städtisches Museum Leverkusen, Schloss Morsbroich, Leverkusen

1975 *Baselitz. Zeichnungen, 1960-1974.* Galerie Michael Werner, Cologne
Georg Baselitz. Adler. Galerie Heiner Friedrich, Munich
Georg Baselitz. Evelyn Weiss, Gespräch mit Georg Baselitz im Schloss Derneburg am 22. 6. 1975. XIII. Bienal de São Paulo 1975, São Paulo, Cologne

1976 *Baselitz. Malerei, Handzeichnungen, Druckgraphik.* Text Johannes Gachnang, Theo Kneubühler. Kunsthalle Bern
Georg Baselitz. Text Carla Schulz-Hoffmann, Günther Gercken, Johannes Gachnang. Galerieverein München e. V. und Staatsgalerie moderner Kunst, Munich
Georg Baselitz. Handzeichnungen. Haus der Kunst, Munich
Georg Baselitz. Gemälde, Handzeichnungen und Druckgraphik. Foreword Horst Keller. Text Siegfried Gohr, Dieter Koepplin, Franz Dahlem. Museen der Stadt Köln, Ausstellung der Kunsthalle, Cologne

1979 *Georg Baselitz. Bilder 1977-1978.* Text Rudi H. Fuchs. Van Abbemuseum, Eindhoven
Georg Baselitz. Tekeningen-Zeichnungen. Text Frans Haks. Gespräch Johannes Gachnang mit G. B. Groninger Museum, Groningen
Georg Baselitz. 32 Linolschnitte aus den Jahren 1976 bis 1979. Text Siegfried Gohr, Fred Jahn. (Œuvre catalogue by Siegfried Gohr) Josef-Haubrich-Kunsthalle, Cologne
Georg Baselitz. Model for a Sculpture. Text Johannes Gachnang, Theo Kneubühler, Klaus Gallwitz. Whitechapel Art Gallery, London

1981 *Georg Baselitz. Grafik og malerier.* Text John Hunov, Per Kirkeby. Kastrupgårdsamlingen, Kastrup
Georg Baselitz, Gerhard Richter. Text Jürgen Harten. Kunsthalle Düsseldorf
Georg Baselitz. Text Jürgen Schilling. Kunstverein Braunschweig

1982 *Georg Baselitz. Das Strassenbild.* Text Alexander van Grevenstein. Stedelijk Museum, Amsterdam
Georg Baselitz. Zeichnungen zum Strassenbild. Text Heribert Heere. Galerie Michael Werner, Cologne
Georg Baselitz. 16 Holzschnitte rot und schwarz 1981/82. Text Per Kirkeby. Galerie Fred Jahn, Munich, Galerie Zwirner, Cologne

Georg Baselitz. Text Richard Calvo-coressi. Waddington Galleries, London
Georg Baselitz. Paintings 1966–1969. Text Rafael Jablonka. Anthony d'Offay Gallery, London

1983 *Georg Baselitz. Holzplastiken.* Text Andreas Franzke, R. H. Fuchs, Siegfried Gohr. Galerie Michael Werner, Cologne
Baselitz Sculptures. Foreword Jean-Louis Froment, Georg Baselitz. Interview with the artist, Jean-Louis Froment and Jean-Marc Poinsot. CAPC, Musée d'Art Contemporain, Bordeaux

III. Group Exhibition Catalogues

1964 *Deutscher Künstlerbund. 13. Ausstellung, Berlin.* Hochschule für bildende Künste, Berlin

1966 *Deutscher Kunstpreis der Jugend 1966, Malerei.* Text Heinz Ohff. Staatliche Kunsthalle, Baden-Baden
Labyrinthe. Phantastische Kunst vom 16. Jahrhundert bis zur Gegenwart. Text Adolf Arndt, Eberhard Roters, Heinz Ladendorf. Akademie der Künste, Berlin
Junge Generation. Maler und Bildhauer in Deutschland. Text Hans Scharoun, Will Grohmann. Akademie der Künste, Berlin

1967 *Berlin – Berlin. Junge Berliner Maler und Bildhauer.* Deutsche Gesellschaft für bildende Kunst (Kunstverein Berlin) Berlin, Athens
Figurationen. Text Dieter Honisch. Württembergischer Kunstverein, Stuttgart

1968 *14 mal 14. Junge deutsche Künstler.* Text Klaus Gallwitz. Staatliche Kunsthalle, Baden-Baden

1969 *Ars viva 69.* Text Martin G. Buttig. Orangerie des Schlosses Berlin-Charlottenburg, Berlin and Erholungshaus der Farbenfabriken Bayer AG, Leverkusen

1970 Rolf Wedewer, Fred Jahn. *Zeichnungen.* Baselitz, Beuys Buthe, Darboven, Erber, Palermo, Polke, Richter, Rot. Städtisches Museum Leverkusen, Schloss Morsbroich, Kunsthaus Hamburg, Kunstverein München, Verlag Jahn & Klüser, Munich

1971 *D'Après.* Rassegna internazionale delle arte e della cultura. Text Giancarlo Vigorelli, Franco Russoli, Guido Ballo, Jean Dypréau. Villa Ciani, Lugano

1977 *Menschenbild, Menschenbilder.* Ed. Interessengemeinschaft Galerien Maximilianstrasse München. Munich

1978 Christel Sauer. *Georg Baselitz.* InK, Halle für internationale Kunst, Zürich (InK Dokumentation 1)

1979 Christel Sauer. *Georg Baselitz.* InK, Halle für internationale Kunst, Zürich (InK Dokumentation 2)

1980 *Forms of Realism Today.* Musée d'art contemporain, Montreal
Georg Baselitz, Biennale di Venezia 1980. Text Johannes Gachnang, Theo Kneubühler. Ed. Klaus Gallwitz. Stuttgart

1983 Michael Schoenholtz, Lutz Wolf, Harald Gruber, Andreas Günzel, Gerhard Hoehme, Georg Baselitz. Städtische Galerie am Markt, Schwäbisch Hall
Expressions: New Art from Germany. The Saint Louis Art Museum

IV. Exhibition Reviews

1972 Ullrich Kuhirt, »Befragung der Realität. Zur 5. documenta-Ausstellung 1972 in Kassel«, *Bildende Kunst,* No. 11, pp. 539-543
»Georg Baselitz, Kunstverein Hamburg«, *Der Spiegel,* vol. 26, No. 19, p. 142

1976 Ernst Thiel, »Für Baselitz steht die Welt auf dem Kopf«, *Interpress* Internationaler Pressedienst (Hamburg), No. 52

1980 Bazon Brock, »Avantgarde und Mythos. Möglichst taktvolle Kulturgesten vor Venedigheimkehrern«, *Kunstforum international,* vol. 40, 4/1980, pp. 86-103
Waldemar Januszczak, »How to Take a German Salute«, *The Guardian,* 22 November
John B. Thompson. »Venice. Aspects of the 1980 Biennale«, *The Burlington Magazine,* November, p. 793

1981 Yvonne Friedrichs, »Georg Baselitz, Gerhard Richter. Kunsthalle Düsseldorf (3. 5.-5. 7. 81)«, *Das Kunstwerk,* vol. 34, No. 4, pp. 80-81
James Burr, »The Realities of Painting«, *Apollo,* vol. 63, No. 227, p. 54

1981 Annelie Pohlen, »Georg Baselitz.
-82 Michael Werner/Cologne«, *Flash Art,* No. 105, pp. 58-59

1982 »Volker Bauermeister: Georg Baselitz. Kunstverein Braunschweig (3. 10.-29. 11. 81)«, *Das Kunstwerk,* vol. 35, No. 1, p. 33

Donald B. Kuspit, »Georg Baselitz at Fourcade. (New York)«, *Art in America,* February, pp. 139–140
Lisa Liebmann, »Georg Baselitz, Xavier Fourcade, and Brooke Alexander Gallery. (New York)«, *Artforum,* vol. 20, No. 7, pp. 69-70
Carter Ratcliff, »A Season in New York«, *Art international,* vol. XXV/7-8, p. 57

1983 Stuart Morgan, »Georg Baselitz, Paintings 1966-69 at Anthony d'Offay Gallery and Recent Paintings and Drawings at Waddington Gallery, London«, *Artforum,* vol. 21, No. 6, pp. 86-87

V. Articles

1964 Michael Werner (Martin G. Butting). *Votum für Heinz Ohff.* (Manifesto) Berlin
»Der Fall Baselitz und das Gespräch von Arwed D. Gorella, Berlin«, *Tendenzen,* vol. 5, No. 30
»Klage und Qual. Baselitz-Prozess«, *Der Spiegel,* vol. 18, No. 26, pp. 82-84

1965 Edouard Roditi, »Le néo-nazisme artistique à Berlin-Ouest«, *L'Arche, Revue du FSJU,* No. 98, pp. 50-53
Martin G. Buttig, »Der Fall Baselitz«, *Der Monat,* vol. 17, No. 203, pp. 90-95

1966 »Georg Baselitz«, *Der Monat,* vol. 18, No. 209
Antje Kosegarten, »Georg Baselitz – Visionen oder Provokationen eines Berliner Malers«, *Die Grünenthal Waage,* vol. 5, No. 4-5, pp. 180-185
Martin G. Buttig, »West-Berlin's Baselitz Case«, *Censorship,* No. 5, winter, vol. 2, No. 1, pp. 35-41

1968 Helmut Goettl, »Kullervos Füsse. Der Maler Georg Baselitz«, *Tendenzen,* vol. 9, No. 52, pp. 143-146

1969 Wolfgang Christlieb, »Georg Baselitz (Kunst und Kritik)«, *Kunst,* No. 34, p. 1149

1976 Siegfried Gohr, »Georg Baselitz«, Museen in Köln, *Bulletin,* vol. 15, No. 7, p. 1442 ff

1977 Carla Schulz-Hoffmann, »Georg Baselitz«, *Kunstforum international,* vol. 20, 2/1977, pp. 97-99

1979 »Georg Baselitz: Vier Wände und Oberlicht. Oder besser, kein Bild an der Wand«, Vortrag anl. d. Dortmunder Architekturtage »Museumsbauten«, 26 April. *Kunstforum international,* vol. 34, 4/1979, pp. 162-164

1980 Axel Hecht, Werner Krüger, »L'art actuel made in Germany. Georg Baselitz, la peinture la tête en bas«, *Art Press*, 42, pp. 16-17
Axel Hecht, Werner Krüger, »Venedig 1980. Aktuelle Kunst made in Germany«, *Art*, No. 6, pp. 40-47

1982 Siegfried Gohr, »In the Absence of Heroes. The Early Work of Georg Baselitz«, *Artforum*, vol. 20, No. 10, pp. 67-69
Dorothea Dietrich-Boorsch, »The Prints of Georg Baselitz: An Introduction«, *The Print Collectors Newsletter*, January-February, pp. 1-3
Antje v. Graevenitz, »Baselitz en de bateke«, *Kunstschrift*, July-August, pp. 132-37

VI. Catalogues of Museum and Private Collections

1970 *Die Handzeichnung der Gegenwart*. Text Gunther Thiem, Marina Schneede-Sczesny. Graphische Sammlung, Staatsgalerie Stuttgart

1971 *Zeichen und Farbe: Aquarelle, Pastelle,*
-72 *Tempera- und Farbstiftblätter seit 1900 aus dem Besitz der Graphischen Sammlung der Staatsgalerie Stuttgart*. Text Gunther Thiem, Heinrich Geissler. Graphische Sammlung, Staatsgalerie Stuttgart

1973 »Neuerwerbungen, Bayerische Staatsgemäldesammlungen«, *Münchner Jahrbuch der bildenden Kunst*, 3. Folge, vol. XXIV, pp. 289-290, Munich

1975 *Birthe Inge Christensen & John Abildgard Humov's samling of nutidig kunst*, Copenhagen

1979 *Neuerwerbungen 1978*. Text D. Stemmler. Städtisches Kunstmuseum, Bonn
Art of the Sixties – Europe and the USA, Ludwig Collection Cologne – Aachen, Tel Aviv Museum, Tel Aviv

1979 *30 Jahre Kunst in der Bundesrepublik*
-80 *Deutschland. Die Sammlung des Städtischen Kunstmuseums Bonn*. Text Dierk Stemmler. Städtisches Kunstmuseum, Bonn

1982 *Graphik aus den siebziger Jahren. Neuerwerbungen der Grafischen Sammlung*. Text Ulrich Weisner, Erich Franz. Kunsthalle Bielefeld
»Neuerwerbungen, Bayerische Staatsgemäldesammlungen«, *Münchner Jahrbuch der Bildenden Kunst*. 3. Folge, vol. XXXIII, pp. 229 and 231, Munich

B. Jörg Immendorff

I. Artist's Writings, Artist's Books

1968 Jörg Immendorff. *Den Eisbären mal reinhalten.* (folder) self published, Düsseldorf
Jörg Immendorff. *Lidlstadt.* self published, Düsseldorf

1973 Jörg Immendorff. *Hier und jetzt: das tun, was zu tun ist.* Cologne, New York

1973 Jörg Immendorff. »An die ›partei-
-74 losen‹ Künstlerkollegen«. *Kunstforum international*, vol. 8/9, 1/1973-74, pp. 162-177

1979 Jörg Immendorff, A. R. Penck. *Deutschland mal Deutschland.* Munich

1982 *Jörg Immendorff. Grüsse von der Nordfront.* Poem: Penck. Galerie Fred Jahn, Munich
Kunst und Klassik: documenta 7 – Artisten ratlos? Basel, pp. 52-53
Jörg Immendorff, A. R. Penck. *Brandenburger Tor Weltfrage* (Brandenburg Gate Universal Question). Poem: Penck. Illustrations: Immendorff. The Museum of Modern Art, New York

II. One-Man Exhibition Catalogues

1977 *Jörg Immendorff.* Text Wouter Kotte, Jürgen Kramer. Hedendaagse Kunst, Utrecht

1978 *Café Deutschland, von Jörg Immendorff.* Text Johannes Gachnang, Siegfried Gohr, R. H. Fuchs. Galerie Michael Werner, Cologne

1979 *Jörg Immendorff. »Café Deutschland«.* Text Dieter Koepplin. Kunstmuseum Basel
Jörg Immendorff. »Situation – Position, Plastiken«. Text Siegfried Gohr, A. R. Penck. Galerie Michael Werner, Cologne

1980 *Jörg Immendorf. Malermut rundum.* Text Johannes Gachnang, Max Wechsler. Kunsthalle Bern

1981 *Jörg Immendorff. Teilbau.* Text R. H. Fuchs, Johannes Gachnang. Galerie Neuendorf, Hamburg
Jörg Immendorff. Lidl, 1966-1970. Text R. H. Fuchs. Van Abbemuseum, Eindhoven

1982 *Jörg Immendorff. Café Deutschland/ Adlerhälfte.* Text Jürgen Harten,

Ulrich Krempel. Kunsthalle Düsseldorf
Jörg Immendorff. »Kein Licht für wen?« Galerie Michael Werner, Cologne

1983 *Jörg Immendorff. Malerier og tegninger.* Text Henning Christiansen. Kastrumgårdsamlingen, Kastrup

III. Group Exhibition Catalogues

1969 *Düsseldorfer Szene.* Text Jean-Christophe Ammann. Kunstmuseum Luzern

1970 *Jetzt. Künste in Deutschland heute.* Catalogue Helmut R. and Petra Leppien. Kunsthalle Köln, pp. 88-89

1976 *B 76. La Biennale di Venezia*, settore arti visive e architettura, catalogo generale. vol. 2, Venice, p. 332

1979 *Für Jochen Hiltmann – eine Solidaritäts-Ausstellung.* Text Ulrich Rückriem, R. H. Fuchs, Carl Vogel. Van Abbemuseum, Eindhoven

1980 *Jörg Immendorff, Milan Kunc. Künstler arbeiten zusammen.* Düsseldorf
Finger für Deutschland. Text Werner Büttner. Studio Jörg Immendorff, Düsseldorf

1981 *Le Moderna Museet de Stockholm au Palais des Beaux Arts.* Brussels

1982 *Neue Skulptur.* Text Patrick Frey, Helmut Draxler. Galerie Nächst St. Stephan, Vienna
Die Schönheit muss auch manchmal wahr sein. Beiträge zu Kunst und Politik. Ed. Dieter Hacker, Bernhard Sandfort. 7. Produzentengalerie, Berlin

1983 *Expressions: New Art from Germany.* The Saint Louis Art Museum

IV. Exhibition Reviews

1973 »Jörg Immendorff, Aus der Aktion ›Babywäsche‹ 1968, Galerie Michael Werner Köln. (Kunstszene des Jahres 1971/72)«, *Kunstjahrbuch. 3*, Hannover, p. 414

1978 Siegfried Gohr, »Das ›Café Deutschland‹ von Jörg Immendorff«, *Kunst Magazin*, vol. 18, No. 2, pp. 48-49
Siegfried Gohr, »Jörg Immendorff's ›Café Deutschland‹«, and Johannes Gachnang, »Jörg Immendorff's ›Café Deutschland‹«, *Kunstforum international*, vol. 26, No. 2, pp. 238-242

1979 Marlis Grüterich, »Jörg Immendorff (Galerie Werner)«, *Kunstforum international*, vol. 36, No. 6, p. 251

1982 Gislind Nabakowski, »›Kommen Sie
 'mal einem Punker mit einem Buch!‹
 Jörg Immendorff ›Café Deutschland –
 Adlerhälfte‹ – Kunsthalle Düssel-
 dorf«, *Kunstforum international,*
 vol. 50, No. 4, pp. 156-157
 Heiner Stachelhaus, »Jörg Immen-
 dorff. Städtische Kunsthalle Düssel-
 dorf (26. 3.-9. 5. 82), Galerie Strelow,
 Düsseldorf-Oberkassel, Luegplatz 3,
 (till 15. 5. 82)«, *Das Kunstwerk,* vol. 35,
 No. 3, pp. 61-62
 »In die Wälder hinunter. In Kassel ist,
 imposant und theoriearm, die siebte
 Documenta eröffnet worden. Ihr Lei-
 ter sieht sie als ›gemessen dahin-
 gleitende Regatta‹«, *Der Spiegel,*
 vol. 36, No. 25, 21, pp. 198-199
1983 Donald B. Kuspit, »Jörg Immendorff
 at Sonnabend«, *Artforum,* vol. 21,
 No. 5, p. 75

V. Articles

 Chris Reinicke, »Gedanken zu Jörg
 Immendorffs Babies und Aktionen.
 (folder)«, *Information,* Staatliche
 Kunstakademie Düsseldorf, No. 2,
 undated
1973 »Jörg Immendorff«, *Kunstforum inter-
 national,* vol. 1, No. 1, pp. 164, 173
1974 »Jörg Immendorff«, *Interfunktionen,*
 No. 11
1977 »Jan Zumbrink, Immendorff:
 Realisme maar geen sovjet-realisme. /
 Marie Louise Flammersfeld: De
 Werkelijkheid van Jörg Immendorff«,
 De Nieuwe Linie, Amsterdam, 15 June,
 p. 9
1978 Jörg Immendorff, »Interview mit
 Joseph Beuys«, *Spuren,* Zeitschrift für
 Kunst und Gesellschaft, No. 5,
 pp. 38-41
 Jörg Immendorff, Michael Schür-
 mann. »Beuys geht (Interview)«,
 Überblick, vol. 2, No. 12, pp. 9-11
1979 Alfred Welti, »Mahnmal für hüben
 und drüben«, *Stern Magazin,* No. 44
 Marianne Brouwer, »Immendorff:
 Het realisme van de ploertendoder«,
 Haagse Post, vol. 66, No. 3, pp. 54-55,
 Amsterdam
 Wolfgang Bessenich, »Ein Maler
 nicht nur für Deutschland«, *Basler
 Zeitung,* No. 53
 »Interview mit Jörg Immendorff
 am 21. 11. 1979 (Faltblatt/Plakat)«,
 Primitivo/Einhorn Produktion,
 No. 6

 Jörg Immendorff, Michael Schür-
 mann, »Interview Joseph Beuys,
 Fortsetzung«, *Überblick,* vol. 3, No. 1,
 pp. 10-11
 »Jörg Immendorff: Baby für Zunder,
 1966. Ulrich Schmidt: Erwerbsbe-
 gründung. (Museum Wiesbaden)«,
 Das Kunstjahrbuch 79. Mainz, pp. 262-
 263
1980 Paul Groot, »De nordelijke ruimte«,
 Kunstschrift, openbaar kunstbezit,
 vol. 24, No. 1, pp. 28-34
 »Wahl '80«. *Art,* No. 9, p. 23
1981 Juan Manuel Bonet, »Como artista
 nunca puedes dejar de provocar«,
 Entrevista con Jörg Immendorff«,
 Pueblo, Madrid, 20. November
1982 Jörg Immendorff, Hans Peter Riegel,
 »Was Kunst soll (Interview)«, *Oetz,*
 Zeitschrift im Fachbereich Design der
 FH Düsseldorf, No. 5, pp. 42-44
 »Malerei zur Lage der Nation. Jörg
 Immendorff«, *Art,* No. 4, pp. 64-71

C. Anselm Kiefer

I. Artist's Writings, Artist's Books

1975 Anselm Kiefer, »Besetzungen 1969«,
 Interfunktionen, No. 12, p. 133-144
1978 Anselm Kiefer. *Die Donauquelle.*
 Galerie Michael Werner, Cologne
Editor's note: In addition, Kiefer has pro-
duced over one hundred single artist's
books, with painted photographs, wood-
block prints, drawings and mixed media
additions.

II. One-Man Exhibition Catalogues

1975 *Anselm Kiefer.* Text Adriaan van der
 Staay, Gosse Oosterhof. Galerie
 t'Venster, Rotterdam Arts Founda-
 tion Verslag, Rotterdam
1977 *Anselm Kiefer.* Text Dorothea von
 Stetten, Evelyn Weiss, Anselm
 Kiefer. Bonner Kunstverein, Bonn
1978 *Anselm Kiefer. Bilder und Bücher.* Text
 Johannes Gachnang, Theo Kneubüh-
 ler, Anselm Kiefer. Kunsthalle Bern
1979 *Anselm Kiefer.* Text Rudi H. Fuchs.
 Van Abbemuseum, Eindhoven
1980 *Anselm Kiefer.* Text Tilman Oster-
 wold. Württembergischer Kunst-
 verein, Stuttgart
 *Anselm Kiefer. Hoffmann von Fallers-
 leben auf Helgoland.* Text Carel Bloth-
 kamp, Günther Gercken. Groninger
 Museum, Groningen
 Anselm Kiefer. Text Rudi H. Fuchs.
 Mannheimer Kunstverein,
 Mannheim
1981 *Anselm Kiefer. Aquarelle 1970-1980.*
 Text R. H. Fuchs. Kunstverein Frei-
 burg, Schwarzes Kloster, Freiburg
1981 *Anselm Kiefer.* Text Zdenek Felix,
-82 Nicholas Serota. Museum Folkwang,
 Essen, Whitechapel Art Gallery,
 London

III. Group Exhibition Catalogues

1969 *Deutscher Künstlerbund. 17. Ausstel-
 lung.* Hannover
1970 *Klasse Antes in Ravensburg.* Text An-
 dreas Franzke. Galerie Altes Theater,
 Ravensburg
1973 *14 mal 14.* Text Klaus Gallwitz. Staat-
 liche Kunsthalle, Baden-Baden

1977 »Pejling af Tysk Kunst. 21 kunstnere
fra Tyskland«, *Louisiana Revy*, vol. 17,
No. 2, pp. 19-20
10ᵉ biennale de Paris: manifestation
internationale des jeunes artistes.
Palais de Tokyo, Musée d'art
moderne de la ville de Paris, Paris
1980 *Anselm Kiefer. Verbrennen, verholzen,
versenken, versanden.* Biennale Vene-
dig 1980. Text Klaus Gallwitz, R. H.
Fuchs. Stuttgart
1981 *Heute, Westkunst.* Ed. Kasper König.
DuMont Buchverlag, Cologne
1982 »Anselm Kiefer. Galerie Paul
Maenz«, *Premieren: Zwanzig Kölner
Galerien und die Museen der Stadt Köln*,
Cologne
De la catastrophe. Text Adelina von
Fürstenberg *et al.* Centre d'Art
Contemporain, Geneva
1982 *Jean-Michel Basquiat, Sandro Chia,*
-83 *Francesco Clemente, Enzo Cucci, Anselm
Kiefer.* A selection of works from a
private collection. Rosa Esman Gal-
lery, New York
1983 *Expressions: New Art from Germany.*
The Saint Louis Art Museum

IV. Exhibition Reviews

1978 *Art actuel. Skira Annuel 78.* Skira,
Geneva, p. 71 and 154
Hans-Joachim Müller, »Anselm
Kiefer. Kunsthalle Bern (7. 10.-
19. 11. 78)«, *Das Kunstwerk*, vol. 31,
No. 6, pp. 62-63
1979 Marlis Grüterich, »Kiefer. Van Abbe-
museum, Eindhoven«, *Kunstforum
international*, vol. 36, No. 6, p. 251
1981 Jörg Johnen, »Anselm Kiefer. Galerie
Paul Maenz, Köln«, *Kunstforum inter-
national*, vol. 43, No. 1, pp. 148-149
Lisa Liebmann, »Anselm Kiefer at
Marian Goodman, New York«, *Art in
America*, vol. 69, No. 6, pp. 125-126
Jörg Zutter, »Brief aus den Niederlan-
den«, *Kunstforum international*,
vol. 43, No. 1, pp. 168-170
1981 Annelie Pohlen, »Anselm Kiefer.
-82 Folkwang Museum/Essen«, *Flash Art*,
No. 105, p. 59
1982 Waldemar Januszczak, »Beuys/
Kiefer«, *Guardian*, London, 3 April
Lisa Liebmann, »Anselm Kiefer at
Marian Goodman Gallery, New
York«, *Artforum*, vol. 20, No. 10,
pp. 90-91
William Feaver, »The Great Shaman«,
Observer, London, 11 April

Roberta Smith, »Kieferland«, *The
Village Voice*, 30 November
1983 Saskia Bos, »Anselm Kiefer. Helen
van der Meij Gallery, Amsterdam«,
Artforum, vol. 21, No. 5, p. 85
R. B., Anselm Kiefer, Mary Boone
(New York), *Art News*, vol. 82, No. 2,
pp. 146-147

V. Articles

1977 Peter Winter, »Karrig, alvorlig og
kølig«, *Louisiana Revy*, vol. 17, No. 2,
pp. 19-20
Micky Piller: »De Duitse avant-
garde«,
(1) »De censuur van het nazisme«.
pp. 72-74
(2) »De negers van Europa«.
pp. 48-53
(3) »Regresne of vernieuwing?«
pp. 68-71
Haagse Post, vol. 64, No. 48, 49, 50,
Amsterdam
Evelyn Weiss, »Anselm Kiefer«,
Kunstforum international, vol. 20,
No. 2, pp. 107-113
1979 Johannes Gachnang, »Anselm
Kiefer«, *Kunst-Nachrichten*, vol. 16,
No. 3, pp. 57-62
1980 R. Fuchs, »Kiefer schildert«,
Museumsjournaal, serie 25, No. 7,
pp. 302-309
Klaus Wagenbach, »›Neue Wilde‹,
teutonisch, faschistisch?«, *Freibeuter*
(Berlin), No. 5, pp. 138-147
Axel Hecht, Werner Krüger, »L'art
actuel made in Germany. Anselm
Kiefer, un bout de chemin . . .«, *Art
Press*, No. 42, pp. 14-15
Axel Hecht, Werner Krüger, »Vene-
dig 1980. Actuelle Kunst made in Ger-
many«, *Art*, No. 6, pp. 48-53
Bazon Brock, »Avantgarde und
Mythos. Möglichst taktvolle Kul-
turgesten vor Venedigheimkehrern«,
Kunstforum international, vol. 40,
No. 4, pp. 86-103
1981 »Anselm Kiefer. Gilgamesch und
Enkidu im Zedernwald«, Text Ingrid
Sischy, *Artforum*, vol. 19, No. 10,
pp. 67-73

D. Markus Lüpertz

I. Artist's Writings, Artist's Books

1964 Markus Lüpertz. »Katalog Gross-
görschen 35, Dithyrambische
Malerei«, Galerie Grossgörschen 35,
Berlin
1966 Markus Lüpertz. »Katalog Gross-
görschen 35, Frühling 66, Kunst, die
im Wege steht, Dithyrambisches
Manifest ›Die Anmut . . .‹«, Galerie
Grossgörschen 35, Berlin
1973 Markus Lüpertz. »Dithyramben, die
die Welt verändern«, *Magazin Kunst*.
vol. 13, No. 50, pp. 100-105
1975 Markus Lüpertz. *9 mal 9, 9 Gedichte
und Zeichnungen.* Verlag Danckert/
Hallwachs, Berlin
1980 Markus Lüpertz. *Sieben über ML.* Edi-
tion der Galerie Heiner Friedrich,
Munich
1982 Markus Lüpertz. »*Ich stand vor der
Mauer aus Glas«.* Galerie Springer,
Berlin

II. One-Man Exhibition Catalogues

1968 *Markus Lüpertz.* »Fasanenstrasse 13,
Markus Lüpertz. Die Anmut des
20. Jahrhunderts wird durch die von
mir erfundene Dithyrambe sichtbar
gemacht«. Text C. Joachimides, Mar-
kus Lüpertz. Galerie Springer, Berlin
*Markus Lüpertz. Dachpfannen dithyram-
bisch – es lebe Caspar David Friedrich.*
Text Markus Lüpertz, Christos M.
Joachimides. Galerie Hake, Cologne
1969 *Markus Lüpertz. Westwall.* Text
Markus Lüpertz, Erasmus Ernst.
Wolfgang Hake Verlag, Cologne
1973 *Markus Lüpertz. Bilder, Gouachen und
Zeichnungen, 1967-1973.* Text Klaus
Gallwitz, George Tabori, Markus
Lüpertz. Staatliche Kunsthalle,
Baden-Baden
1975 *Markus Lüpertz.* Text Günther
Gercken, Markus Lüpertz. Galerie
Zwirner, Cologne
Markus Lüpertz. 13 neue Bilder. Text
Günther Gercken. Galerie Neuen-
dorf, Hamburg
1976 *Markus Lüpertz.* Galerie Michael
Werner, Cologne
Markus Lüpertz. Bilder 1972-1976. Text
Reiner Speck, Markus Lüpertz.
Galerie Rudolf Zwirner, Cologne

1977 *Markus Lüpertz. Stilmalerei.* Text Rudi H. Fuchs. Van Abbemuseum, Eindhoven
Markus Lüpertz. Text Siegmar Holsten, Werner Hofmann. Hamburger Kunsthalle, Hamburg
Markus Lüpertz. Dithyrambische und Stil-Malerei. Text Johannes Gachnang, Theo Kneubühler. Kunsthalle Bern
Markus Lüpertz. Zeichnungen. Text Theo Kneubühler, Johannes Gachnang. Dortmunder Architekturhefte No. 7. Gebr. Lensing Verlagsanstalt, Dortmund

1978 *Markus Lüpertz. 5 Bilder.* Text Siegfried Gohr. Galerie Michael Werner, Cologne

1979 *Markus Lüpertz. »Stil« Paintings, 1977-79.* Text Nicholas Serota, Siegfried Gohr. Whitechapel Art Gallery, London

1979 *Markus Lüpertz. Gemälde und Hand-*
-80 *zeichnungen, 1964 bis 1979.* Text Siegfried Gohr, Markus Lüpertz. Josef-Haubrich-Kunsthalle, Cologne

1981 *Markus Lüpertz.* Text Tony Godfrey. Waddington Galleries, London
Markus Lüpertz. Zeichnungen, Gouachen, Aquarelle, 1964-1981. Galerie Fred Jahn, Munich
Markus Lüpertz. »Wieder in Gedanken«. Text Andreas Franzke. Kunstverein Freiburg, Schwarzes Kloster, Freiburg
Markus Lüpertz. »und ich, ich spiele . . .«. Galerie Springer, Berlin

1982 *Markus Lüpertz. Acht Plastiken.* Text Jiri Svestka. Galerie Michael Werner, Cologne
Markus Lüpertz. Grüne Bilder. Reinhard Onnasch Ausstellungen, Berlin

1983 *Markus Lüpertz. Hölderlin.* Text R. H. Fuchs, Johannes Gachnang, Siegfried Gohr. Poems by the artist. Van Abbemuseum, Eindhoven
Markus Lüpertz. Text Nadine Lehni, Markus Lüpertz. Musée d'Art Moderne de Strasbourg
Markus Lüpertz. Über Orpheus. Galerie Hubert Winter, Vienna

III. Group Exhibition Catalogues

1968 *Retrospektive Grossgörschen 35.* (Galerie) Grossgörschen 35 und Senator für Wissenschaft und Kunst in den ehemaligen Räumen der Galerie des 20. Jahrhunderts, Berlin

1969 *14 mal 14: Eskalation.* Ein fotografischer Bericht von Herbert Schwöbel. Text Klaus Gallwitz. Staatliche Kunsthalle, Baden-Baden

1970 *Villa Romana 1970.* Lüpertz, Nierhoff, Schoenholtz, Willikens. Text Markus Lüpertz, Giancarlo Cantagalli. Florence

1971 *Zwanzig Deutsche.* Text Klaus Honnef. Onnasch Galerie, Berlin, Cologne
Zeichnungen. Galerie René Block, Berlin
Aktiva '71: Kunst der Jungen in Westdeutschland. Text Thomas Grochowiak. Haus der Kunst, Munich
Entwürfe, Partituren, Projekte: Zeichnungen. Text René Block. Galerie René Block, Berlin

1972 *The Berlin Scene 1972. Works by 17 Artists Living in Berlin.* Gallery House, London

1973 *8e biennale de Paris:* manifestation internationale des jeunes artistes. Musée d'art moderne de la ville de Paris, Paris

1974 *Erste Biennale Berlin 1974.* Erste Biennale Berlin e. V., Berlin

1975 *Primeira bienal Berlin 1974.* Museu de arte, Rio de Janeiro

1982 *»Markus Lüpertz. Skulpturen.* Galerie Michael Werner«. *Premieren: zwanzig Kölner Galerien und die Museen der Stadt Köln,* Cologne
Kölner Herbstsalon 1982. Text Siegfried Gohr. Josef-Haubrich-Kunsthalle, Cologne
Picasso, Cézanne, Hockney, Dimitrijevic, Lüpertz. Waddington Galleries, London

1983 *Expressions. New Art from Germany.* The Saint Louis Art Museum

IV. Exhibition Reviews

1973 »Trunken, begeistert. (Markus Lüpertz malt ›dithyrambisch‹)« *Der Spiegel,* vol. 27, No. 35, pp. 99-100

1974 Heinz Ohff, »KUNST-Szene, Berlin«, *Magazin KUNST,* vol. 14, No. 3, p. 86

1977 Peter Winter, »Markus Lüpertz. Hamburger Kunsthalle (15. 4.-29. 5. 77)«. *Das Kunstwerk,* vol. 30, No. 3, p. 79

1979 Marlis Grüterich, »Markus Lüpertz. Kunsthalle Köln, bis 13. Januar 1980«, *Kunstforum international,* vol. 36, No. 6, pp. 248-251

1980 Hanno Reuther, »Markus Lüpertz. Kunsthalle Köln (23. 11. 79-31. 1. 80)«, *Das Kunstwerk,* vol. 33, No. 2, p. 80
Marlis Grüterich, »Markus Lüpertz, Gemälde und Handzeichnungen 1964 bis 1979. Josef-Haubrich Kunsthalle Köln, 1. 12. 79-12. 1. 80«, *Pantheon,* vol. 38, No. 2, p. 100

1982 Ross Skoggard, »Markus Lüpertz at Marian Goodman (New York)«, *Art in America,* vol. 70, No. 2, pp. 141-142
Stuart Morgan, »Markus Lüpertz. (Waddington Galleries London)« *Artforum,* vol. 20, No. 8, p. 89-90

1983 R. C., Markus Lüpertz, Marian Goodman (New York), *Art News,* vol. 82, No. 2, pp. 147-148
Antje von Graevenitz, Eindhoven. Stedelijk Van Abbemuseum, Markus Lüpertz, *Pantheon,* vol. 41, No. 2, pp. 165-166

V. Articles

1977 Walter Ehrmann, »Markus Lüpertz, Bemerkungen zum Problem Identität bei Markus Lüpertz«, *Kunstforum international,* vol. 20, No. 2, pp. 100-106

1980 Siegfried Gohr, »Markus Lüpertz, le jeu de l'ironie«, *Art Press,* No. 42, p. 12

1980 Robert J. Harding, »M. Lüpertz Inter-
-81 view«, *Art World,* vol. 6, No. 4, p. 1

1982 A. Dagbert, »Markus Lüpertz«, *Art Press,* No. 62

VI. Catalogues of Museum and Private Collections

1978 *Aspekte der 6oer Jahre. Aus der Sammlung Reinhard Onnasch.* Text Dieter Honisch. Nationalgalerie Berlin, Staatliche Museen Preußischer Kulturbesitz, Berlin, pp. 46-47, 128-129

1982 *Berlin — la rage de peindre:* les œuvres de Karl Heinz Hödicke, Bernd Koberling, Markus Lüpertz, Rainer Fetting, Helmut Middendorf, Salomé dans les collections de Peter Pohl et Hans Hermann Stober à Berlin. Text Erika Billeter. Musée cantonal des Beaux-Arts, Lausanne

VII. Monographs

1983 *Markus Lüpertz. Zeichnungen, 1963-1973.* (Œuvre catalogue) Text Siegfried Gohr. Karsten Schubert, Berlin (forthcoming)

E. A. R. Penck

I. Artist's Writings, Artist's Books

1967 A. R. Penck. *Standartmaking.*
1968 A. R. Penck. *Das Bewusstsein.*
1970 A. R. Penck. *Standarts.* Ed. Galerie
 Michael Werner, Köln. Verlag Jahn
 und Klüser, Munich
 A. R. Penck. *Was ist Standart.* Verlag
 Gebr. König, Cologne, New York
1971 A. R. Penck. *Ich-Standart Literatur.*
 Edition Agentzia, Paris
1973 A. R. Penck. *Deskriptive Einführung 1
 und 2.* L'Uomo e l'Arte editore, Milan
 A. R. Penck. *Europäische Sonette.*
 Galerie Wide White Space, Antwerp
1974 A. R. Penck, »Ich über mich selbst«,
 Kunstforum, vol. 12, pp. 139-149
1975 A. R. Penck. *Macht und Geist. Analy-
 tische Studie zu Kunst im politischen
 Kampf.* Pour Écrire la Liberté, Brussels
1976 A. R. Penck. *Ich bin ein Buch, kaufe
 mich jetzt.* Verlagsgesellschaft Grene,
 Obertshausen
1978 A. R. Penck. *Der Begriff Modell,
 Erinnerungen an 1973.* Galerie Michael
 Werner, Cologne
 A. R. Penck. »Mig selv om mig selv«,
 Louisiana Revy, vol. 19, No. 2, p. 18
1979 Jörg Immendorff, A. R. Penck.
 Deutschland mal Deutschland. Rogner
 & Bernhard, Munich
 A. R. Penck. *Sanfte Theorie über Arsch,
 Asche und Vegetation.* Museum
 Groningen
1981 A. R. Penck. *Ende im Osten.* 98 Zeich-
 nungen, 1000 copies. Rainer Verlag,
 Berlin
 A. R. Penck. *Je suis un livre achète-moi
 maintenant.* Galerie Gillespie-Laage-
 Salomon, Paris
1982 A. R. Penck. *Krater und Wolke.* No. 1,
 June. No. 2, November. Michael
 Werner, Cologne
 A. R. Penck, Jörg Immendorff. *Bran-
 denburger Tor Weltfrage.* (Brandenburg
 Gate Universal Question) Poem:
 Penck. Illustrations: Immendorff.
 The Museum of Modern Art, New
 York

II. One-Man Exhibition Catalogues

1971 *A. R. Penck. Zeichen als Verständigung,
 Bücher und Bilder.* Text Paul Wember.
 Museum Haus Lange, Krefeld

1973 *A. R. Penck. Anna Leonowens Gal-
 lery,* Nova Scotia College of Art &
 Design, Halifax (Canada)
1974 *A. R. Penck.* Galerie Nächst
 St. Stephan, Vienna
1975 *A. R. Penck. Penck mal TM.* Text R. H.
 Fuchs, Dieter Koepplin, A. R. Penck.
 Kunsthalle Bern, Van Abbemuseum,
 Eindhoven
 A. R. Penck. Text Günther Gercken.
 Galerie Neuendorf, Hamburg
1977 *A. R. Penck. Bilder 1967-1977.* Galerie
 Fred Jahn, Munich
1978 *A. R. Penck Y. Zeichnungen bis 1975.*
 Text Johannes Gachnang, A. R.
 Penck, Dieter Koepplin. Kunst-
 museum Basel
 *Y. (A. R. Penck). Vierzehnteilige Arbeit
 1977.* Galerie Fred Jahn, Munich,
 Galerie Michael Werner, Cologne
1979 *Y., naive naive, rot-grün, grün-rot, 7 7,
 Alternative Alternative.* Galerie
 Michael Werner, Cologne
 A. R. Penck. Concept conceptruimte.
 Text W. A. L. Beeren, Johannes
 Gachnang, M. Visser, P. Groot, A. R.
 Penck. Museum Boymans-van
 Beuningen, Rotterdam
1980 *A. R. Penck. Zeichnungen und Aqua-
 relle.* Text Rolf Wedewer. Städtisches
 Museum Leverkusen, Schloss
 Morsbroich, Leverkusen
 A. R. Penck. Bilder 1967-1977. Galerie
 Fred Jahn, Munich
1981 *a. Y. (a. r. penck) T.* Text Johannes Gach-
 nang, A. R. Penck. Kunsthalle Bern
 a. Y. (a. r. penck). Text A. R. Penck,
 Günther Gercken. Galerie Neuen-
 dorf, Hamburg
 *A. R. Penck. Gemälde, Handzeich-
 nungen.* Text Siegfried Gohr, A. R.
 Penck. Josef-Haubrich-Kunsthalle,
 Cologne
 A. R. Penck. Übergang. GEWAD, Ghent
1982 *A. R. Penck.* Text Richard Calvo-
 coressi, A. R. Penck. Waddington
 Galleries, London
 A. R. Penck. À Paris. Gillespie/Laage/
 Salomon, Paris

III. Group Exhibition Catalogues

1973 *Medium Fotografie.* Fotoarbeiten bil-
 dender Künstler von 1910 bis 1973.
 Text Rolf Wedewer, Fred Jahn,
 Lothar Romain. Städtisches Museum
 Leverkusen
 *6. Internationale Triennale für farbige
 Druckgraphik.* Grenchen, Switzerland

1974 *Kunst bleibt Kunst. Projekt '74. Aspekte
 internationaler Kunst am Anfang der
 70er Jahre.* Kunsthalle, Cologne
1975 *Funkties van tekenen, functions of draw-
 ings.* Text R. Oxenaar, R. H. Fuchs.
 Rijksmuseum Kröller-Müller, Otterlo
 Europalia 1975. Paleis voor Schone
 Kunsten, Brussels
1978 Christel Sauer. *A. R. Penck.* InK, Halle
 für internationale Kunst, Zürich (InK
 Dokumentation 1)
1979 *The 3rd Biennale of Sydney. European
 dialogue.* Sydney
1979 Peter Blum. *A. R. Penck.* InK, Halle
-80 für internationale Kunst, Zürich
 pp. 12-17 (InK Dokumentation 5)
1982 *Portraits et figures, faces and figures,
 Gesichter und Gestalten.* Galerie
 Beyeler, Basel
 *Künstlerbildnisse vom 16. bis 20. Jahr-
 hundert.* Text Gerhard Kolberg,
 Brigitte Lymant, Hella Robels. Wall-
 raf-Richartz Museum und Museum
 Ludwig, Cologne
 New Work on Paper 2. Text Bernice
 Rose. The Museum of Modern Art,
 New York
 Baldessari, Borofsky, Chia,
 Clemente, Cucchi, Disler, Penck,
 Winnewisser. Peter Blum Edition,
 New York. Groninger Museum,
 Groningen
1983 *Expressions: New Art from Germany.*
 The Saint Louis Art Museum

IV. Exhibition Reviews

1973 Rick James, »Halifax – A. R. Penck«.
-74 *Arts Canada,* Nos. 184-187, pp. 202-
 203
1974 Barbara Catoir, »A. R. Penck. Galerie
 Werner, Köln (1.-31. 5. 74)«, *Das
 Kunstwerk,* vol. 27, No. 4, pp. 43-44
1975 Marlis Grüterich, »Exhibition
 Switzerland – A. R. Penck, Kunst-
 halle Bern«, *Studio international,*
 vol. 190, No. 977, p. 158
1978 Titia Berlage, »Opmerkingen over
 A. R. Penck Boymans Bijdragen«,
 Uitg. Stichting Museum Boymans-
 van Beuningen, Rotterdam
 T. A. Heinrich, »A. R. Penck –
 documenta 6 – Painting«, *Arts
 Canada,* April-May, pp. 35-62
1979 »Y – Zeichnungen bis 1975. Kunst-
 museum Basel, 13. Mai-25. Juni
 1978, . . .« *Das Kunstjahrbuch 79.*
 Mainz, pp. 376-377

Marlis Grüterich, »Penck (Ludwig Museum)«, *Kunstforum international*, vol. 36, No. 6, p. 251

1981 Peter Winter, »A. R. Penck. Gemälde, Handzeichnungen. (Josef-Haubrich-Kunsthalle, Köln, 15. 4.-17. 5. 81)«, *Das Kunstwerk*, vol. 34, No. 4, pp. 82-84
Annelie Pohlen, »A. R. Penck – Retrospektive. Kunsthalle Köln, 15. 4.-17. 5. 1981«, *Kunstforum international*, vol. 44/45, Nos. 2-3, pp. 299-300
Alfred Welti, »Bern, Abenteuer eines Museumschefs. (A. R. Penck)«, *Art*, No. 8, p. 118

1982 Donald B. Kuspit, »A. R. Penck at Sonnabend (New York)«, *Art in America*, vol. 70, No. 2, p. 139
Thomas Lawson, »A. R. Penck. Sonnabend Gallery, New York«, *Artforum*, vol. 20, No. 7, p. 72, 107
Edward Lucie-Smith, »London Letter. A. R. Penck. (Waddington Galleries)«, *Art International*, vol. 25, Nos. 7-8, p. 67
Kate Linker, »New Work on Paper 2. (The Museum of Modern Art, New York)«, *Artforum*, vol. 21, No. 3, pp. 76-77
Helena Kontova, »A. R. Penck. Studio Cannaviello/Toselli, Milan«, *Flash Art*, vol. 16, No. 107, p. 54
Jean Marc Prévost, »A. R. Penck. Galerie Gillespie-Laage-Salomon/ Paris«, *Flash Art*, vol. 16, No. 107, p. 54

V. Articles

1973 »A. R. Penck«, *Flash Art*, No. 43, p. 24
-74
1974 »Der Adler«, *Interfunktionen*, No. 11, pp. 28-42
Dieter Koepplin, »Experience in Reality. The Art of A. R. Penck«, *Studio international*, vol. 187, No. 964, pp. 112-116
1975 Johannes Gachnang, »Gespräch mit dem Künstler A. R. Penck alias Ralf Winkler in Dresden«, *Kunst-Nachrichten*, vol. 11, No. 6, pp. 146-151
1977 »Een vriendenportret.« *Kunstecho's*, vol. 6, No. 3, p. 7
1978 Günther Gercken, »Information on Ralf Winkler alias A. R. Penck alias Mike Hammer«, *Louisiana Revy*, vol. 19, No. 2, pp. 16-17

1979 Harald Szeemann, »Beiträge zu einer Geschichte des Dekorativen und des Pattern im 20. Jahrhundert«, *Du*, vol. 39, No. 6, p. 63
1980 »Vom roten Maschinengewehr zum grünen Speer. Interview mit A. R. Penck«, *Art*, No. 9, pp. 113-114
1981 Germano Celant, »A. R. Penck«, *Artforum*, vol. xx, No. 3, pp. 56-62
1982 »Ralf Winkler«, *Art*, No. 1, p. 113

VI. Catalogues of Museum and Private Collections

1974 *Kunst na 1960 int het Kunstmuseum Basel*. Nijmeegs Museum, Nijwegen
1976 *Zeichnen/Bezeichnen: Zeichnungen aus der Sammlung Mia und Martin Visser, Bergeyk, mit Beiträgen aus der Sammlung Geert Jan Visser, Antwerpen*. Foreword Franz Meyer, R. H. Fuchs. Text: Zdenek Felix. Kunstmuseum Basel
1977 *Kunst um 1970. Sammlung Ludwig Aachen*. Künstlerhaus, Vienna Wolfgang Richter, *Kunststadt Aachen*. Greven Verlag, Cologne
1978 »A. R. Penck: N & Komplex, 1976«, Wolfgang Becker: Erwerbsbegründung. (Aachen, Neue Galerie-Sammlung Ludwig) *Das Kunstjahrbuch 77/ 78*, pp. 170-171. Alexander-Bauer-Presse
1981 *Jahresbericht der Öffentlichen Kunstsammlung Basel für das Jahr 1980*. Kunstmuseum Basel, p. 24, Ill. 27
1982 A. R. Penck. *45 Zeichnungen, Bewußtseinsschichten*. Text Dieter Koepplin. (Ausstellung Städtisches Kunstmuseum Bonn). Kunstmuseum Basel »Neuerwerbungen, Bayerische Staatsgemäldesammlungen«, *Münchner Jahrbuch der Bildenden Kunst*, 3. Folge, vol. XXXII, Munich

F. Common Bibliographic Section

VIII. Common Group Exhibition Catalogues

1966 *Deutscher Künstlerbund. 14. Ausstellung*. Ausstellungshallen am Gruga-Park, Essen (B, L)
1967 *Berlin-Berlin. Junge Berliner Maler und Bildhauer*. Deutsche Gesellschaft für bildende Kunst (Kunstverein Berlin), Berlin, Athens (B, L)
Jacques Damase présente: Jeunes peintres de Berlin. Text Eberhard Roters, Jacques Damase. Galerie Motte, Geneva, Paris (B, L)
1969 *Sammlung 1968, Karl Ströher*. Text Hans Strelow, Jürgen Wissmann. Deutsche Gesellschaft für bildende Künste e. V. (Kunstverein Berlin), Neue Nationalgalerie, Berlin, Städtische Kunsthalle Düsseldorf (B, L)
1972 *Zeichnungen der deutschen Avantgarde*. Text Peter Weiermair. Galerie im Taxispalais, Innsbruck (B, I, P)
documenta 5: Befragung der Realität, Bildwelten heute. Text Harald Szeeman, Jean-Christophe Ammann. Kassel (B, I, P)
1972 *Zeichnungen 2*. Text Rolf Wedewer.
-73 Städtisches Museum Leverkusen, Schloss Morsbroich, Leverkusen (B, I, L, P)
1973 Galerie Heiner Friedrich editions by Baselitz, Richter, Palermo, Penck and Knoebel. Multiples Inc., New York
Prospect 73. Maler/painters/peintres. Text Evelyn Weiss, Konrad Fischer, Jürgen Harten, Hans Strelow. Städtische Kunsthalle Düsseldorf (B, L, P)
1973 *Bilanz einer Aktivität*. Galerie im
-74 Goethe-Institut/Provisorium, Amsterdam (B, K, L, P)
1975 *Je/nous-ik/wij*. Text Jörg Immendorff, Redebeitrag für das xx. Internationale Kunstgespräch in Wien, 1974. Isi Fiszman, Pour écrire la liberté. Musée d'Ixelles, Brussels (I, P)
1976 *B 76. La Biennale di Venezia*, settore arti visive e architettura. Catalogo generale. Venice (I, P)
1977 *documenta 6*. vol. 1 Einführung, Malerei, Plastik-Environment, Performance. (B, L, P) vol. 3 Handzeichnungen, utopisches Design, Bücher. (B, K, L, P) Kassel

*Zum Beispiel Villa Romana, Florenz –
Zur Kunstförderung in Deutschland 1.*
Text Elio Gabbuggiani, Hans Albert
Peters, Joachim Burmeister *et al.*
Staatliche Kunsthalle, Baden-Baden,
Palazzo Strozzi, Florence (B, L)

1978 *13° East – Eleven Artists Working in
Berlin.* Whitechapel Art Gallery,
London (L, P)

1979 *Zeichen setzen durch zeichnen.* Text
Uwe M. Schneede, Günther Gercken.
Kunstverein Hamburg (B, P)
Malerei auf Papier. Text Michael
Schwarz. Badischer Kunstverein,
Karlsruhe (B, I, K, L, P)
*Staatliche Akademie der Bildenden
Künste Karlsruhe, zum 125jährigen
Bestehen.* Karlsruhe (B, L)

1980 *La Biennale di Venezia,* settore arti
visive. Catalogo generale. Venice
(B, I, K, L, P)
Les nouveaux fauves, die Neuen Wilden.
Text Wolfgang Becker. Neue Galerie –
Sammlung Ludwig, Aachen
(B, I, K, L, P)
*Der gekrümmte Horizont: Kunst in
Berlin 1945-1967.* Text Johannes Gach-
nang. Akademie der Künste, Berlin
(B, L, P)
*Zeichen des Glaubens, Geist der Avant-
garde: religiöse Tendenzen in der Kunst
des 20. Jahrhunderts.* Schloss Char-
lottenburg, Grosse Orangerie, Berlin
(B, L)

1980 *Après le classicisme.* Text Jacques
-81 Beauffet, D. Semin, Anne Dary-
Bossut. Musée d'Art et d'Industrie et
Maison de la Culture, Saint-Étienne
(B, I, K, L, P)

1981 *Baselitz, Immendorff, Lüpertz, Penck.* Gale-
rie Gillespie/Laage/Salomon, Paris
A New Spirit in Painting. Text Christos
M. Joachimides, Norman Rosenthal,
Nicholas Serota. Royal Academy of
Arts, London (B, K, L, P)
Laszlo Glozer: *Westkunst: zeitgenös-
sische Kunst seit 1939.* DuMont Buch-
verlag, Cologne (B, I, P)
Art Allemagne aujourd'hui. ARC,
Musée d'art moderne de la ville de
Paris (B, I, K, L, P)
*Schilderkunst in Duitsland 1981, pein-
ture en Allemagne 1981.* Text Johannes
Gachnang, Siegfried Gohr, Theo
Kneubühler, Dieter Koepplin,
Günther Gercken, Trols Andersen,
Christos M. Joachimides. Vereniging
voor Tentoonstellingen van het Paleis
voor Schone Kunsten, Brussels
(B, I, K, L, P)

*Die Professoren der Staatlichen Akade-
mien der Bildenden Künste Karlsruhe
und Stuttgart.* Staatliche Kunsthalle,
Baden-Baden (B, L)
*Hunden tillstöter under veckans lopp, der
Hund stösst im Laufe der Woche zu mir.*
Jörg Immendorff, Per Kirkeby, Markus
Lüpertz, A. R. Penck. Text Siegfried
Gohr. Moderna Museet, Stockholm

1981 *2. Biennale der europäischen Grafik
-82 Baden-Baden.* Baden-Baden (B, P)

1982 *'60'80: Attitudes, Concepts, Images.*
Stedelijk Museum, Amsterdam (B, K)
documenta 7. vol. 1.2. Kassel
(B, I, K, L, P)
La nuova pittura tedesca: Georg
Baselitz, Jörg Immendorff, Anselm
Kiefer, Per Kirkeby, Markus Lüpertz,
A. R. Penck. Text Johannes Gach-
nang, Siegfried Gohr. Studio
Marconi, Milan
Erste Konzentration. Text Alexander
Dückers. Maximilian Verlag, Sabine
Knust, Munich (B, I, L, P)
Achille Bonito Oliva: *Avanguardia
transavanguardia.* Electa, Milan.
Exhibit: Mura Aureliane da Porta
Metronia, a Porta Latina, Rome
(B, I, K, L, P)
*Vergangenheit, Gegenwart, Zukunft:
zeitgenössische Kunst und Architektur.*
Text Tilman Osterwold, Andreas
Vowinckel, Frank Werner. Württem-
bergischer Kunstverein, Stuttgart
(I, K, P)
Mythe, drame, tragédie. Text Jacques
Beauffet, Bernard Ceysson, Achille
Bonito Oliva. Musée d'Art et d'Indu-
strie et Maison de la Culture, Saint-
Étienne (B, K, L, P)
Zeitgeist. Internationale Kunstaus-
stellung, Berlin 1982. Martin-
Gropius-Bau. Text Christos M.
Joachimides, Norman Rosenthal *et al.*
Frölich & Kaufmann, Berlin
(B, I, K, L, P)
Pressure to Paint. Text David P. Robin-
son. Curated by Diego Cortez. Marl-
borough Gallery, New York (B, L, P)
*The 4th Biennale of Sydney 1982. Vision
in disbelief.* Text William Wright,
Elwyn Lynn. Sydney (B, I, L)
German Drawings of the Sixties. Ed.
Dorothea Dietrich-Boorsch. Yale Uni-
versity, New Haven, Art Gallery of
Ontario, Toronto (I, L, P)
*9. Internationale Triennale für farbige
Originalgraphik.* Veranstaltet von der
Kunstgesellschaft Grenchen. Halden-
schulhaus, Grenchen (B, I, L, P)

La Transavanguardia Tedesca. Text
Achille Bonito Oliva. Galleria
Nazionale d'Arte Moderna, San
Marino (B, I, L, P)
*New Figuration. Contemporary Art from
Germany.* Text Donald B. Kuspit.
Frederick S. Wight Art Gallery, Uni-
versity of California, Los Angeles
(B, I, K, L, P)

1983 *Mensch und Landschaft in der zeitgenös-
sischen Malerei und Graphik aus der
Bundesrepublik Deutschland.* Moscow,
Leningrad (B, L)
*Mensch und Landschaft in der zeitgenös-
sischen Malerei und Graphik.* Ministe-
rium für Kultur der UdSSR, Deutsche
Bank AG, Kunstverein für die Rhein-
lande und Westfalen aus der Bundes-
republik Deutschland. Text Ursula
Peters, Karin Thomas, Gerd de Vries,
Nicholas Serota, Werner Hofmann.
Kunstverein für die Rheinlande und
Westfalen, Düsseldorf (B, I, K, L)
*L'Italie et l'Allemagne. Nouvelles sensibi-
lités, nouveaux marchés.* Gravures de
Chia, Paladino, Cucchi, Clemente,
Baselitz, Penck, Lüpertz, Immen-
dorff. Postfaces de Maurice Besset et
al. Cabinet des estampes, Musée
d'art et d'histoire, Genève (B, I, L, P)
Jannis Kounellis, Daniel Buren, Sig-
mar Polke, Luciano Fabro, Anselm
Kiefer, Georg Baselitz, Jan Dibbets,
Art & Language, Stanley Brouwn.
Paintings, installations. Van Abbe-
museum, Eindhoven (B, K)

IX. Exhibition Reviews

1973 Johannes Gachnang, »Galerie im
Goethe-Institut, Provisorium, ein
Ausstellungsexperiment in Amster-
dam«, *Kunst-Nachrichten,* vol. 10,
No. 4/5
Piet van Daalen, Johannes Gach-
nang, »De funktie van de galerie in
het Goethe instituut te amsterdam«,
Museumsjournaal, serie 18, No. 6,
pp. 268-272 (B, K, L, P)

1979 Johannes Halder, »Malerei auf
Papier. Badischer Kunstverein,
Karlsruhe (24. 7.-16. 9. 79)«, *Das
Kunstwerk,* vol. 32, No. 5, pp. 83-84

1980 Renate Puvogel, »Les nouveaux
fauves – die neuen Wilden. Neue
Galerie – Sammlung Ludwig, Aachen
(19. 1.-21. 3. 80)«, *Das Kunstwerk,*
vol. 33, No. 2, pp. 80-81 (B, K)

Ingrid Rein, »Venedig, Ausstellung, 39. Biennale, Arti visive '80«, *Pantheon*, vol. 38, No. 4, pp. 331-334
»Die Kritik riecht Blut und greift an. Documenta-Leiter Rudi H. Fuchs über das deutsche Biennale-Echo«, *Der Spiegel*, vol. 34, No. 26, pp. 197-198 (B, K)
Schwieriger Siegfried, »Zwei Maler vom ›Rande der Krisenplätze‹«, Georg Baselitz und Anselm Kiefer, vertreten die Bundesrepublik bei der Biennale in Venedig«, *Der Spiegel*, vol. 34, No. 22, pp. 218-222
»Dunkles Pulsieren. Die Biennale in Venedig definiert die Kunst der 80er Jahre: ›Wieder ein Abenteuer‹«, *Der Spiegel*, vol. 34, No. 23, pp. 213-214 (B, K)
Giancarlo Politi, »Venice Biennale. An Interview with Harald Szeeman«, *Flash Art*, No. 98-99, pp. 5-7 (I, P)

1981 »Malerei: Zurück zur Mutter. (A New Spirit in Painting, London)«, *Der Spiegel*, vol. 35, No. 4, pp. 150-151 (B, L)
Roberta Smith, »Fresh Paint? (New Spirit in Painting, Royal Academy, London)«, *Art in America*, vol. 69, No. 6, pp. 70-92 (B, K, L, P)
Catherine Millet, »›St. Étienne – Après le classicisme‹ Musée d'Art et d'Industrie«, *Art Press*, vol. 45, p. 38
Klaus Honnef, »Art Allemagne aujourd'hui«, *Kunstforum international*, vol. 43, No. 1, pp. 116-120 (B, I, K, L, P)
Stuart Morgan, »Cold Turkey: ›A New Spirit in Painting‹ at the Royal Academy of Arts, London«, *Artforum*, vol. 19, No. 8, p. 47
Christos M. Joachimides, »Ein neuer Geist in der Malerei«, *Kunstforum international*, vol. 43, No. 1, pp. 18-47 (B, K, L, P)
Peter Schjeldahl, »Anxiety as a Rallying Cry«, *The Village Voice*, 16-22 September, p. 88
»Westkunst, Realismus, Mimesis«, *Kunstforum international*, vol. 44/45, No. 2-3 (B, I, P)
William Zimmer, »Blitzkrieg Bopped«, *Soho News*, 22 December, p. 61
Kim Levin, »Rhine Whine«, *The Village Voice*, 16-22 December, pp. 126-127

1981 Kay Larson, »Heavy Going«, *New York*, 28 December-January 4,
-82 pp. 88-90

1982 Marie Hüllenkremer, »New York, die deutschen Wilden haben nun Konjunktur«, *Art*, No. 1, p. 111 (B, I, K, L, P)
Robert Hughes, »Upending the German Chic«, *Time*, 11 January, pp. 84-87
Peter Schjeldahl, »Mass Productions«, *The Village Voice*, 23 March, pp. 84-85
Mark Stevens, »Art's Wild Young Turks«, *Newsweek*, 7 June, pp. 68-69 (B, L, P)
Kay Larson, »Arts: Pressure Points«, *New York*, 28 June, pp. 58-59
Annelie Pohlen, »The Dignity of the Thorn«, Kate Linker, »Grim Fairy Tales«, Donald B. Kuspit, »The Night Mind«, Richard Flood, »Wagner's Head«, Edit de Ak, »Stalling Art«, (documenta 7), *Artforum*, vol. 21, No. 1, pp. 57-75
Jeanne Silverthorne, »The Pressure to Paint, Marlborough Gallery«, *Artforum*, vol. 21, No. 2, pp. 67-68
Richard Flood, Donald B. Kuspit, Lisa Liebmann, Stuart Morgan, Annelie Pohlen Schuldt, »documenta 7: continued«, *Artforum*, vol. 21, No. 2, pp. 81-86
Elwyn Lynn, »Letter from Australia. The Fourth Biennale of Sydney«, *Art international*, vol. 25, No. 7-8, pp. 43-48 (B, I, L)
Corinne Robins, »Ten Months of Rush-Hour Figuration«, *Arts Magazine*, September, pp. 100-103
»documenta 7 – ein Rundgang«, *Kunstforum*, vol. 53/54, No. 7-8 (B, I, K, L, P)
Gerald Mazorati, »documenta 7«, *Portfolio*, September-October, pp. 92-95 (B, K, P)
»Der Zeitgeist weht durch den Palazzo«, *Der Spiegel*, vol. 36, No. 41, pp. 241-244 (B, P)
Noel Franckman, Ruth Franckman, »documenta 7: The Dialogue and a Few Asides«, *Arts*, October, pp. 91-97
»Zeitgeist«, *Kunstforum international*, vol. 56, No. 10 (B, I, K, L, P)
Waldemar Januszcak, »Exhibition Berlin (Zeitgeist)«, *Studio International*, vol. 195, No. 997, pp. 78-79 (P, K)
Calvin Tomkins, »The Art World – Looking for the Zeitgeist«, *The New Yorker*, 6 December, pp. 150-152
Johannes Gachnang, »›Zeitgeist‹ und meine Reise nach Berlin«, *Kunst-Bulletin*, No. 12

1983 Wolfgang Max Faust, »The Appearance of the Zeitgeist«, *Artforum*, vol. 21, No. 5, pp. 86-93
William Feaver, Dispirit of the times (Zeitgeist), *Art News*, vol. 82, no. 2, pp. 80-83 (B, K, P)
Leon Paroissien, Report from Sydney, The fourth Biennale, *Art in America*, vol. 71, no. 2, pp. 25-29 (B, I, L)
Joan Simon, Report from Berlin »Zeitgeist«, the times & the place, *Art in America*, vol. 71, no. 3, pp. 33-37 (B, I, K, L, P)

X. Articles on Contemporary German Art

1973 Heinz Ohff, »Das neue Porträt oder: Was ist neu dran«, *Kunstforum international*, vol. 6-7, No. 1, pp. 94-123 (B, I, L, P)
1976 Theo Kneubühler, »Die Kunst, das ›Ungleiche‹ und die Kritik«, *Kunst-Bulletin des Schweizerischen Kunstvereins*, vol. 9, No. 10, pp. 8-12 (K, P)
1977 Michael Schwarz, »Spontanmalerei. Über das Verhältnis von Farbe und Gegenstand in der neueren Malerei«, *Kunstforum international*, vol. 20, No. 2, pp. 46-66 (B, K, L)
1978 Theo Kneubühler, »Malerei als Wirklichkeit – Baselitz, Kiefer, Lüpertz, Penck«, *Kunst-Bulletin des Schweizerischen Kunstvereins*, vol. 11, No. 2, pp. 2-11
Jörg Zutter, »Drie vertegenwoordigers van een nieuwe Duitse schilderkunst. Opmerkingen bij het werk van Georg Baselitz, Markus Lüpertz en Anselm Kiefer«, *Museumsjournaal*, serie 23, No. 2, pp. 52-61
1979 Wolfgang Becker, »Die Sammlung Ludwig in der Neuen Galerie Aachen«, *Du*, No. 1, p. 80 (I, L, P)
1980 Klaus Jürgen-Fischer, »Come-back der Malerei?«, *Das Kunstwerk*, vol. 33, No. 3, pp. 3-57 (B, L)
Bazon Brock, »Was heisst Avantgarde auf Deutsch? Auf die Kunst des deutschen Mythos reagiert die Kritik mit Polemik: eine Flucht aus der Betroffenheit«, *Ergo*, vol. 10, pp. 4-10. Carl Hanser Verlag, Munich (B, I, K, L, P)
Klaus Wagenbach, »Neue Wilde, teutonisch, faschistisch?«, *Freibeuter*, No. 5, pp. 138-147 (K, L)
1981 Bazon Brock, »The End of Avant-Garde? and So the End of Tradition.

Notes on the Present ›Kulturkampf‹ in West Germany«, *Artforum*, vol. 19, No. 10, pp. 62-67 (B, I, K, L, P)

Wolfgang Max Faust, »Du hast keine Chance, Nutze Sie! With It and Against It: Tendencies in Recent German Art«, *Artforum*, vol. 20, No. 1, p. 39 ff.

Ernst Busche, »Violent Painting«, *Flash Art*, No. 101

Donald Kuspit, »The New (?) Expressionism: Art as Damaged Goods«, *Artforum*, vol. 20, No. 3, pp. 47-55 (I, K, P)

Benjamin H. D. Buchloh, »Figures of Authority, Ciphers of Regression: Notes on the Return of Representation in European Painting«, *October*, No. 16, pp. 55 ff.

Calvin Tomkins, »The Art World: An End to Chauvinism«, *The New Yorker*, 7 December, pp. 146-151

Marlis Grüterich, »Natural Emotions for Artificial Worlds«, *Parachute*, vol. 25, pp. 20-23 (B, K, L, P)

John Russell, »Art: The News is All from West Germany«, *The New York Times*, 11 December

Peter Plagens, »The Academy of the Bad«, *Art in America*, vol. 69, No. 9, pp. 11-17 (B, L)

»Malerei '81: Triumph der Wilden«, *Art*, No. 10, pp. 22-43

Achille Bonito Oliva, »The International Trans-Avantgarde«, *Flash Art*, No. 104, pp. 36-43 (B, I, K, L, P)

Thomas Lawson, »Last Exit: Painting«, *Artforum*, vol. 20, No. 2, p. 45

»Neuer Expressionismus in Deutschland«, *Das Kunstwerk*, vol. 34, No. 6

Douglas Crimp, »The End of Painting«, *October*, No. 16, p. 80

1981 Bernhard Passel, Wolfgang Max
-82 Faust, »Worüber zu sprechen ist. Ein Florilegium aus Kritiken und Rezensionen zum Zeitschnitt, 30 Deutsche«, *Kunstforum international*, vol. 47, pp. 172-175, 177 (B, I, K, L, P)

1982 Corinne Robins, »Nationalism, Art, Morality and Money, etc.«, *Arts Magazine*, January

Johannes Gachnang, »New German Painting«, *Flash Art*, No. 106, pp. 33-37 (B, I, K, L)

Siegfried Gohr, »The Situation and the Artists«, *Flash Art*, No. 106, pp. 38-46 (B, I, K, L, P)

»Rudi Fuchs über seine documenta 7: Die Avantgarde ist tot«, *Art*, No. 6, pp. 20-46 (B, I, K, L)

Donald B. Kuspit, »Acts of Aggression. German Painting Today (Part 1)«, *Art in America*, vol. 70, No. 8, pp. 141-151 (B, I, K, L, P)

Donald B. Kuspit, »Report from Berlin, ›Bildwechsel‹: Taking Liberties«, *Art in America*, vol. 70, No. 2, pp. 43-49

Siegfried Gohr, »La peinture en Allemagne. Les confusions de la critique«, *Art Press*, vol. 57, pp. 15-17 (B, I, L, P)

Klaus Brandt, »Kunstmarkt-Kreisläufe. Anmerkungen zur aktuellen Kunstszene«, *Tendenzen*, vol. 22, No. 136, pp. 45-48 (B, I, K, L, P)

Siegfried Gohr, »Skulptur als Fortsetzung der Malerei«, *Art*, No. 6, pp. 26-27 (B)

Joseph Kosuth, »Necrophilia, Mon Amour«, *Artforum*, vol. 20, No. 9, p. 6

Dobrah C. Phillips, »No Island is an Island: New York Discovers the Europeans«, *Art News*, vol. 81, No. 8, pp. 66-71

Cathérine Francblin, »La peinture dans les chaînes«, *Art Press*, No. 61

1983 Craig Owens, »Honor, Power and the Love of Women«, *Art in America*, vol. 71, No. 1, pp. 7-13

Hal Foster, »The Expressive Fallacy«, *Art in America*, vol. 71, No. 1, pp. 80 ff.

Donald B. Kuspit, »Acts of Aggression: German Painting Today (Part II),« *Art in America*, vol. 71, No. 1, pp. 90 ff. (B, I, K, L, P)

Carter Ratcliff, »The Short Life of the Sincere Stroke«, *Art in America*, vol. 71, No. 1

XI. Monographs on Modern and Contemporary German Art

1966 *Kunst unserer Zeit.* Ed. Will Grohmann. DuMont Buchverlag, Cologne, p. 262, Ill. 320 (B)

1973 Gerd Winkler. *Kunstwetterlage.* Belser Verlag, Stuttgart (B, I, P)

1974 Wieland Schmied. *Malerei nach 1945.* Propyläen Verlag, Frankfurt, Berlin, Vienna (B, I, L, P)

1975 Karin Thomas. *Bis heute.* Stilgeschichte der bildenden Kunst im 20. Jahrhundert. 3. erweiterte und neubearbeitete Auflage. DuMont Buchverlag, Cologne (P)

1981 Amine Haase. *Gespräche mit Künstlern.* Wienand Verlag, Cologne (B)

1982 Andreas Franzke. *Skulpturen und Objekte von Malern des 20. Jahrhunderts.* DuMont Buchverlag, Cologne (B, I, L, P)

Wolfgang Max Faust, Gerd de Vries. *Hunger nach Bildern. Deutsche Malerei der Gegenwart.* DuMont Buchverlag, Cologne (B, I, K, L, P)

Flavio Caroli. *Magico primario. L'arte degli anni ottanta.* Gruppo Editoriale Fabbri, Milan (B, I, K, P)

Günther Wirth. *Kunst im deutschen Südwesten, von 1945 bis zur Gegenwart.* Watje, Stuttgart (B, K, L)

Berlin, das malerische Klima einer Stadt. Text Erika Billeter. Benteli, Bern (L)

Maler in Berlin. (Interviews) Verlag Happy Happy, Berlin (B, I, L, P)

XII. Catalogues of Museum and Private Collections

1973 *Bilder, Objekte, Filme, Konzepte.* (Sammlung Herbig). Städtische Galerie im Lenbachhaus, Munich (B, I, P)

1975 Wolfgang Becker: »Tätigkeitsbericht der Neuen Galerie–Sammlung Ludwig«, *Aachener Kunstblätter*, vol. 46, pp. 319-321. DuMont Buchverlag, Cologne (B, P)

1976 *Bis heute.* Zeichnungen für das Kunstmuseum Basel aus dem Karl A. Burckhardt-Koechlin-Fonds. Text Carlo Huber, Martin H. Burckhardt, Dieter Koepplin. Kunsthalle Basel

1977 *Zeitgenössische Kunst aus der Sammlung des Stedelijk Van Abbemuseum Eindhoven.* Text Rudi Fuchs, Johannes Gachnang. Kunsthalle Bern, Kunstmuseum Bern (I, L, P)

Wolfgang Becker. *Der ausgestellte Künstler.* Museumskunst seit 45. Ludwig Collection 1977. Vol. 1.2. Neue Galerie–Sammlung Ludwig, Aachen (B, P)

1978 *Kunst des 20. Jahrhunderts aus Berliner Privatbesitz.* Text Eva Poll, Rudolf Springer. Catalogue Hanspeter Heidrich. Akademie der Künste, Berlin, Kunsttage Berlin (B, L, P)

Works from the Crex Collection, Zurich, Werke aus der Sammlung Crex, Zürich. Text Urs Raussmüller, R. H. Fuchs, Georg Jappe. InK, Zürich, Louisiana Museum, Humlebaek, Städtische Galerie im Lenbachhaus, Munich, Stedelijk Van Abbemuseum, Eindhoven (B, L, P)

1979 *Handbuch Museum Ludwig:* Kunst des
20. Jahrhunderts, Gemälde, Skulp-
turen, Collagen, Objekte, Environ-
ments. Cologne (B, L, P)
*Museum moderner Kunst: Sammlung
Ludwig.* Ed. Gesellschaft der Freunde
des Museums moderner Kunst.
Vienna (B, L, P)
*Museum moderner Kunst: Kunst der
letzten 30 Jahre.* Ed. Gesellschaft der
Freunde des Museums moderner
Kunst. Vienna (B, L, P)
Formaties. Text P. Heijnen. Museum
Boymans- van Beuningen,
Rotterdam (B, I, K, L, P)

1980 *De collectie van het Stedelijk Museum,*
The Stedelijk Museum Collection,
1974-78. Amsterdam (B, P)
*Jahresbericht der Öffentlichen Kunst-
sammlung Basel für das Jahr 1978.*
Kunstmuseum Basel, pp. 36, 38, Ill.
24, 26, 27 (I, P)
*Baselitz, Beuys, Penck. Sammlung
Ludwig.* CAPC, Entrepôt Lainé,
Bordeaux

1981 *Tendenzen der modernen Kunst, Samm-
lung Ingrid und Hugo Jung.* Text Adam
C. Oellers, Renate Puvogel, E. G.
Grimme. Suermondt-Ludwig-
Museum und Museumsverein,
Aachen (B, K, L, P)

1982 *Die Handzeichnung der Gegenwart II:
Neuerwerbungen seit 1970.* Text Gun-
ther Thiem, Magdalena M. Moeller.
Graphische Sammlung, Staatsgalerie
Stuttgart (B, L, P)
Bernhard Schnackenburg, Wilhelm
Bojescul: *Kunst der sechziger Jahre in der
Neuen Galerie Kassel.* Neue Galerie,
Staatliche und Städtische Kunst-
sammlungen, Kassel (B, P)
Werke aus der Sammlung Crex,
Zürich. Text Jean-Christoph
Ammann. Kunsthalle Basel (B, P)
*Zeichnungen international aus dem
Kunstmuseum Basel.* Text Dierk
Stemmler, Dieter Koepplin.
Städtisches Kunstmuseum, Bonn
(B, I, K, P)
Deutsche Zeichnungen der Gegenwart.
Museum Ludwig, Cologne (B, P)
Neuerwerbungen. Staatliche
Graphische Sammlung München.
Neue Pinakothek, Munich (B, L, P)
*Kunst unserer Zeit. Neuerwerbungen
1980-1982.* Groninger Museum,
Groningen (B, K, P)

1983 *Neue Zeichnungen aus dem Kunst-
museum Basel.* Kunstmuseum Basel,
Kunsthalle Tübingen, Neue Galerie,

Staatliche und Städtische Kunst-
sammlungen, Kassel (B, I, P)
Riva Castleman: *Prints from block
Gauguin to now.* The Museum of
Modern Art, New York (B, P)
Zwischen New York und Moskau. »Zur
Geographie der Gegenwartskunst«.
Meisterwerke der Sammlung
Ludwig. Mannheimer Kunstverein,
Mannheim (B, K, P)

XIII. Lexicons

1968 *Kunst der jungen Generation:* ein
Literaturverzeichnis und biographi-
sches Nachschlagewerk. Amerika-
Gedenkbibliothek, Berliner Zentral-
bibliothek, Berlin (B)

1970 *Kunst der jungen Generation 2:* ein
Literaturverzeichnis und biographi-
sches Nachschlagewerk. Amerika-
Gedenkbibliothek, Berliner Zentral-
bibliothek, Berlin (B, I, L)

1977 Karin Thomas, Gerd de Vries:
*DuMont's Künstler Lexikon von 1945 bis
zur Gegenwart.* DuMont Buchverlag,
Cologne (B, K, L, P)
Contemporary Artists. Ed. Colin Nay-
lor, Genesis P-Orridge. St. James
Press, London, St. Martin's Press,
New York (B, P)

1979 *Archiv für Techniken und Arbeits-
materialien zeitgenössischer Künstler.*
Ed. Erich Gantzert-Castrillo. Vol. 1.
Harlekin Art, Museum Wiesbaden,
Wiesbaden (B, I, P)

1981 *Dictionary of Contemporary Artists.* Ed.
Babington Smith. Glio Press, Oxford
(B, I, K, L, P)

1982 Carl Vogel: *Zeitgenössische Druck-
graphik.* Künstler, Techniken, Ein-
schätzungen. Keyser, Munich (B, I, P)
Knaurs Lexikon der Modernen Malerei.
Von den Impressionisten bis heute.
Ed. Barbara Hammann. Droemer
Knaur, Munich, Zürich (B, I, K, L, P)

Appendix: Discography

Jörg Immendorff

1982 *Die Vielleichtors, Café Deutschland.*
With Markus Oehlen as part of *Krater
und Wolke,* ed. A. R. Penck, Michael
Werner. Cologne, No. 2

A. R. Penck

1979 *Gostritzer 92.* Weltmelodie, WM-LP-
0100

1980 *Hinter der Wüste sterben die Gespenster
Afrika Para noia.* Weltmelodie, WM-
LP-4715 / 1 + 2

1981 *Konzert in der Kunsthalle Bern 14. 8. 81.*
Kowald Trio I, Kunsthalle Bern,
30-771
*Nacht Café Deutschland, A + B = C?
oder was?? A. R. Penck Kontrabass Solo,
Mini Synthesizer Harmonix.* Welt-
melodie, WM-LP-4717 / 1 + 2

Photo Credits

The Saint Louis Art Museum and the publishers wish to thank the owners of the paintings and the galleries for their permission to reproduce them and for providing photographic material. They also wish to thank the following photographers:

van den Bichelaer, Geldrop
Mary Boone, New York
Balthasar Burkhard, La Chaux-de-Fonds
Stuart Friedman
Anne Gold, Aachen
Benjamin Katz, Cologne
Bernd-Peter Keiser, Braunschweig
J. Littkemann, Berlin
Frank Oleski, Cologne
Rheinisches Bildarchiv, Cologne
H. P. Riegel, Düsseldorf
Friedrich Rosenstiel, Cologne
Steven Sloman
Zindman/Fremont